Percy Moore Turner

Percy Moore Turner

Connoisseur, Impresario & Art Dealer

Sarah A. M. Turner

UNICORN

First published by Unicorn
an imprint of the Unicorn Publishing Group LLP, 2018
101 Wardour Street
London W1F 0UG
www.unicornpublishing.org

10 9 8 7 6 5 4 3 2 1

ISBN 978-1-910787-80-9

Cover design Unicorn Publishing Group
Typeset by Vivian@Bookscribe

Printed and bound in China for Latitude Press Ltd

Dedication

To my grandmother, Mabel Grace Turner, who stood by my grandfather through both good and bad times.

'To finish, I must pay tribute to his sunny, generous, genial and tireless disposition until, in his later years, ill health and certain disillusionments led to regrettable changes of outlook and general character.'

Taken from Notes by Mabel Grace Turner on Percy Moore Turner's account of his own career, *written several years after his death.*

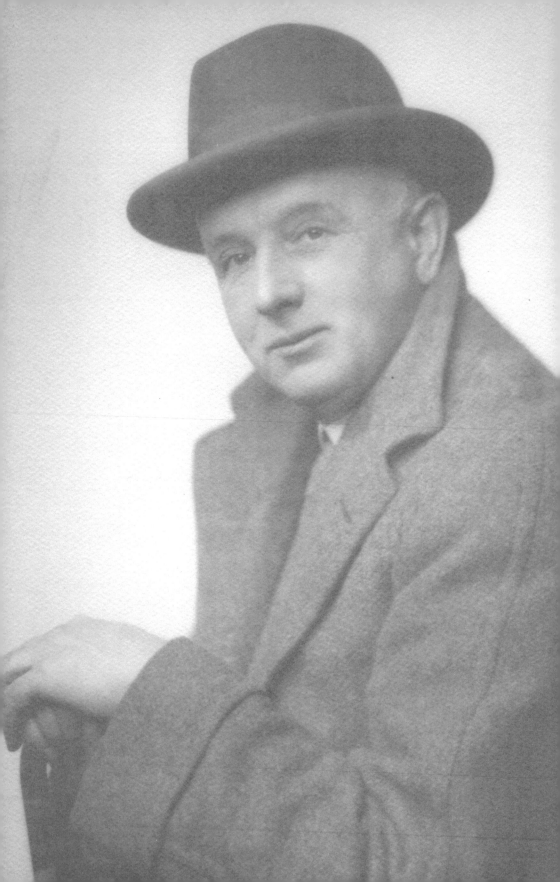

CONTENTS

PREFACE

I grew up knowing very little about the life of my grandfather but in July 2012 Dimitri Salmon, Collaborateur Scientifique at the Musée du Louvre, contacted my brother and me as he was researching the life of Percy Moore Turner. Dimitri has extensively researched the works of Georges de La Tour and he was particularly interested in the *St Joseph, the Carpenter*, which my grandfather had presented to the Louvre in 1948. This gave me the incentive to research my grandfather's life in collaboration with Dimitri.

Although I have undertaken research in my own clinical speciality, I have no background in the history of art. The Turner family have very few of my grandfather's papers, so his life has had to be mostly pieced together using his invaluable unpublished autobiography, letters, newspaper articles and exhibition catalogues. Some of these are written in French, so the titles of pictures have been given in French in those instances. The titles and attributions of pictures in the text have changed over time and the new titles have been included where possible. I have been unable to trace some pictures, perhaps because of these changes.

My grandfather wrote his unpublished autobiography in 1948. It is typewritten and my grandmother chose to preserve it as she thought that it might be of 'some interest and even use to the family at some future date'. A few years after my grandfather's death she added a handwritten preface to the manuscript. In this she explained: 'It must be remembered that, at the time of writing, he was a very sick man and, by reason of his state of health and his enforced inactivity which left him so much time to fret and brood after such an active and interesting life, plus his anxiety about the eventual disposition of his artistic possessions, he had developed an extraordinary obsession with the importance of his achievements and an inordinate desire for full credit and recognition of them.'

The fifty-one page autobiography did omit some of the highlights of my grandfather's life that I describe in Chapter 7, but it did provide invaluable leads to information that were crucial to the research into his life. Some parts of my grandfather's autobiography I was unable to verify, such as his friendship with individuals linked with the Museo Nacional del Prado and his association with John Crome's *The Poringland Oak* of around 1818–20, purchased by the Tate Gallery in 1910. These and other parts of his autobiography have not been included in the text.

To distinguish Percy Moore Turner from other members of his family mentioned in the book and the artist William Mallord Turner, I have used Percy rather than Turner as the abbreviated form of my grandfather's name.

I hope this book will encourage art historians to research my grandfather's life further.

Sarah A. M. Turner

1 CHILDHOOD – FROM HALIFAX TO NORWICH

Percy Moore Turner was born on 6 July 1877 in Halifax in Yorkshire. During the mid-Victorian era, the population of the borough of Halifax more than doubled, rising from 25,159 in 1851 to 65,510 in 1871, initially due to the expansion of the local textile industries.[1] As the textile industries declined in the second half of the nineteenth century, Halifax's population growth was sustained by an increasing diversification whereby Halifax earned a reputation as 'a town of 100 trades'.[2] These included confectionery, construction, engineering, cable and machine tool-making industries.[3]

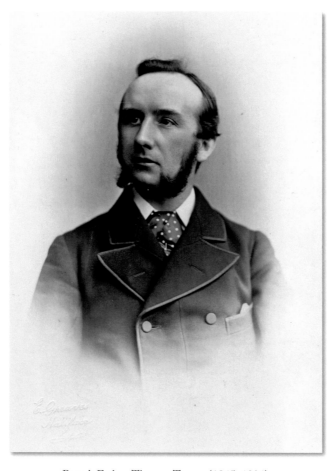

Percy's Father, Thomas Turner (1845–1906)

Percy's father, Thomas Turner (1845–1906), was listed by profession in the censuses for England as 'a hosier' (1861), 'a master hosier employing 4 girls and boys' (1871), 'hosier' (1881), 'living on his own means' (1891) and 'a retired hosier and haberdasher' (1901).[4] In the Halifax local trade directories, he is listed as 'a hosier at 13 Old Market' (1867),[5] 'a hosier at 14 and 16 Old Market' (1871),[6] under the category of hosiers and glovers at 14 Old Market (1887),[7] and as 'a hosier at 14 and 16 Old Market' (1889).[8] In the Turner Family Papers there is a brass printing plate illustrating Thomas Turner's shop at 12 and 13 Old Market, which was a ladies' outfitter, Berlin wool and fancy repository, hosier, glover and shirt maker. It has not been possible to identify when Thomas Turner opened his shop but it was sold in 1889 when Thomas Turner and his family moved to Norwich.[9]

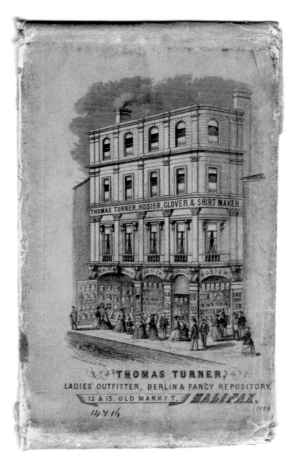

Thomas Turner's shop at 12 and 13 Old Market

Percy's mother was Sarah Jane Robotham (1844–1928). Her father was a hosier and haberdasher.[10] Sarah married Thomas on 2 February 1870 at St John the Baptist Church in Halifax.[11] On 13 March 1879, fifteen months after Percy was born, Sarah gave birth to his sister Maud Ethel Moore Turner.[12] The family lived at 14 and 16 Old Market, Halifax until 1889.[13]

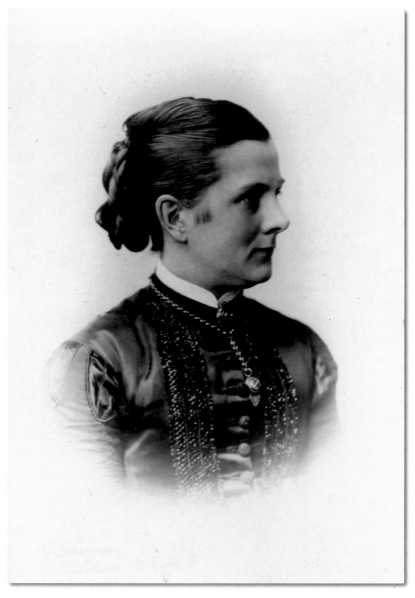

Sarah Jane Robotham (1844–1928), Percy's mother

Left: Percy and Maud Ethel Moore Turner, taken in Halifax, 11 June 1881 (Thomas Turner's birthday)

Right: Percy and Maud Ethel Moore Turner, taken in Halifax, 11 June 1883

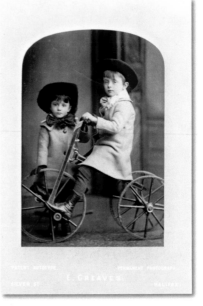

Left: Percy and Maud Ethel Moore Turner, taken in Halifax, 11 June 1885

Thomas Turner was advised by his doctor to move to a drier climate in 1889, so he retired and the family moved to 42 Mill Hill Road, Norwich. Thomas brought his extensive art collection with him, which included a fine collection of old master line engravings, chiefly after Peter Paul Rubens and Anthony van Dyck, inherited from his brother, who had died young. He also owned a few good oil paintings, one by the School of Titian, a William Hogarth, a Salvator Rosa and an Abraham or Jacob van Strij. He contined to add to his collection while living in Norwich and gradually acquired numerous minor examples of the Norwich School.

The Turner family at 42 Mill Road, Norwich

Percy frequently accompanied his father when making his purchases. All of this hugely impressed Percy as a boy.[14] On 25 February 1895 Thomas Turner sold engravings and mezzotints through Sotheby, Wilkinson and Hodge in London in twenty-nine lots.[15] In 1897, Thomas instructed Maddison, Miles and Maddison of Great Yarmouth to sell a number of oil paintings, drawings, etchings, coins, books, microscope and musical instruments as he was considering making structural alterations to his house. There were 102 lots of oil paintings, including paintings by J.M.W. Turner, Rubens, Van Dyck, the Norwich School, Rembrandt, Paolo Veronese and Thomas Gainsborough, and seventeen lots of

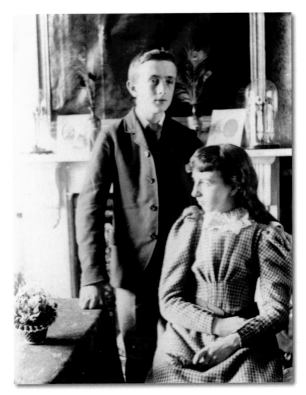

Percy and Maud Ethel Moore Turner at 42 Mill Road, Norwich

watercolours, including those by Gainsborough, J.M.W. Turner and Sell Cotman. Out of twenty-five lots of drawings, seven were from the collection of the late Reverend E.T. Dawell, including those by John Crome and John Sell Cotman. Engravings by Edwin Henry Landseer, Adriaen van Ostade, Gainsborough and Joshua Reynolds were included in the forty-six lots of engravings.[16]

Both Percy and Maud attended Norwich Higher Grade School in Duke Street,[17] which was a working class secondary school opened in 1889.[18] It has not been possible to find out the age at which Percy left school. Certainly, he was still at school in 1891,[19] and it is possible that he did not leave school until 1893. Although the Elementary Education (School Attendance) Act of 1893 increased the school leaving age to eleven,[20] boys at Norwich Higher Grade School were encouraged to sit the Cambridge Local Examinations.[21] These examinations could not be sat until the December a pupil had reached the age of sixteen.[22]

The boat and shoe trades were among the principle industries in

Norwich and Percy's parents thought they might present an admirable career for him. Accordingly, he entered the employment of Hales Brothers, a shoe business in Westwick Street, Norwich, where he remained for a number of years.[23]

In November 1894 Percy visited a loan exhibition of pictures and watercolour drawings held at the Agricultural Hall Gallery, Norwich, during the Grand Oriental Bazaar. The pictures were by deceased artists of the Norwich School, including John Sell Cotman, John Crome, Joseph Stannard and James Stark, with the MP J.J. Colman loaning the largest number of works. The preface to the exhibition catalogue was written by Henry G. Barnwell and Robert Bagge Scott.[24] In 1925, after the death of Robert Bagge Scott, Percy wrote that the preface was 'full of sympathetic perception, and still more important, full of hints to guide a public, in whom responsiveness was largely latent, into paths of appreciation of the best in art. That preface made a profound impression upon me and my joy was unbounded when a fortuitous incident arising out of the exhibition enabled me to meet him.'[25]

Robert Bagge Scott (1849–1925) was born in Norwich in 1849 but was mainly educated in France. Although he qualified as an officer in the Merchant Navy and travelled the world, he decided to pursue a career in art and was admitted as a student to the Royal Academy of Fine Arts, Antwerp, under Albert de Keyser. He also attended lessons with the landscape painter Jozef van Luppen. After travelling extensively in France and Holland, which provided him with the subjects for his pictures, he married a Dutch women and returned to Norwich where he became actively involved in the artistic life of the city.[26]

A friendship between Percy and Robert Bagge Scott sprang up that terminated only with the latter's death in 1925. During the early years of Percy's career in art, he frequently met up with Bagge Scott. After Bagge Scott's death, Percy wrote that 'I owe to him more than I can express.'[27]

It was only when Percy's father bought a small Dutch School oil painting on copper of the head of a peasant that Percy resolved to find a way to quit the boot business and enter the art business. There were no facilities for studying the old masters or art in Norwich so he had to find some means of going to London.[28]

2 GETTING STARTED

In 1897[1] Percy started applying to numerous jobs advertised in the *Daily Telegraph*. As a result of one of these applications, Frederick Tew appeared in person at 42 Mill Hill Road and engaged Percy on the spot as a prospective salesman for his leather business based in Edmund Place, Aldersgate. The business made mostly saddlery and travelling cases on commission for various clients in London.

Percy and Maud Ethel Moore Turner, taken in Norwich, 11 June 1897

At Frederick Tew's instigation, Percy went to live with Tew's widowed sister-in-law at North Villas, Camden Square, where Percy was provided with everything except his midday weekly meal. The wages were low and Percy had difficulty making ends meet, but this employment did afford him the opportunity he wanted. He cut short his midday meal, eating a couple of scones on the bus as he went to and fro the National Gallery, in order to steal a half hour or so for study. Saturday and Sunday afternoons were given over to study at the National Gallery, the Wallace Collection and South Kensington Museum (now the Victoria and Albert Museum). His tastes were catholic and embraced not only pictures but also any kind of work of art. His evenings were devoted to studying French, German and Spanish at a polytechnic, having violin lessons as he was passionate about music and playing in many amateur orchestras and in friends' quartets. These activities so stretched his finances that, more often than not, he had to walk home to Camden Square as he could not afford the bus fare home.

It was not long before Percy had decided that he must somehow visit the galleries of Europe. Eventually he managed to save £5 and took advantage of a Sunday League Easter excursion to Antwerp and Brussels, which gave him two days in each city. Later, he took advantage of a Sunday League Whitsuntide excursion to Paris.[2] By 1901 he had moved to Islington and was lodging with the Baker family at 19 Sparsholt Road. He now made his living as a fully fledged leather commercial traveller.[3]

In August 1901 Percy's article illustrated by Robert Bagge Scott, 'The Artist on the Ramble Down the Yare and Bure', was published over two issues of the *Art Record*, an illustrated review of the British art scene. Starting in Norwich, Percy described the scenery along the Yare, Bure and Waveney rivers, the Norfolk Broads and the coast near Yarmouth that could appeal to an artist. Percy finished the article with the remark that it was only by studying the county and feeling the scenery of Norfolk that Crome could appear in his true light, second to none other than the seventeenth-century Dutch artists Jacob van Ruisdael, Meindert Hobbema and Aelbert Cuyp.[4] Beginning in September 1901, Percy's 'The Ethics of Taste' was published in nine parts in the *Art Record*, in which he systematically discussed the question 'What is Art?'. At the end of part nine (published in February 1902), it was implied that there would be further parts to the discussion but none were published subsequently.[5] In October 1901 the *Art Record* published Percy's comprehensive review of the 'Third Exhibition of the International Society of Painters, Sculptors and Gravers' held at the Royal

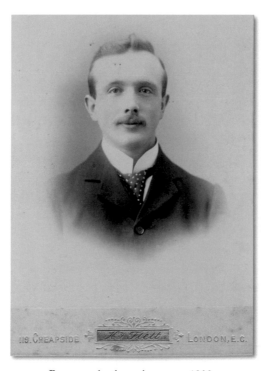

Percy as a leather salesman, *c.* 1900

Institute of Painters in Water Colours in Piccadilly. This review started with the seven works by the President of the Society, James Abbott McNeill Whistler, and concluded with the sculptures which, in Percy's opinion, were the weak point of the exhibition.[6]

According to Percy's unpublished autobiography, Percy and Tew fell out in 1902. Percy was largely to blame. He was now unemployed with no resources behind him. Quite by chance, while looking for another job, Percy saw a French art firm opening premises in Old Bond Street. He went in and had the good fortune to encounter the proprietor, Jules Lowengard of the boulevard des Italiens, Paris. Percy asked Lowengard whether he required an assistant. At first, Lowengard was hesitant, but, finally, he asked Percy whether he knew anything about works of art. After putting Percy through an examination, Lowengard engaged him on a small wage, with Percy starting work the next morning.

The entire personnel consisted of a French man, Émile Molinier, a couple of porters and Percy.[7] Émile Molinier (1857–1906) was born in Nantes in 1857 but educated in Paris, firstly, at the Lycée Charlemagne and the École Nationale des Chartes where he obtained an archivist

diploma in palaeography in 1879. The same year, he started work in the Louvre in the Department of Sculptures and Objets d'Art from the Middle Ages, Renaissance and Modern period. In 1889 he was appointed as a lecturer at the École du Louvre and collaborated in the organisation of a retrospective exhibition of French art at the Exposition Universelle in Paris. He was promoted to professor in 1890 at the École du Louvre. In 1892 he was promoted to Assistant Curator

Émile Molinier

and then, in 1893, to Curator of Objets d'Art of the Middle Ages, Renaissance and Modern period in the Musée du Louvre.[8]

Émile Molinier's career at the Louvre was marked by important research on the works in his care and by the special relationship he fostered with collectors, which resulted in him writing about fifteen catalogues on major private collections, including the collection of Frédérick Spitzer. During the sale of the Spitzer collection in 1893, Molinier was accused, in terms laced with anti-Semitic sentiments, of colluding with the collector's family for financial gain.[9]

In 1898 he was implicated in the Dreyfus affair, having signed on 23 January a second address in support of Émile Zola who had published 'J'accuse', an open letter addressed to the President of France that appeared on the front page of the newspaper, *L'Aurore*, on 13 January 1898.[10] It accused the government of anti-Semitism and the unlawful jailing of the Jewish army officer Alfred Dreyfus. In 1902 Émile Molinier resigned from the Louvre, taking early retirement.[11]

Two days after Percy's engagement, Molinier asked Percy whether he spoke French as he did not speak a word of English. Imperfect as Percy's French was, Molinier was much relieved from that moment. Realising how keen he was, Molinier took a great interest in Percy who became his pupil for the next three years. Jules Lowengard encouraged this situation as, if anything happened to Molinier, Lowengard had nobody to fall back on but Percy. Percy, therefore, occasionally accompanied Molinier on continental journeys and to Ireland, a place that Molinier had long wished to visit but up until then had not due to the language difficulties.[12]

In September 1904 Percy's article, 'The House and Collection of Mr Edgar Speyer', was published in the *Burlington Magazine*. The article described the house and the contents in detail, expanding on its three styles: Gothic, Renaissance and the prevalent style of the reigns of Louis XIV, XV and XVI in France.[13]

In 1905 Lowengard and Molinier quarrelled and Molinier left for Paris to establish his own business. Percy became manager of the London business and frequently travelled to Paris for work. Percy also travelled the continent for Lowengard, chiefly couriering important works of art. While travelling, Lowengard gave Percy free time and the opportunity to see and study great public and private collections in Germany, Austria, Hungary, Italy, Spain, Belgium and Holland. Percy came into personal contact with the most important continental directors and collectors.

In London Percy conducted substantial business on Lowengard's behalf with American and English collectors.[14] In 1906 Percy unsuccessfully asked Lowengard for better remuneration.[15] Thus when Percy had an offer from friends to establish a gallery in Paris in association with the then joint editor of the *Burlington Magazine*, Robert Dell, Percy and Lowengard parted, but on the best of terms.[16]

In 1903 Robert Edward Dell (1865–1940) helped found and became the first editor of the *Burlington Magazine*, together with the art historians Bernard Berenson, Herbert Horne and Roger Fry. The intent was to produce a British art journal for the serious art scholars and connoisseurs. The magazine, however, was losing money and in the same year Fry appointed Charles J. Holmes as co-editor.[17] In October 1906 Dell resigned from the joint editorship of the *Burlington Magazine*[18] in an apparent power struggle with Fry.[19]

Percy moved to Paris and took a flat in the rue Vaneau and he and Robert Dell opened Galeries Shirleys at 9 boulevard Malesherbes where they ran a series of exhibitions.[20] The first exhibition was in December 1906: 'The Retrospective Exhibition of Watercolours and Drawings by English Masters of 18th and 19th Century'. Percy's father had died, just before its opening, in Norwich on 15 November 1906.[21] The foreword was written by Percy,[22] and one of his father's exhibited paintings, *The Glade* by John Crome, was fittingly reproduced as the frontispiece for the catalogue. This picture would subsequently be given by Percy to the Castle Museum in Norwich with thirty-seven other drawings by Crome in May 1935 through the National Art Collection Fund.[23] The exhibition was reviewed in *The Times* in England[24] and in *L'Aurore* in Paris.[25]

John Crome, *The Glade*, pen and ink with wash on paper, 129.5 x 104.1 cm, undated

A short interlude in England followed: at the end of December 1906, Percy returned to London to marry Mabel Grace Wells (1884–1978). Their wedding took place on 28 December at St Mary's Church, Hornsey Rise, London.[26] A further seven exhibitions held at Galeries Shirleys have been identified: 'Exhibition of Drawings by Aubrey Beardsley, 1872–1898' (February 1907);[27] 'Retrospective Exhibition of Pictures by Adolphe Monticelli' (12 April–4 May 1907);[28] 'Exhibition of English Decorative Art by Miss Birkenruth, Misses Casella and Miss Halle' (17 May–15 July 1907);[29] 'Pictures by Old Masters' (December 1907);[30] 'Exhibition of French Watercolours and Drawings' (February 1908);[31] 'Watercolours and Drawings by Charles Louis Geoffroy[-Dechaume]' (March 1908);[32] and 'Drawings of the French Masters of 18th Century and the School of 1830' (April 1908).[33]

During this period, a number of Percy's articles were published: 'The Representation of the British School in the Louvre I – Constable, Bonington and Turner' (1907);[34] 'The Representation of the British School in the Louvre II – Gainsborough, Hopper and Lawrence' (1907);[35] and 'Philips and Jacob de Koninck' (1909).[36] He also wrote three books: *Van Dyck* (1908),[37] *Stories of the French Artists from Clouet to Delacroix*, collected and arranged by P.M. Turner (chapters 1–17) and C.H. Colin Baker (chapters 18–30) (1909),[38] and *Millet* (1910).[39]

However, as time went on, Dell, who had become not only the Paris representative for the *Burlington Magazine* but also the Paris correspondent of the *Manchester Guardian*, became more and more absorbed in extreme politics.[40] He had joined the Fabian Society in 1889 and had converted to Roman Catholicism in 1897. In 1906 the *Aberdeen Free Press* printed that 'Mr Robert Dell [. . .] deplores and condemns the aggressive attitude of the Papacy in France.'[41] Dell held stimulating meetings at his flat near St Clothilde, which Percy attended. However, all this badly affected the business, and clientele gradually deserted the gallery, which was forced to close down in 1910.[42]

Percy moved to a flat in the rue Rouget-de-l'Isle, where he acted as Paris representative for W.B. Paterson of Old Bond Street, London, buying and selling. Percy found that Paterson lacked an understanding of the Paris and continental markets and their relationship became increasingly difficult despite remaining amicable.

Percy also extended his circle of influential friends in Paris and the continent. These friends included curators at the Louvre – Paul Jamot, Jean Guiffrey and Paul Vitry – art dealers, auctioneers and artists. He

knew, to a varying degree, Auguste Rodin, Pierre-Auguste Renoir, Edgar Degas, Claude Monet, Camille Pissarro, André Dunoyer de Segonzac, Jean Marchand, Othon Friesz, Raoul Dufy, Charles Dufresne, Jean-Louis Boussingault, Luc-Albert Moreau, Henri Matisse, Pierre Bonnard, Édouard Vuillard, Aristide Maillol and Charles Despiau.[43] In September 1911, Percy's article, 'The Painter of *A Galiot in a Gale*', was published in the *Burlington Magazine*,[44] and Percy and James Reeve, a consultant to and former Curator of the Norwich Castle Museum,[45] disagreed over the attribution of the Tate's *Near Hingham* (now *Hingham Lane Scene, Norfolk* after John Crome) and a John Sell Cotman at the National Gallery printed in the *Eastern Daily Press*.[46]

Around November 1911 Percy approached Henri Barbazanges, owner of Galerie Barbazanges, with a proposition to set up a gallery with him using English capital. Barbazanges would be the director for Paris and France and Percy would be the director for foreigners. Barbazanges declined this offer,[47] but Percy and Barbazanges would both be involved with Galerie Levesque et Cie, which was established in Galerie Barbazanges in 1912.

3 GALERIE BARBAZANGES

Judging from the dates of the exhibition catalogues, it would appear that Galerie Barbazanges had been founded by Henri Barbazanges in around 1904. The gallery was initially based at 48 boulevard Haussmann before moving to 109 rue du Faubourg Saint-Honoré,[1] a new building built by the celebrated dressmaker Paul Poiret.[2] Unfortunately it was difficult to attract visitors to the exhibitions held at this large gallery.[3]

In 1912 a proposition was made to Percy to join his friends, Roger Levesque de Blives and Henri Barbazanges, in a new business, Levesque et Cie.[4] In July Roger de Blives took over Henri Barbazanges's gallery and business, the finance being provided by Joachim Violet whose family had invented Byrrh, the wine-based apéritif. Barbazanges stayed on in the gallery but Percy set up a business arrangement with de Blives, whereby Percy did not go into the business but instead sold pictures from his own flat and gave up representing Paterson.[5]

The gallery was mostly devoted to modern art but old masters were not neglected. In addition to Violet's considerable capital, the gallery had access to Prince de Wagram's collection of modern paintings,[6] and was involved in their sale. Violet looked after the finances and Percy became the travelling representative, as he was the only member of the firm to speak any language other than French. He built up connections in America, Canada, Spain, Germany, Austria, Hungary, Holland, Scandinavia, Ireland and Scotland. He also acted for Charles Vignier (1863–1934) who was the expert on Asian arts at the Parisian auction house Hôtel Drouot.[7]

In July 1912 Roger Fry organised an 'Exposition de Quelques Artistes Independent Anglais' at the gallery. Besides Fry, Vanessa Bell, Frederick Etchells, Jessie Etchells, Charles Ginner, Spencer Gore, Duncan Grant, Charles Holmes, Wyndham Lewis and Helen Saunders were represented.[8] Later that summer Percy returned to England for the birth of his only son, Geoffrey (1912–58). Geoffrey was born at Sutton in Norfolk on 16 August.[9]

In October 1912 the French artist Jean Frélaut held his first exhibition (thirty-seven paintings) at Galerie Barbazanges, and it is here that Barbazanges introduced Frélaut to Percy[10] – the start of a very significant relationship that endured until the end of Percy's life.

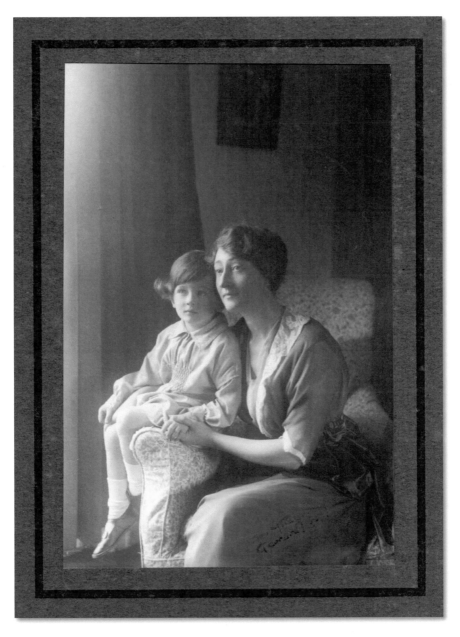

Percy's wife, Mabel Grace, and their son, Geoffrey

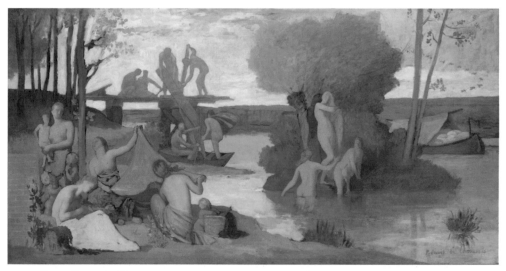

Pierre Puvis de Chavannes, *The River (La Rivière)*, oil on canvas, 129.5 x 252.1 cm, *c.* 1864

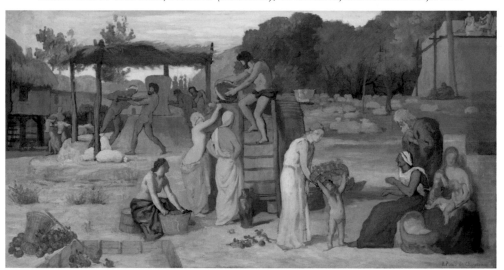

Pierre Puvis de Chavannes, *Cider (Le Vendange)*, oil on canvas, 129.5 x 252.1 cm, *c.* 1864

A few months later, in February 1913, Percy was in New York staying at 718 Fifth Avenue, while he was trying to sell two Puvis de Chavannes: *La Rivière* (around 1864) and *Le Vendange* (around 1864). They were Puvis's scheme for two of the Amiens panels that were selected by the French government for the Paris Exhibition of 1900. Percy had offered the pictures to the collector John Quinn[11] for $28,000 in instalments but an American museum, the Worcester in Massachusetts, was interested in

them. The museum asked to loan them for a couple of months if Quinn did not take them.[12] During this time Percy also managed to have an article, 'Pictures of the English School in New York', published in the February edition of the *Burlington Magazine*.[13]

In March, John Quinn agreed to purchase the two pictures but preferred to exhibit them in New York rather than at the Worcester, giving public credit to Percy or Levesque et Cie.[14] In May 1913 Percy, writing to Quinn from his flat at 19 rue d'Anjou, confirmed that the two Puvis de Chavannes came directly from Prince de Wagram who had bought them from the art dealer Paul Durand-Ruel who, in his turn, purchased them from Puvis in 1894.[15] On 12 June 1913, Percy wrote to Quinn from Paris asking whether he was coming to Europe as Percy had just acquired a masterpiece by Paul Gauguin that he would like to show him.[16]

On 27 June 1913, Barbazanges wrote to Jean Frélaut, announcing that Percy was in New York on the track of an extraordinary client who would put the gallery in a good position if he bought pictures. Percy was going that night to present Frélaut's pictures to the Director of the Metropolitan Museum and he was planning an exhibition of them in America. Barbazanges predicted that Percy would do well for Frélaut.[17]

A couple of months later, on 2 August 1913, Quinn confirmed that he was unable to go abroad, but he asked for more details of the Gauguin. He asked for a reprieve in paying for the last instalment on the Puvises, as a large fee he was expecting had yet to arrive, and indicated that he would want to pay for the Gauguin in instalments if it were a considerable amount.[18]

On 22 August, Percy confirmed that Quinn could send a cheque around 20 October when he received his money. As for the Gauguin, this was the celebrated canvas of which Gauguin speaks in his letter from Tahiti, reproduced in a well-known life of the artist. Gauguin inscribed its title on the canvas, *d'où venons-nous, que sommes nous, où allons nous* (*Where do we come from? Where are we? Where are we going?*) and dated it 1897. It caused a sensation in the Paris art world, and there was even talk of a national subscription for the purpose of presenting it to the Musée de Luxembourg. Levesque et Cie wanted $30,000 for it.[19] Gauguin had painted this picture after his failed suicide attempt in Tahiti. He bought the picture back to France and sold it to a man in Bordeaux from whom de Blives and Percy bought it.[20]

In November, John Quinn declined the Gauguin as the price was out of his reach for the next year or so.[21] In 1913 Percy was also listed among

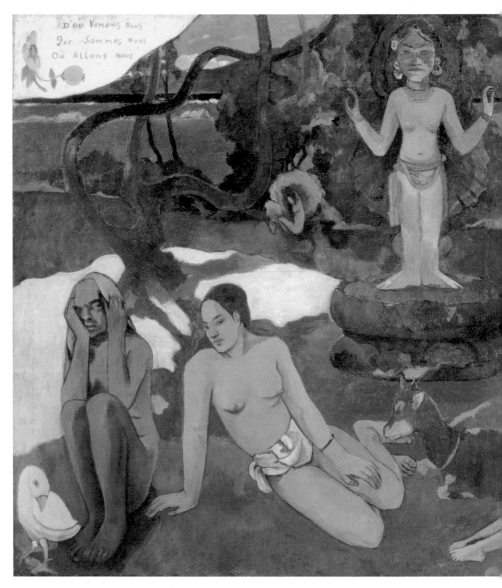

Paul Gauguin, *Where do we come from? What are we? Where are we going?*,
oil on canvas, 139.1 x 374.6 cm, 1897–98 (left side detail)

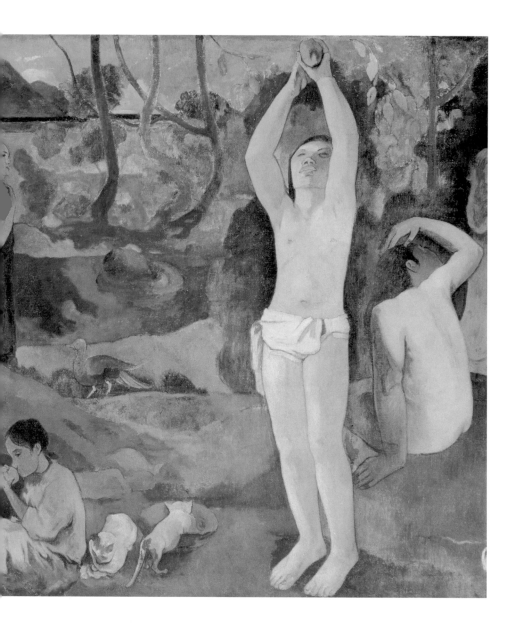

the visitors to see Michael Sadler's pictures at 41 Headingley Lane, Leeds. Michael Ernest Sadler (1861–1943) was then the Vice-Chancellor of the University of Leeds.[22]

By February 1914 Percy was back in New York for a fortnight, taking with him pictures by Paul Cézanne, Gauguin and Édouard Manet among others, which he is was keen to show John Quinn.[23] While in New York, Percy was contacted by Dr Albert Coombs Barnes, an American physician, chemist, businessman and art collector who went on to establish the Barnes Foundation in 1922. Barnes thought Percy's firm could do good business with paintings by two or three Americans. Barnes particularly recommended William Glackens and suggested that he bring him to their meeting so that Glackens could talk to Percy and arrange a visit to his studio.[24] During the first half of 1914 André Dunoyer de Segonzac had his first solo exhibition at Galerie Levesque.[25] Segonzac had been exhibiting his work since 1908 and his work had been included in a group exhibition at Percy's friend's Galerie Marseille in 1913.[26] Judging from a letter Segonzac wrote to Percy in 1950, it would appear that Percy and Segonzac first met in 1914.[27]

At the beginning of August 1914, with the World War I about to break out, Percy luckily just managed to escape from Berlin on the last Nord Express to leave Germany for Paris. He found Paris in pandemonium, with the French forces being mobilised. Roger de Blives and Barbazanges had received their provisional mobilisation papers. Violet was too old for active service. Roger de Blives went to see Théophile Declassé, the French foreign minister, who reassured de Blives about the political situation. Assured, Percy proceeded to London to carry out business on behalf of the firm before joining his family for their annual holiday in Norfolk. Here, he received a telegram from de Blives asking him to return as quickly as possible to Paris, as de Blives and Barbazanges had received their calling-up papers and had had to leave Violet alone in the gallery.

With the mobilisation of the British army, Percy failed to get further than London; after many abortive attempts to get to Paris, he returned to Norfolk. He had only £25 in his English bank, so he was forced to borrow money which set a pattern until the end of World War I.[28]

In November 1914 Percy was still living at the holiday cottage that he and his family took each year, known as Haslemere in Stalham, Norfolk. He had been drafted into the Norfolk Special Constabulary, as he had been exempted from the military for medical reasons. As there were more than enough people in the force, he had been able to visit Paris in

November and December to open up the business, settle the accounts and pay the taxes. He was the only member of the firm not mobilised.

The gallery still had a large amount of stock, but also owed a considerable amount of money, both in Europe and America. During his November visit, Percy offered to stay on, but Violet rejected this offer. Due to a moratorium in force in France, Percy was unable to take out any of his money. Violet refused to advance Percy any money either in France or in England, so they had a row and Percy left and never saw him again.[29]

In January 1915 Percy returned to the gallery. Henri Barbazanges seemed to have been discharged from the army since he informed Jean Frélaut by letter that he was going to the gallery three times a week to reply to letters and to receive clients who had not bought anything. As Percy had wanted to see all of Frélaut's pictures again, he and Barbazanges had made their own exhibition.[30]

By March 1915 Percy had moved to Alanhurst, his sister-in-law's family house, in Gerrards Cross, Buckinghamshire. He visited Paris to find business at a standstill. He had, however, been able, at last, to get in touch with Prince de Wagram about the Renoirs for Dr Albert Coombs Barnes. Prince de Wagram was fighting on the front and was not in a postition to part with any of his pictures.[31]

Multiple portrait of Percy *c.* 1917

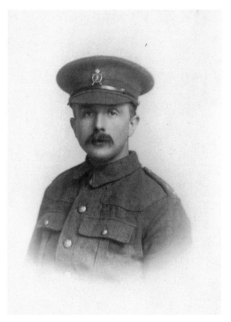

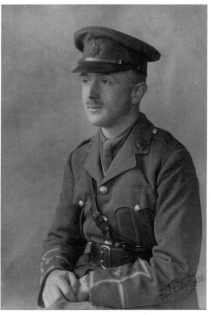

Percy as a Private in 2/1st Northern Cyclist
Battalion, February 1917

Percy in uniform as a Second Lieutenant,
June 1917

Percy with the 67th (2nd Home Counties) Division

At the end of March 1915, knowing that John Quinn was interested in Charles Edward Conder, Percy wrote to Quinn about the potential opportunity to buy the finest collection of Conder's works in existence. Previously the owner would not have thought of selling it but Percy thought that an offer of £8,000 would tempt him. In April, Quinn informed Percy that he was interested in Conder's work, but it was beyond his reach at the moment.[32]

On 9 May 1915 Roger de Blives was killed at Arras.[33] Levesque et Cie was put into the hands of the lawyers to protect the rights of Roger de Blives's wife and daughter under French Law. Henri Barbazanges, having been discharged from the army on the grounds of ill health, was appointed as caretaker for the gallery by the government. Unable to sell anything without official sanction, Barbazanges was given a small salary and was left free to deal on his own account outside the business.[34]

At the beginning of June 1915 Percy was in Paris again. He felt that the executors may decide to sell Levesque et Cie and if so, he believed he might be able to buy it on advantageous terms if he could secure sufficient capital. He asked Barnes to back him but Barnes's money was committed elsewhere.[35]

As Levesque et Cie would remain in the hands of the Court until six weeks after the declaration of peace, Percy, therefore, applied to the Court to be appointed as administrator for the intervening period. However, at the beginning of July 1915, when one of the lawyers discovered he was English, the Court had to reconsider his application. Percy had already realised that he would have certain problems after the War when de Blives's capital was withdrawn. Percy could not afford to continue at Galerie Barbazanges. The alternative would be a smaller gallery, his flat or New York.[36]

Percy enlisted voluntarily on 8 December 1915 during the short-lived existence of voluntary enlistment introduced by Herbert Kitchener in the autumn of 1915. On being accepted, he was placed into Section B Army Reserve until he received a mobilisation order.[37]

At the end of February 1916 Percy wrote to Barnes as Whistler's *The Girl in Red* was about to come on the market. He also doubted whether he would be able to revive Levesque et Cie. Replying in May 1916, Barnes told Percy that he was only buying Renoirs and Cézannes.[38]

On 2 February 1917 Percy was mobilised and allotted to a unit of the territorial army as a private in the 2/1st Northern Cyclists Battalion. Percy's posting to this unit arose, at least in part, as he was medically graded

for home service only. He was posted into the battalion's B Company. The battalion was based at Skegness, where it provided detachments for local defence of the Lincolnshire coast.

Percy completed an application for commission as an officer on 13 March 1917. He requested placement, once commissioned, into the Army Service Corps (ASC). His application was accepted and he was posted to No. 2 Cadet Company of the ASC at Aldershot. He passed the selection and training course, and was commissioned as a second lieutenant on 29 June 1917.[39] This commission gave him a regular income, enabling him to give his wife an allowance for the first time since the beginning of the War.[40]

Percy was posted to join the 67th (2nd Home Counties) Divisional Train on 7 July 1917. This was a group of four horse transport companies of the ASC under the command of the formation known as the 67th (2nd Home Counties) Division. The companies were numbered 545–8. The entire formation was based in Kent with divisional headquarters (HQ) in Canterbury and the various units were widely scattered.[41]

In September 1917 Percy was sent on an attachment to the 221st, one of the infantry brigades that were also under the 67th (2nd Home Counties) Division. It was then based in Sandwich, but later moved to Deal and then to Ipswich. Percy acted as the key liaison officer with the ASC, initially in an acting capacity but, later, in a more permanent role. In Ipswich he was in charge of the 67th Divisional Unit of Supply, which was essentially a supply planning and management office.[42] Percy found army work hard and exacting but also interesting. However, he was missing his contact with art.[43] In October 1917 Percy wrote to Barnes as he had heard of the death of his good friend Mr Johnson, and wanted to know what had happened to his collection.

Henri Barbazanges, in a letter to Jean Frélaut dated November 1917, recounts that he had received a letter from Percy in which it appeared that Percy had realised a considerable sum of money from the sale of a great Gauguin which half belonged to him and he was interested to buy Frélaut's picture of a large, heavy orange sky with a woman keeping pigs in the foreground. Frélaut was asked to write to Percy.[44] In reality Percy did not actually receive this money at this time (see page 37).

At the end of October 1918 Percy applied for, and was granted, one month's special leave to go to Paris on business. He reported back to divisional HQ, now at Chelmsford in Essex, on 12 December 1918.[45] In a letter dated 7 December 1918, Percy told Barnes that he had just returned

from France where Levesque was in the hands of the liquidators. He was trying to fix up an arrangement with the liquidators and he hoped he would know in a few weeks, otherwise, he would probably go on his own to Paris.[46]

In a letter dated 26 December 1918, Roger Fry wrote to Vanessa Bell about the possible foundation of an artists' association with a secretary and a dealer. The idea of founding an artists' association was originally the brainchild of Percy and the unemployed David 'Bunny' Garnett who, at that time, was being influenced to become an art dealer by his lover Duncan Grant, and Vanessa Bell. Fry arranged to meet Percy in early January to talk over the whole business. Fry realised that the business needed a good head and a very good nature. (Fry must have believed that the Omega Workshops Ltd could not continue for much longer.) Fry considered Percy to have long experience and a good manner but suspected that Percy would want to do something with modern French art, probably in England.[47] Meanwhile, Percy was promoted to lieutenant on 29 December 1918.[48]

Percy told Barnes in January 1919 that he was in litigation with the Levesque liquidators over the sale of the large Gauguin that Percy and Roger de Blives had jointly bought. The liquidators wanted to bring Percy's share of the picture into the Levesque liquidation. Percy also revealed to Barnes that when he could see how difficult things were likely to become after de Blives's death, he had gone to Paris and removed to his flat a number of things entrusted to them by friends, which included Barnes's painting by Pierre-Narcisse Guérin.[49]

In a letter written by Roger Fry to André Gide on 9 February 1919, Fry mentioned that Percy had encouraged his painting. Percy had not seen his work for years and was so delighted with what Fry had done recently that he had bought six of Fry's pictures to exhibit in Paris. According to Percy, Fry was almost the only English painter that Percy could handle there.[50]

After he had been demobilised at the No. 1 Dispersal Unit at Crystal Palace, London, on 19 March 1919,[51] Percy returned to Paris. He went to Galerie Barbazanges to find Henri Barbazanges and Camille Hodebert, a comparatively small-scale antique dealer before the War, in the office. The two of them had made a proposition to the French government who had accepted it on behalf of de Blives family. They made a derisory financial offer to Percy, knowing that he was financially ruined (he owed £3,000 in England and £2,000 in rent for his flat in the rue d'Anjou). Neither of them spoke English and they wanted Percy's foreign clients. He left the gallery in disgust, telling them 'to go somewhere else'.

The next day he went to see his landlords who agreed to a payment of £200 in full settlement of outstanding rent to be paid when he could. He then went to see his friend Leon Marseille, who had a small gallery in the rue de Seine. He suggested that they should go out to Versailles for the day and discuss what Percy could do next. Marseille suggested that Percy should try the modern movement in England. Marseille could supply a little money and a fair amount of stock on a sale-or-return basis if Percy could find premises. Percy and Marseille would be partners.[52] Leon Marseille would also send his son, Robert, to help, saving on wages while Robert gained experience.

In London Percy went to see his friend Philip Lee-Warner, the Managing Director of the Medici Society, whose premises were situated at 7 Grafton Street, Mayfair. Years earlier, Percy had helped Lee-Warner, while still at Chatto and Windus, to establish the Medici Society. Lee-Warner could offer Percy the third floor flat of the Medici Society building.[53] Percy borrowed £400 against a life insurance policy and named his new gallery the Independent Gallery.[54] Percy only had enough money to pay Lee-Warner a quarter's rent in advance and half jocularly remarked that it might well be the only rent that he was likely to see from Percy as it was pure adventure. If it did not come off, Percy would be abjectly broke.[55]

4 STARTING AGAIN – THE INDEPENDENT GALLERY

*'… Percy Moore Turner, who loved a good story, almost as well as he
loved the Norwich School and the French Impressionists …'*

Taken from *Russel James Colman 1861–1946* by Jonathan Mardle.
Pulished by Fletcher and Sons Ltd., Norwich, 1954 pp. 88–9

'Also, he minded about the young.'

Taken from a letter to Karl T. Parker, Keeper at the Ashmolean, from
Hon. Andrew Shirley, 28 February 1951

It is not entirely clear whether the Independent Gallery opened in
the spring of 1919[1] or 1920.[2] In an advertisement published in the
Burlington Magazine in 1924, Percy stated the gallery opened in the
spring of 1919. However, in Percy's letters to Dr Albert Barnes, Charles
Lang Freer and John Quinn, there is no indication that the gallery opened
until 1920 and it appears as if Percy was in Paris in the spring of 1919.[3] In
April 1919 Percy let Barnes know that he had been demobilised and that
he was back in Paris.[4] A month later, from 19 rue d'Anjou, Percy wrote to
Freer, who Percy had met in Detroit before the War when he was acting
as an agent for Charles Vignier.[5] Percy was now in the position to sell
Freer *Nocturne Cremorne Gardens, No.3* by James McNeill Whistler.[6] In
June Percy arranged the shipping of this picture from Paris to Freer who
was ill.[7] Percy received payment of £3,000 in September when he was at
42 Mill Hill Road, Norwich.[8]

In May 1919 Percy also let Quinn know that he had survived the
War and was now in his Paris flat. He would like to meet Quinn if he
was coming to Europe. Percy had a number of Segonzac drawings and
paintings in his private collection, and he had heard from a mutual friend,
Leon Marseille, that Quinn was fond of his work as well.[9]

In his reply to Percy at the end of May, John Quinn said he did not
expect to come to Europe but thought Percy had known that he had tried
to sell the large Gauguin painting to the Metropolitan Museum of Art,

when Percy or his associate in New York had told him that it could be secured for 100,000 francs. Robert Weeks de Ferest, the President, and George Blumenthal, one of the directors of the museum, were in favour, but it was blocked by the Director, Edward Robinson. Quinn asked Percy whether he expected to go back into the art business in this letter.[10]

In Percy's reply to John Quinn in June 1919, Percy admitted that the War had been a tremendous ordeal for a man of forty-two but he felt better for having been involved even if it had worn him out physically. Percy also let Quinn know that he had an appealing small private collection of works by younger English artists, which was beginning to attract attention. Otherwise, he was representing the *Burlington Magazine* in Paris, doing a little dealing and buying for a number of museums and private collections: British, American, Belgian and Norwegian. He was on the spot, and they trusted Percy's judgement and seemed to like what he was buying for them. They not only continued to buy from him but also sent their friends to him. The large Gauguin had been sold to a dealer in Copenhagen for a much higher price than that offered to the Metropolitan Museum in New York. Percy also mentioned that the closure of the Leversque Gallery, along with the death of Roger de Blives, had been a great blow in every way. He had lost one of the best friends he had ever had, and he had lost a fortune, but he was steadily finding his feet again.[11]

On 4 July 1919 Percy was still in Paris and sent Barnes photographs of two Renoir portraits dating from 1875 to 1880. Percy asked Barnes if there were any collectors who were buying modern French art for whom he might buy on commission at sales or elsewhere. Things were pretty difficult just then on this side of the Atlantic and such a help from Barnes's side might assist Percy considerably. He let Barnes know that he was leaving Paris the next day to go to his mother's home in Norwich and would not return to Paris until the middle of September.[12]

In October 1919 Percy was back in Paris and had lunch with Jean Marchand and his wife on the 21st. As Marchand wanted to meet Jean Frélaut, Percy invited Frélaut to lunch with Marchand, Marchand's wife and André Dunoyer de Segonzac the following Tuesday, meeting at Marchand's house, 73 rue de Caulaincourt at 11.45 am.[13]

During Percy's return to his flat in Paris in 1919, he was accompanied by his wife, Mabel, his son, Geoffrey, and his nephew, Patrick Arthur Aston Lewis (1912–1977). Mabel stayed in Paris for about a year while Percy established the Independent Gallery and she negotiated with the French authorities for permission to remove all their furniture and

Percy in the 1920s

possessions to England. Meanwhile, the two boys attended school in Paris and became bilingual. However, on their return to England, they were called 'little Frenchies' by their new schoolmates and determined never to speak another word of French.[14]

In February 1920 Percy wrote to Jean Frélaut from his Paris flat. Percy had just returned from a great trip to England and Scotland. Percy was not sure if Frélaut knew that both he and Robert Marseille had installed themselves in London in a small gallery, well placed for selling modern French painting. Percy naturally wanted to feature two Frélaut pictures in their first exhibition but he was not in a position to forward money to Frélaut, as setting up the exhibition had already consumed a lot of money. Percy did not expect the exhibition to open before 15 April.[15]

Percy had a collection of pictures, the modern portion of which he

proposed showing, augmented by a number of modern pictures he could borrow on a sale or return from Paris. Robert Marseille helped Percy arrange the initial exhibition and he did a modest amount of advertising, as he could not afford much.[16]

An exhibition of modern French paintings and drawings, held at the Independent Gallery, opened in May 1920. Thirty-seven paintings and fifty-five drawings and lithographs were exhibited. The artists included in the exhibition were Jean Marchand, Henri Matisse, André Dunoyer de Segonzac, André Derain, Robert Lotiron, Luc-Albert Moreau, Othon Friesz, Louis Valtat, Henri Labasque, Pierre Bonnard, Charles Dufresne, Karl Edvard Diriks, André Lhote, Charles Bischoff, Maximillian Luce, George Rouault, Zonia Lewitzka, Maurice de Vlaminck, Jean Bousingault, Eugène Boudin, Eugène Carrière, Othon Coubine, Honoré Daumier, Raoul Dufy, Alexandre-Gabriel Decamps, Frélaut, Paul Gauguin, Jean-Auguste-Dominique Ingres, Henri de Toulouse-Lautrec, Aristide Maillol, André Mare, Jean Puy, Camille Pissarro, Pierre Puvis de Chavannes, Auguste Rodin, Paul Signac, Théophile Steinlen, Vincent van Gogh, Louis Valtat and Suzanne Valadon.[17] A favourable review of the exhibition appeared in the June edition of the *Burlington Magazine*.[18]

For the first five days of the opening week not a soul appeared. Marseille and Percy were so bored that they improvised a game resembling shove-halfpenny on the parquet floor. Percy had almost given up hope and was contemplating returning to Paris in the near future. However, on the Saturday morning, the door bell rang and Marseille brought up a young man, who was probably about twenty-five years old. He soon became most interested in the exhibits and began to ask Percy questions about them and the movement that had produced them. Before leaving about 1 pm, he asked Percy whether he could return with a friend. Percy returned from lunch at 2.30 pm to find two young men awaiting him. He spent the whole afternoon with them, the young men departing about 6.30 pm.

On the following Monday, a steady trickle of people visited. During the week the attendance steadily grew and although Percy sold quite a number of pictures and drawings they were of no great value. Towards the end of the week, the collector Frank Hindley Smith (1863–1939) confessed to Percy that he had, for some time, been interested in the modern movement. Anxious to learn more about its artists, Hindley Smith bought a Cubist example by André Lhote[19] and an early Bonnard landscape to try out on his walls at home.[20]

Frank Hindley Smith was a bachelor who initially trained as a solicitor

André Lhote, *Study for 'Homage to Watteau'*, oil on canvas, 33.3 x 36.0 cm, 1918

Pierre Bonnard, *Landscape,* oil on mill board, 56.2 x 78.1 cm, 1902

but had to abandon his career in order to take control of the family business on the death of his father. He inherited the Lever Bridge Mills (a cotton mill) at Darcy Lever, Bolton, which was part of the company William Gray and Sons. Towards the middle of the following week, he reappeared at the gallery to enthuse about the appeal of the two pictures and invite Percy to pass a weekend as his guest at his house in Birkdale, near Southport, where he kept the considerable collection he already possessed. Percy went to Birkdale on the Friday afternoon and found a charming house, built by its owner, with walls covered with modern English pictures and shelves of books, both in English and French. The Lhote and the Bonnard were on easels in the centre of the drawing room. After dinner Percy and Hindley Smith went around the pictures and talked about art and France but no mention was made of the two pictures.

The following morning they went for a walk over the golf course, and after lunch Hindley Smith asked Percy what he thought of his collection. It was the second collection that he had created in his life: the first, he had disposed of because he had tired of it. Hindley Smith then put a very awkward question to Percy; how did Percy think the two pictures fitted

in with those he already had? Percy told him 'Not at all, they would be somewhat unhappy together.' Whereupon, he asked Percy a still more embarrassing question as to what Percy advised him to do. Percy told him that he would have to choose between the two and Hindley Smith said he would mull it over. Nothing more was said on the matter that weekend.

Towards the end of the next week, Hindley Smith reappeared at the gallery and asked Percy to lunch at the Reform Club. There he told Percy that he had decided to part with the major part of his present collection and to begin again along the lines indicated by the two pictures that he had acquired from Percy. This was the start of Frank Hindley Smith's huge collection. Percy and Hindley Smith became great friends, Percy always being welcomed for a weekend, a situation that continued when he moved to a home built for him at Seaford.[21] Percy, on his numerous visits to Seaford, occupied a bedroom with a Constable watercolour over the washbasin, which would be bequeathed to Norwich Castle Museum.[22] Hindley Smith extended this hospitality to very few people. Percy, in turn, introduced Hindley Smith to Roger Fry, Duncan Grant, Vanessa Bell, Maynard Keynes and André Dunoyer de Segonzac.[23]

In May 1920, Percy was also preparing for his next exhibition of works by Roger Fry. In a letter to his daughter Pamela, Fry wrote he had started a *toile huge* for the Salon d'Automne (Autumn Salon) but now that Percy wanted many more pictures, he would try to bring this body of work over as it would almost fill one of his walls.[24] Fry told Vanessa Bell that Percy had written to say that he must have sixty pictures by the end of May.[25]

At the beginning of June 1920, Percy made a brief visit to Paris but he failed to meet up with Jean Frélaut who Percy had heard was in Paris. Percy had sold two of Frélaut's pictures in the first exhibition at the Independent Gallery and was keen to promote Frélaut in England as he had done for Marchand and Segonzac. During his stay in Paris, he had talked to Henri Barbazanges (Barba) about mounting an exhibition composed exclusively of Frélaut pictures, drawings and etchings for February 1921.[26]

'The Exhibition of Recent Paintings and Drawings by Roger Fry' opened at the Independent Gallery in June 1920 with eighty-one paintings and thirty-three watercolours and drawings.[27] It was reviewed in the July edition of the *Burlington Magazine*,[28] the exhibition's only favourable review.

Roger Fry wrote to his close friend, the painter Marie Mauron, in June 1920 that his exhibition was keeping him terribly busy,[29] but by 20 June he wrote again to Mauron with the sad news that the exhibition had not

been well received.[30] However, on 3 July 1920, when Fry wrote to Mauron when the exhibition was nearing its end, he had sold the large painting he had intended for the Salon d'Automne in Paris, two other small paintings and ten watercolours and drawings. This, at least, would pay for the frames and canvases although he had made little profit. He also mentioned his dealer had been splendid. He pointed out that he was not too commercially minded; on the contrary, he had his aesthetic notions and would not give up in the face of the public's hostility and indifference.[31]

Percy wrote to Jean Frélaut on 25 July 1920, hoping that he would have thirty pictures and forty drawings and etchings for the February exhibition. Meanwhile, Percy would introduce two good canvases to each group exhibition of French art, so that Frélaut would not be forgotten by the English public. Percy reminded Frélaut that he had spoken of a picture expressly for Percy's private collection for which Percy would pay Frélaut. However, Percy was then pretty short of cash as he was having to pay sixty per cent of all profits to the government, but he would put aside a few hundred francs.

In the same letter, Percy delicately broached the subject of Frélaut's painting style. Percy's taste was based on his studies of the old masters but he had developed his eye for modern paintings in Paris where he was surrounded by the best French art. Percy had been very stubborn and had continued to buy Marchand, Segonzac and Frélaut when nobody wanted them but now that there were many buyers for Marchand and Segonzac, Percy wanted to see Frélaut in the same category.

Percy knew that Barba had spoken to Frélaut about Percy's critique of Frélaut's last pictures but Percy wanted to give his frank opinion directly. After the War Frélaut had been influenced by what he had seen in Paris. Percy had appreciated several pictures and had bought them for his collection. However, Frélaut tried in vain to find his old style when he returned to Vannes. He needed to develop his own unique style free from the influence of contemporary Parisian artists.[32]

In a letter to Roger Fry in August 1920, Vanessa Bell said Percy wanted Duncan Grant and her to have a show of watercolours in his smaller rooms when Robert Lotiron would have a show in the large room.[33]

While Percy was at Skulks Farm, Buxton Lamas, Norfolk for the month of August, he confirmed to Jean Frélaut that his photograph had arrived in time to be reproduced in an important book on painting along with Marchand and Segonzac.[34] At the end of August 1920 Percy wrote to Frélaut, reminding him that he would be in Paris at the end of September

for the Salon d'Automne and he was impatient to see Frélaut's pictures. His holiday had passed well despite the weather and had prepared him for the next struggle to break down the prejudice against modern art. Percy had persisted with certain enlightened collectors who had warmed to Frélaut pictures greatly, one or two months after buying them.[35]

In October 1920 Roger Fry was in Paris and reported that Percy had turned up in the hope that Fry would look at pictures that interested Percy for the *Burlington Magazine*. Fry wrote to Pamela that he had to escape from Percy's clutches.[36]

An exhibition of thirty-two paintings by Félix Vallotton was held at the Independent Gallery in London in October 1920. A review in the *Burlington Magazine* enthused that 'Still, despite certain limitations, this exhibition is undoubtedly one of the most interesting now.'[37] This was soon followed by an exhibition of oil paintings by Robert Lotiron and watercolours by Duncan Grant and Vanessa Bell, which opened at the Independent Gallery on 5 November 1920. There were thirty-one works by Lotiron, twenty watercolours by Duncan Grant and sixteen by Vanessa Bell.[38] The *Burlington Magazine* stated, 'The excellently arranged exhibition at the Independent Gallery is a notable event.'[39] However, despite these excellent reviews, in November 1920, Fry wrote to Marie Mauron that Percy was at the end of his means. The English public had shown such indifference and given little recognition to what he was doing, and Fry was disgusted.[40]

Meanwhile, the indefatigable Percy told Frélaut that although the struggle was desperate, he was making some progress. There were plenty of people (almost 1,200 visitors) for each exhibition and he was beginning to attract serious collectors. Moreover, he was giving lectures in the provinces and municipalities on modern art with slides. The room was always full and the lecture went down well with many questions asked.[41] At the same time, Percy also told Frélaut, in confidence, that his landscape with apple trees in flower had entered a very great English collection.[42]

By December 1920 Percy was making arrangements for his visit to Paris in January. He asked Frélaut for the times of the trains to Vannes and for the best hotels as he intended to keep his word to spend two or three days in Vannes.[43] He also arranged a lunch with Paul Jamot and Jean Guiffrey, Assistant Curator and Curator of Paintings, Drawings and Etchings at the Louvre respectively, on Wednesday, 5 January at the Petit Lucas.[44]

On 3 December 1920 Percy opened an exhibition of pictures and drawings by Thérèse Lessore and representative works by contemporary

Jean Frélaut, *Pommier en Fleur,* oil on canvas, 60 x 74 cm, 1920

French painters at the Independent Gallery. The exhibition included fifty paintings by Lessore and the contemporary artists included Marchand, Frélaut, Rouault, Friesz, Signac and Segonzac. The review in the *Burlington Magazine* remarked that the exhibition 'well sustains the reputation of this gallery'.[45]

On 23 December 1920 Percy had a long discussion with his publishers of his forthcoming book *The Appreciation of Painting*, who suggested the book should be translated into French and Spanish. Percy followed this up by inviting Paul Jamot to write a short preface for the possible French edition and asking whether he would like to translate the book.[46]

Percy arrived in Paris on 5 January 1921 and then went by train to Vannes on 8 January where Jean Frélaut had, on Percy's instructions, booked a room at the Grand Hôtel du Commerce et de L'Épée.[47] After visiting Frélaut's family, he returned to Paris on 13 January. Here he visited Galerie Barbazanges to pay Frélaut's commission and buy Frélaut's

Les Ruches and *La Chasse aux Poux* with the intention of returning with them to London. Percy went to London via Brussels and Ghent.[48]

A group exhibition was held at the Independent Gallery from 5 to 20 February 1921, which comprised fifty-four paintings, thirty-three drawings, one mosaic and four sculptures. The artists included Elliot Seabrooke, Matthew Smith, Nina Hamnett, Roger Fry, John Nash, Thérèse Lessore, Walter Sickert (lent by Walter Taylor), Duncan Grant, F.J. Porter, Mark Gertler (lent by Siegfried Sassoon), Paul Nash, Bernard Menisky, Bernard Adeney, F. Griffith, Keith Baynes, Annie Estelle Rice, G.H. Barnes, Edward Wadsworth, Vanessa Bell, Edward McKnight Kauffer, William Roberts, Rupert Lee, Boris Anrep and Frank Dobson.[49] The exhibition was accompanied by a book of photographs, *Some Contemporary English Artists* by Augustine Birrell and David Garnett.[50] In the review in the *Burlington Magazine* in March 1921, Clive Bell stated that the exhibition 'is the most hopeful symptom manifested for some time by that chronic invalid, British Art'.[51] Despite an entrance fee, the exhibition had 1,400 visitors.[52]

Percy continued with his lectures, visiting Norwich, Bradford, Dundee, Brighton and the University of Cambridge. At Brighton the lecture room was full to capacity and people had to be sent away; Percy returned the following week to give the lecture to those who could not find a place. As a result of his lecture in Cambridge, Percy was asked to put on an exhibition of modern pictures in early 1921. He exhibited pictures by Marchand, Segonzac, Friesz, Fry, Grant and Frélaut. The University of Oxford also invited Percy to mount an exhibition in June 1921; Percy proposed to display the same paintings as those exhibited in Cambridge,[53] but this does not seem to have materialised until 1923 (see Chapter 5).[54]

In March 1921 Percy organised an exhibition of watercolours by Paul Signac at the Independent Gallery.[55] His book, *The Appreciation of Painting*, was published by Selwyn and Blount at the end of March 1921,[56] 'Dedicated without permission to Robert Bagge Scott who started me on my way'.[57]

In April 1921 an exhibition of modern French paintings was held at the Independent Gallery. No catalogue has been found for this exhibition but two Matisses, Friesz, Marchand, Segonzac, Lotiron and Frélaut (*La Chasse aux Poux* and *Les Ruches*) were exhibited.[58] One of the Matisses's was *Skates on the Beach*.[59] Percy continued to be very busy despite the depressed postwar market negatively affecting his bank balance. He still believed he could succeed, and was becoming increasingly anxious to

obtain the best examples of Jean Frélaut's work for his first solo exhibition in England.[60]

A solo exhibition of Othon Friesz's paintings[61] and an exhibition of Paris cafés and gardens by Nina Hamnett[62] were held at the Independent Gallery in May and June 1921. According to Percy, the twenty-five works by Friesz attracted many visitors.[63]

Percy's article, 'Two Attributes to Carel Fabritius', was published in the May edition of the *Burlington Magazine*. He discussed the work of Carel Fabritius (1622–54) who was a pupil of Rembrandt, and introduced two paintings attributed to Fabritius: *A Portrait of a Man* from the Musée royaux des Beaux-Arts de Belgique, Brussels, and *A Portrait of a Girl* from the Musée des Beaux-Arts, Ghent.[64]

Percy admitted to Jean Frélaut on 15 June 1921 that he was leaving home at 7 am and returning at 11 pm, stupefied. Percy's wife feared that if he continued like this, it would kill him. By 15 June 1921 Frélaut's exhibition of paintings, drawings and etchings had been hung at the Independent Gallery. Percy decided against hanging the drawings that Frélaut had recently sent, as he did not consider them to be the same standard as those that Percy had had framed.[65] The private view of the exhibition was held on 22 June and the exhibition was open from 23 June to 22 July 1921.[65] No catalogue has been found but *Repas de Noce en Bretagne* (1908)[67] and *La Brigantine* (1919)[68] featured in the exhibition, and it soon became clear that the exhibition's visitors were violently divided into two camps: for and against.[69]

Percy went to Belgium for the family holidays at the end of July 1921. Unfortunately, his nephew, who had been brought up as a brother for Percy's only son, was taken ill in Blankenberghe with appendicitis. It was a worrying time for Percy, as his nephew had to spend four weeks in hospital in Bruges before being transferred to London.[70]

In August 1921 Percy sent Dr Albert Barnes a copy of *The Appreciation of Painting*, asking if he would review the book in an American paper.[71] Barnes agreed and sent the review to the arts magazine, the *Dial*.[72] Percy also sent a copy of the book to John Quinn in September 1921.[73] Quinn responded in November 1921, saying it was exceedingly well done and ought to have wide appeal. However, he advised Percy not to continue with the more comprehensive work unless he was sure that it would be well published and the publishers would pay him well.[74]

At the end of September 1921 Percy mounted an exhibition of drawings and watercolours by French and English artists, including Marchand,

Friesz, Segonzac, Matisse, Moreau and Lotiron.[75] Percy was soon fully booked for the winter, including teaching a course at Leeds University and teaching in several public schools. He had also started a book about contemporary art in its widest sense but with so much on he struggled to find time to write it.[76]

It was a busy autumn for Percy in terms of dealing and organising exhibitions. In November 1921 Percy sold one of Frélaut's etchings, *Village de Locmiquel Morbihan*, to the British Museum; the University of Oxford also made a request for the same etching.[77] He held a succession of interesting exhibitions, including an exhibition of F.J. Porter's latest work held at the Independent Gallery in December 1921, which received a favourable review in the *Burlington Magazine*.[78]

On 14 December 1921, Vanessa Bell wrote to Roger Fry that she had had a letter from Percy, full of compliments about her pictures, which she thought had been written to cheer her up for being so unappreciated by the public. His compliment also took the form of buying one of her pictures, as well as talking about a show in January or February. However, Vanessa Bell already had an exhibition coming in June and could not afford to send things elsewhere first.[79]

Percy had also told Roger Fry in December 1921 that he wanted another show of the London Group, a society set up to break the Royal Academy's monopoly on exhibiting new work. Percy said it needed Duncan Grant to send some pictures. Roger Fry was not keen on this show, and Percy, disappointed with the London Group's low prices, told Fry that he could not carry on with such low profit margins. During the discussion with Roger Fry about the proposed show, Percy became very nervous.[80]

On the one hand, by the end of December, Percy had given up on the February show for the London Group.[81] On the other, Percy's book had become a great success and had sold well. Fry wrote to Vanessa Bell about the book, stating, 'The public is really wonderful because it's all the queerest muddle (jumble) really means nothing at all. However, I suppose people think they understand it best when there's nothing to understand at all.'[82]

Towards the end of December 1921, Percy admitted to Jean Frélaut that 1921 had been one of the most laborious and anxious years of his life. He had given twenty-seven lectures, put on eighteen exhibitions, worked on two books and produced twenty-seven articles on painting. On many occasions he had been at the end of his resources, morally and materially, but, each time, he had recouped his losses. He thanked God

for this. There was a satisfaction in having convinced a lot of people it was in art that solace was found, an antidote against the ferocity and the superficiality of modern life.[83]

On 5 January 1922, a mixed exhibition of pictures opened at the Independent Gallery. In addition to Chinese drawings, works by Cézanne, Eugène Delacroix, Courbet, Pissarro, Renoir, Gauguin and other modernists were exhibited.[84] Also in January, Percy started his course of lectures at Leeds University despite being overworked and exhausted.[85]

On 17 February 1922, Percy was in Paris with his wife, staying at Hôtel Cambon.[86] During their stay, they had lunch with Vanessa Bell and Duncan Grant at Hôtel de Londres. Vanessa Bell could not work out what Percy thought about their pictures as when he looked at them, he never said a word. However, he had seemed more cheerful than when she had seen him in London with Roger Fry. Percy had scraped together £200 to spend on pictures in Paris, as he said dealers were willing to sell for practically any price. Percy had bought an André Derain, although he still hated him. He also told Vanessa Bell and Duncan Grant that he was soon to have a mixed show and he wanted them to send works.[87]

Percy had a telephone conversation with Roger Fry at the end of February 1922. The Marchand exhibition at the Independent Gallery had fallen through as Marchand had flu. Percy was, therefore, going to have a mixed show and he wanted Roger Fry, Vanessa Bell and Duncan Grant to send works despite last year's disappointing prices.[88] The exhibition of drawings and a few oil paintings by British and French artists took place between 21 March and 13 April 1922 at the Independent Gallery and included works by Gauguin, Van Gogh, Jean-François Millet, Matisse, Segonzac, Luc-Albert Moreau, Marchand, Friesz, Paul Signac, Dufresne, Henri Vergé-Sarrat, Frélaut, Roger Fry and Duncan Grant.[89] The review of the exhibition in the *Burlington Magazine* noted, 'This exhibition not only maintains the standard of its predecessors but has a special interest of its own.'[90]

At the end of April 1922, Percy confessed to Jean Frélaut that he had been very ill during the last two months. The doctors did not know what he had but told him that his state was the result of overwork. Percy accepted the doctors' advice that he should take to the country and rest. Here he was seized by dark thoughts, with rest making no difference. He then developed a toothache and went to his dentist, believing his tooth needed to be extracted. Once in the dentist's chair, Percy was given the news that he had two abscessed teeth that had burst and infected the

bone (osteomyelitis of the jaw). He was referred to a surgeon and, over a period of four weeks, Percy underwent five general anaesthetics during which eight teeth and nine pieces of bone were removed. He now felt a new man.[91]

Percy found that business was poor in England, but the names of Lord Ivor Spencer-Churchill, Lord Sandwich, Lord Henry Bentinck and the economist Maynard Keynes began to appear in the gallery's stockbooks from 1922.[92] Lord Sandwich and Lord Ivor Spencer-Churchill were friends of the artist Paul Lucien Maze. After the end of World War I, Maze had resumed his painting career, renting a studio on the fourth floor of 13 rue Bonaparte where his neighbours were André Dunoyer de Segonzac and André Derain. Maze moved to England after his marriage to the widow of his close friend, Captain Thomas Nelson.[93] The day that Maze approached Percy to make his first exhibition, Percy told Maze that he had had enough of London and was ready to put the key under the door mat and close the gallery as there was a complete lack of interest in French Impressionists in London. Maze dissuaded Percy from doing this and gradually bought Percy a number of keen buyers.[94]

Between April and July 1922 Percy mounted four exhibitions at the Independent Gallery. An exhibition of paintings and drawings of Bernard Adeney and Keith Baynes was held in April and May 1922.[95] An exhibition of paintings and drawings by Vanessa Bell was held alongside an exhibition of recent watercolours by Othon Friesz in May and June 1922.[96] An exhibition of paintings and drawings by Jean Marchand was held in June and July 1922. There were forty exhibits of which three were loans; *La Maternité* lent anonymously, *Paysage de Montmartre* lent by M.L. Justice Esq. and *Les Eucalyptus* by the Duchess of Marlborough.[97]

At the end of July Percy was passing through Paris and, between trains, he tried to see both Jean Guiffrey and Paul Jamot at the Louvre. Jamot had sent Percy a copy of 'Les Frères Le Nain' which had been published as three consecutive articles in the *Gazette des Beaux-Arts* from February to March 1922. The Le Nain cited as belonging to Percy actually belonged to Frank Hindley Smith.[98] The picture, *Four Figures at a Table*, formerly *Le Bénédicité*, by the Le Nain brothers had been published in the *Burlington Magazine* to accompany 'Notes on Various Works of Art' in March 1922.[99] Paul Jamot later indicated in his book *Les Le Nain* that Percy had discovered this picture in England, and that it had been acquired by Hindley Smith[100] for £600.[101] In 1924, Hindley Smith asked Percy to sell the picture, on commission, as he required money to purchase certain

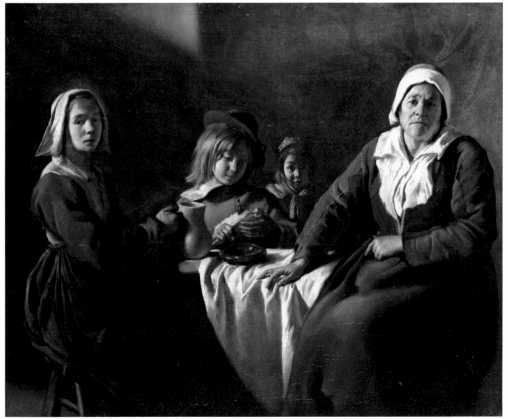

The Le Nain Brothers, *Four Figures at a Table*, oil on canvas, 44.8 x 55 cm, *c.* 1643

pictures. Percy brought the picture, which had been valued at £1,250, to the attention of the National Gallery who expressed a desire to buy it. Hindley Smith preferred to give rather than sell it to the National Gallery. Percy was quite prepared to forego his commission but Hindley Smith, aware that Percy was not a wealthy man, insisted that the Trustees of the National Gallery paid Percy his commission.[102]

In August 1922 Percy received a confidential letter from John Quinn with a list of his collection of pictures and drawings by Augustus John. Percy thought that, in the majority of cases, there was every possibility that Quinn would get his money back and make a profit. Percy wanted to see the collection when he was in New York in November in order to discuss with Quinn the prospects of selling this collection in London.[103]

One Saturday morning in September 1922, two women appeared at the Independent Gallery. Percy had a long conversation with them about the neglect of modern art in Britain. One woman then asked Percy

the price of Jean Marchand's *Saint-Paul*. He took them into his inner room and showed them a few pictures that he had in reserve, amongst them a fairly late Renoir, *Woman at her Toilet*. After asking the price, she requested Percy to reserve the two pictures until the following Tuesday. That Tuesday, Percy received a telegram, saying that she would take the two and would settle up on her return. That telegram was signed 'Courtauld'. At that juncture, the name meant nothing to Percy.

In due course, Mrs Courtauld turned up, paid Percy for the pictures and asked him to deliver them to her house in Berkeley Square. She also enquired whether she could send her husband to see him.[104] Samuel Courtauld's eyes had been opened to modern French painting by seeing the Hugh Lane Collection in the Tate Gallery's newly built modern foreign galleries in 1917.[105] His final conversion to this type of painting occurred at the Burlington Fine Arts Exhibition in 1922[106] where Percy exhibited *Le Printemps* by Renoir, which Samuel Courtauld bought in 1927.[107]

When Courtauld visited Percy, he told him that his wife had been interested in Percy's indictment of the British authorities in neglecting the vital French movement of the nineteenth century. Percy had warned that first-rate examples were becoming scarce, as they were being absorbed into many European and American collections and, if the neglect persisted, nothing worthwhile would be available for the education of British people.

Percy clearly had made a strong impression on the Courtaulds and, a few days later, Samuel Courtauld offered to help to put matters on a different footing.[108] Courtauld made it his personal responsibility, creating the Courtauld Fund with a gift of £50,000 in 1923.[109] The trust fund provided the means for the Tate Gallery to purchase works by nineteenth-century French painters who were, at that time, hardly represented in the gallery.[110] The fund's committee included Samuel Courtauld, Lord Henry Bentinck, Sir Charles Holmes, Sir Michael Sadler and Charles Aitken, then the Director of the Tate.[111]

Many of the purchases for the Courtauld Fund, and particularly for the Courtauld's private collection, were made from or through Percy. On occasion, and most notably for Courtauld's two most expensive purchases, Renoir's *La Loge* (*Theatre Box*; 1874) in May 1925 and Manet's *A Bar at the Folies-Bergère* (1882) in March 1926, Percy explicitly acted as an intermediary and was paid a sizeable commission. His role was probably that of an agent or intermediary for many of the other purchases which were made by direct purchase, on paper at least, from Percy at the Independent Gallery.[112] The list is extensive: October 1923, Van Gogh's

Courtauld catalogue

COLLECTION

DE

TABLEAUX FRANÇAIS

FAITE À LONDRES

20 PORTMAN SQUARE

PAR

SAMUEL ET ELIZABETH COURTAULD

1914-1931

TEXTE PAR

PAUL JAMOT ET PERCY MOORE TURNER

The title page from the Courtauld catalogue

Landscape with Cypress Trees (1889), now *Wheatfield with Cypresses* (National Gallery, London); June 1925, Seurat's *Study for La Baignade* (1883–4); now known as *White and Black Horses in the River*); December 1925, Bonnard's *La Table* (1925; now Tate), Cézanne's *Portrait of Cézanne Chauve* (1880–81; now *Self Portrait*, National Gallery, London), Renoir's *Nu dans l'eau* (1888), Sisley's *L'Abreuvoir* (1875?; now *The Watering Place at Marly-le-Roi*, National Gallery, London); January 1926, Cézanne's *Le Lac bleu* (1896); now *Le Lac d'Annecy*, The Courtauld Gallery, London); June 1926, Degas's *Les Danseuses* (1874; now *Two Dancers on the Stage*,

The Courtauld Gallery) and Sisley's *Snow at Louveciennes* (around 1874; The Courtauld Gallery); June 1927, Renoir's *Le Printemps* (1872–5); now *Spring at Chatou*, private collection); December 1927, Degas's *Après le Bain* (around 1895; now *After the bath – woman drying herself*, The Courtauld Gallery), Seurat's *Bord de Seine* (around 1883; now *Boat by the Bank, Asnières*, The Courtauld Gallery); month unknown 1928, Bonnard's *Le Balcon bleu* (1910); The Courtauld Gallery); March 1928, Toulouse-Lautrec's *Au Rat Mort* (1899); The Courtauld Gallery); June 1928, Manet's *Le Déjeuner sur l'herbe* (1863); The Courtauld Gallery); November 1928, Seurat's *L'homme poignant son bateau* (1883); now *Man painting a boat*, The Courtauld Gallery); July 1929, Seurat's *Homme dans une barque* (around 1883); November 1929, Daumier's *Sauvetège* (1870); December 1929, Toulouse-Lautrec's *Jeanne Avril* (around 1892); now *Jeanne Avril sortant du Moulin Rouge et mettant ses gants*, The Courtauld Gallery).[113] All the evidence suggests that Percy was Samuel Courtauld's

Pierre-Auguste Renoir, *Le Printemps* (now *Spring at Chatou*), oil on canvas, 59 x 74 cm, *c.* 1872–5

principle adviser.[114] It was Percy who arranged the hang of pictures when the Courtaulds moved to Home House in Portman Square, London, W1 in 1926.[115]

On 21 September 1922 Percy sailed on the *Empress of France* for North America to give a series of lectures and to mount an exhibition in New York.[116] On arrival in Quebec on 28 September, Percy went straight to Toronto to stay for about two weeks with his friend P.L. Carroll, who had a gallery at 117 King Street, West.[117] During his time in North America, Percy gave a series of lectures on modern art.[118] He also took the opportunity to visit the Canadian public galleries, which prompted him to write an article for the Canadian Forum entitled 'Painting in Canada', in which he expressed his disappointment that the quality of art exhibited in Canada had not improved since he last visited nine years earlier; he was, however, very pleased that a friend had encouraged him to see the paintings of the Group of Seven.[119]

While Percy was away from England in October 1922, an exhibition of paintings and drawings by British and French artists was held at the Independent Gallery. It included works by Vanessa Bell, Duncan Grant, David Bomberg, Roger Fry, Keith Baynes, Othon Friesz, Jean Marchand, André Dunoyer de Segonzac, André Lhote and Gwen Raverat.[120] It was in the middle of this month that Percy also seems to have met John Quinn in New York; Percy had previously agreed to meet him in November to discuss his Augustus John collection.[121]

Returning to Toronto on 16 October 1922, Percy proceeded west to begin lecturing. He returned to Toronto on 28 October to begin his lectures at the university,[122] which finished on 3 November. He then went to New York on 8 November.[123] There he mounted an exhibition at the Ehrich Galleries, which included pictures by Marchand, Segonzac, Frélaut, Moreau and Matisse.[124]

On 12 November 1922 Percy went to Philadelphia to see a picture attributed to John Crome, the property of a recently deceased Philadelphian cotton manufacturer. He lunched with Dr and Mrs Barnes.[125] Percy gave a lecture entitled 'The Evolution of Art in the XIXth and XXth Centuries' at the Ehrich Galleries on the evening of 14 November 1922 and his interview with the *American Arts News* was published on 18 November, in which he suggested the serious side of modern painting was essentially a evolutionary rather than a revolutionary movement. He believed in the importance of modern art for the aesthetic advancement of the world.[126] Percy left New York on 19 November 1922 for New England.[127] Here he

visited the Worcester Museum and put John Quinn's *The Mumpers* (1912) by Augustus John before the director. If they decided against it, Percy would let London know and would 'discreetly' show the picture to other galleries.[128] On 27 November Percy set sail from Quebec on the *Empress of Britain* bound for England,[129] having given twenty-seven lectures on art and travelled over 30,000km.[130]

In December 1922 Percy was making his arrangements for the next session; however, he did not want to complete the list of exhibitions without arranging a good place for the Augustus John show. Percy needed Quinn to let him have the pictures, drawings and the list of particulars so that he could proceed with the catalogue and press notices.[131] At the end of December, Percy suggested to Quinn that the exhibition should be done in two parts, as Percy did not believe in overcrowding exhibitions: first the paintings and then the drawings. The second exhibition would attract people who could not afford the paintings. Percy asked Quinn whether he would be sending his James Dickson Innes with the other John pictures. Percy intended to sell the etchings by Augustus Johns en bloc. It had been agreed in New York that Percy would get 10 per cent of any sums realised up to the total cost price of the whole collection and then 25 per cent of the sum realised between the total cost price of the collection and the sum total realised by the sales.[132]

At the very end of December 1922, while Percy was in Norwich attending to his mother's trust, he received a letter from Dr Barnes expressing a wish to buy two Segonzacs and a Lotiron for his foundation. Percy had sent these pictures among others to Ehrichs Gallery to get a footing in the New York market.[133]

On 30 December 1922, eight boxes containing seventy-two oil paintings, seventy-two watercolours and drawings, and five sealed packages were shipped on behalf of John Quinn from New York to Southampton on the *Olympia*. The pictures included those by Augustus Johns, James Dickson Innes, Spencer Gore, John Currie, Christopher R.W. Nevinson, Edward Wadsworth, Mark Gertler, David Bomberg, William Orpen, Francis Dodd, Gordon Craig and Derwent Lees.[134] Percy was to bear all expenses connected with the exhibition and sale of the pictures. John Quinn preferred not to have the pictures exhibited or advertised as his property.

Quinn left it to Percy's discretion as to whether he would notify John or his agent, Chenil, in advance of the exhibition.[135] Quinn had learnt that Augustus John was coming to America and imagined this would boost his popularity in the States. Quinn anticipated that John would be furious

when he heard of the sale, and thus he advised Percy to give a good reason for selling in England: these works belong in England.[136]

On 8 January 1923, Percy wrote, in confidence, to ask if John Quinn was interested in a Renoir landscape, *Le Printemps*. Percy had purchased it around 1908 before the Cologne Gallery could buy it. He had only exhibited it once the previous year at the Burlington Fine Arts show where it was insured for £4,000. After Percy and his family had left their Paris flat and put their furniture in storage, Percy was surprised to find how hard it was to rent a house. As a consequence, he bought a plot of land (in Gerrards Cross) and now needed money to build the house. He offered the Renoir to John Quinn for £4,000.[137] Quinn declined the picture in March 1923.[138]

Having received Quinn's list of selling prices, Percy cabled Quinn on 9 January 1923 that the selling prices appeared low and asked if he could augment them at his discretion. Quinn cabled back giving Percy his authority to do this.[139] On 16 January 1923 Percy reported to Quinn that he had finished unpacking the pictures and four were damaged. The show would open the following week as 'a show of Augustus John with other paintings being shown privately'.[140]

John visited the exhibition of a private collection of his works on 23 January, the day before the press view. Percy reported to Quinn that John had taken the matter well, liked the hanging of the pictures (six canvases and thirty-three panels) and gave Percy permission to photograph what he wanted. The private view took place on the Thursday and the exhibition opened to the public on the Friday. Three days before the show opened, Percy had already sold some of the pictures and the Australian government had approached Percy asking for any Johns that might be left be sent out to Australia for exhibition.[141]

On the day of the opening, the *Morning Post* identified the collection at once as 'the property of Mr. John Quinn, a New York Lawyer' and reported the rumour that the sale had been arranged without the artist's knowledge.[142] Percy kept Quinn informed about the progress of the exhibition. Quinn, on 5 February, told Percy that Martin Birnbaum of Scott and Fowles in New York was very disappointed that Quinn had sent the paintings and drawings to Percy. In turn, Percy told Quinn, on 6 February, that the first half a dozen people who came into the show, including John himself, could guess from whom the pictures came and, of course not through Percy, passed the information to the press. By 15 February, the sales amounted to £3,670 and Quinn thought that was

'doing remarkably well'. By the end of the show (24 February), Percy had sold twenty-one pictures and four were to be sent to Australia.[143]

At the end of January 1923 Dr Barnes sent Percy two copies of the *Arts*, in which Dr Barnes's review of Percy's book, *The Appreciation of Painting*, had appeared.[144] This edition of *Arts* also gave an account of the Barnes Foundation building, which Percy read with great interest. Percy, at this time, also took the liberty of suggesting that Dr Barnes added a Jean Marchand to his collection. Percy began to collect him early and now had a very fine collection and was steadily buying him for pleasure. Percy had another suggestion for Dr Barnes; 'one or two painters in England, whom I think are making history'. Percy named Duncan Grant , Vanessa Bell, F.J. Porter and Roger Fry.[145]

Percy let Quinn know on 20 February 1923 that he had announced the show of drawings by Augustus John for July. Percy had shown *Way down to the Sea* to the Tate Gallery. If they did not take it, he would submit it to two provincial galleries. Percy had been visited by the manager of Knoedler & Co. and, following this visit, Percy anticipated that Quinn might be approached by the New York branch to purchase it.[146]

Percy cabled John Quinn on 6 March: 'Advise ignore Chicago meanwhile'.[147] Percy had received a letter from the Art Institute of Chicago before the exhibition had opened. It was expecting to hold an exhibition of works of Augustus John in the autumn and asked whether Quinn would be willing to loan some of the unsold works at the close of the exhibition.[148] Quinn approved Percy's decision, as he thought Percy had every chance of selling the oils. Quinn also believed that Percy had done much better than either Martin Birnbaum or William Marchant could have done.[149]

On 15 March Percy sent John Quinn a list of prices for the drawings but Percy was uncertain whether he could get them. He believed he would be in a better position when several other John drawings came to the market in the course of a month. Meanwhile, Percy felt that a large number of the drawings needed remounting and reframing.[150] On 20 March, Percy, returning to the subject of pricing, asked Quinn to give him considerable liberty of action with regard to the drawings, as the Alpine Gallery was having an exhibition of John paintings at the end of March and also a number of other John paintings were coming to the market. At the end of March, Quinn approved the prices of the drawings as well as their remounting and reframing. He had also received the press clippings that Percy had sent him. He had found them to be, for the most part, rather

good but one of his 'good friends' made Quinn out to be a 'Tammany lawyer', and that was incorrectly repeated in several of the articles since he had never been a member of the Tammany Hall.[151]

During March and April 1923 Percy held two exhibitions at the Independent Gallery; 'Paintings by Contemporary French Artists'[152] and 'Recent Paintings by Roger Fry'.[153] An article printed in the April issue of the *Art News* stated, 'The Independent Gallery is at the present time concerned with an exhibition of contemporary French art, with which movement it is now well identified. If one wants to study Matisse and Cézanne, Segonzac and Frélaut, this is the gallery for one's purpose, for the shows are organised by one who is thoroughly conversant with the modern movement in French painting and these in consequence are more educative than those brought together by the comparatively uninformed.'[154] Roger Fry exhibited thirty-two paintings and twenty-three drawings. The exhibition was a failure and Percy suggested Fry give up painting altogether.[155]

On 11 April 1923, Percy asked Quinn if he could lend his James Dickson Innes to the 'Memorial Innes' exhibition which was opening immediately at the Chenil Gallery, as Percy thought that there was an excellent chance of selling it. Quinn's approval was given by return.[156] At approximately the same time, Percy also sold three Inneses, reducing the price by £10 to secure the deal.[157]

During May, Percy continued to sell Quinn's pictures when he could. A Mark Gertler went to the Tate. Percy let Quinn know that he was writing to Scott and Fowles to let them know that Percy would be pleased to see Mr Stevenson Scott when he came to London and would show him any John paintings and drawings which had not been sold. Percy also gave Quinn an undertaking to do his best to disabuse the press about Quinn ever being a Tammany lawyer.[158] Percy also held a small exhibition of seventeen paintings[159] by Bonnard in May at the Independent Gallery.

At the end of May, Percy was trying to finalise arrangements with Quinn for the exhibition of John drawings. Percy wanted to use John Quinn's name on the catalogue and be given latitude with the pricing so that he could clinch any deal as it presented itself.[160] On 2 June 1923 Quinn confirmed that Percy could use his name on the catalogue.[161]

Quinn had picked up on a statement that John had bought several of his oil paintings. Percy confirmed that John had come to the gallery with a lady when the purchase took place but it was not possible to say who had made the purchase as the payment was made in bank notes.[162]

In June 1923 an exhibition of recent paintings and drawings by

Duncan Grant was held at the Independent Gallery. There were twenty-seven paintings and thirteen drawings.[163] This exhibition was reviewed in the July issue of the *Burlington Magazine*.[164] John Alton, in the *New Statesman*, wrote, 'Mr. Turner is a notable exception to Oscar Wilde's remark, which might well have applied to picture-dealers, about people knowing the price of everything and the value of nothing. We generally count on finding something worth seeing at the Independent Gallery. This time it is the work of the most individual of younger painters, Duncan Grant.'[165]

At the beginning of June, Percy let Quinn know that John wanted to meet him.[166] This meeting took place on or around 20 June.[167] Quinn did not know until after the meeting, the full extent of John's feelings about the sale of the drawings and etchings. It worried Quinn considerably and he asked Percy if it was too late to remove his name from the catalogue. Quinn gave Percy permission to show his letter to John if he saw him.[168]

The press preview of the 'Exhibition of Mr. John Quinn's Collection of the Earlier Drawings of Augustus John' was held on 3 July 1923, the private view the next day and the opening on 5 July.[169] There were sixty-four drawings and watercolours by Augustus John and eight other drawings by five other artists.[170] Percy had set the prices above what he considered the market price, despite believing the John market had been rather overworked.[171] Seven pictures sold before the opening of the show and only two after the opening. There was a heatwave and London was practically deserted. The show closed on 26 July.[172]

Percy's article '*The Sharpe Family* by William Hogarth' was published under 'Notes on Various Works of Art' in the August edition of the *Burlington Magazine*. The picture, at that time, was in Boston, USA and showed numerous members of the Sharpe family. Percy proposed that the most probable origin of the picture was that Hogarth had painted it on the occasion of Horatio Sharpe's leaving England to take up the governorship of Maryland in 1793.[173]

In mid August 1923, John Quinn gave Percy approval to send one Augustus John, two Spencer Gores and two James Dickson Inneses to a commercial exhibition of British art in Stockholm.[174] By then Percy was on holiday at Buxton Lamas, Norfolk. He hoped that the pictures would go down well in Stockholm, but the economic downturn in Europe was worsening and Percy was afraid that it would be a difficult winter.[175]

At the end of September Vanessa Bell had lunch with Percy and André Dunoyer de Segonzac. She saw Segonzac's pictures standing on the floor

at the Independent, and thought they were very good, especially some of the earlier ones. Percy was just about to take Segonzac off on a tour of the north,[176] prior to the opening of an exhibition of paintings, drawings and etchings by André Dunoyer de Segonzac in October 1923. The exhibition contained sixteen paintings, nine drawings and twelve etchings.[177] Percy sold practically everything in spite of 'the bad times'.[178]

Percy held two exhibitions at the Independent Gallery between November 1923 and January 1924; 'Exhibition of Etchings and Lithographs by Toulouse-Lautrec'[179] and 'Drawings by the Girls of Dudley High School'.[180]

By December 1923 John Quinn was becoming anxious about the sale of the watercolours and drawings, as he had expected Percy to have sold more of them by then. Quinn had also been told by Augustus John that Percy was going with the art dealer John Knewstub into a new gallery.[181] At the end of December, Percy confirmed to Quinn that he had sold three more John drawings and was hoping to organise something over the next month or so with the remainder of the Johns, but business had been very bad. He also confirmed that he had agreed to be a director of the New Chenil Gallery but it would not interfere with his own business.[182]

In January 1924 Percy held an exhibition of etchings, *Les Peintres-Graveurs Independents* at the Independent Gallery.[183] Scott (of Scott and Fowles) and Birnbaum had also been in touch with Quinn about selling some of the pictures that Percy had yet to sell but Quinn had declined as this would have affected Percy's commission.[184] In February 1924 Percy asked Quinn if it would be better to send over a selection of paintings and drawings to the States, as Scott and Fowles seemed to be very keen to do something.[185] Percy held an exhibition of drawings by Elliot Seabrooke between 12 February and 1 March 1924 at the Independent Gallery[186] and plans were drawn up for Percy's new house in Gerrards Cross, Oxnead, Buckinghamshire.[187]

At the beginning of March 1924 Percy and Quinn agreed that the John pictures being returned from Australia should not be sent to the Venice International Exhibition, as there was little chance of selling them there.[188] However, at the same time, Percy did seem to be in a more positive mood when he wrote to Jean Frélaut: thanks to persistence, he was making progress.[189] During March and April 1924 Percy mounted an exhibition of contemporary British artists, which included works by Vanessa Bell, Bernard Adeney, Keith Baynes, Matthew Smith, Elliot Seabrooke, Duncan Grant, Rupert Lee, Frank Dobson and Osbert Sitwell.[190]

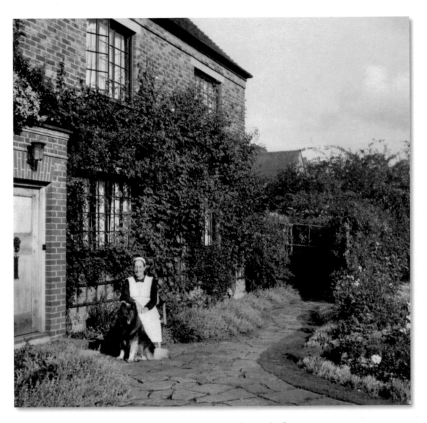

Oxnead, Marsham Way, Gerrards Cross

The garden at Oxnead, Marsham Way, Gerrards Cross

On 5 April 1924, the *Saturday Review* printed details of an opportunity to take up shares in the New Chenil Gallery. Five directors were named: Eugene Goossens, Herbert Granville Fell, Percy Moore Turner (residing at Gresham House, Packhorse Road, Gerrards Cross), John Ethelbery Slade and John Knewstub. The intention was to erect ground floor art and sculpture galleries, together with an extensive restaurant, an art school and other buildings.[191] The Chenil Galleries had been founded in 1905 in an old Georgian house situated between Chelsea Town Hall and the Six Bells public house located at 183a King's Road, Chelsea and known as Charles Chenil & Co. Ltd. It was opened in 1906 and was run by Jack Knewstub, who was brother-in-law to both William Rothenstein and William Orpen. Knewstub ran the business not only as an art gallery and dealership but also as a frame maker and artist-colour man supplying all the needs of the local art milieu. It has been suggested that the art dealership operated largely for the benefit of Augustus John.[192] Indeed, it was Augustus John who laid the foundation stone for the New Chenil Galleries on 25 October 1924. The galleries emerged on a 1,300-square-metre (14,000-square-feet) site at 183a King's Road the following year.[193]

At the end of May 1924 Percy admitted to Quinn that he had been doing his upmost to dispose of the remaining John paintings, drawings and etchings but, so far, without success. However, he had had a small offer of £400 for five oil paintings and one drawing. At the same time, Percy offered Quinn Seurat's *Grande Jatte* (1886) for £400.[194] At the end of June Quinn agreed to sell five of the pictures – *Myth and Caspar, Three Little Boys, Woman and Child, The Orange Frock* and *The Red Skirt* – for £400.[195]

Percy held two exhibitions in June 1924: a French show and works by Roger Fry, Vanessa Bell, Duncan Grant, Keith Baynes and other moderns.[196] Vanessa Bell wrote to Roger Fry on 22 June 1924, that she had gone to help hang the French show with Porter at the Independent Gallery. She seemed to have had some difficulties with Percy, but she and Porter had been firm about things and nothing awful had happened. The French show seems to have been very good on the whole, especially the Matisse. There was also a good Derain.[197] Percy held an exhibition of drawings by Walter Sickert in July 1924.[198] On 28 July, John Quinn died from cancer of the liver, shortly after being diagnosed on 21 June 1924.[199]

In September 1924 the executors of John Quinn's estate decided that the unsold pictures should be returned to the USA. Percy had twelve Augustus John paintings out of thirty-nine unsold, fifty-five drawings

unsold out of sixty-four, 114 etchings in five portfolios unsold and thirty-nine pictures by other artists unsold.[200] Arrangements seemed to have been in hand to sell the etchings at the Chenil Gallery, a catalogue having been already prepared, but the death of Quinn had put pay to this sale.[201]

Percy continued to organise exhibitions at the Independent Gallery but he also became more involved in exhibitions elsewhere (see Chapter 5). In October 1924 an exhibition of watercolours of Venice and the Lido and a few statuettes by Frank Dobson (twenty-four watercolours and six statuettes) was held at the Independent Gallery.[202] This was followed by an exhibition of drawings by contemporary French Artists in December 1924,[203] an exhibition of twenty-four paintings of the tropics and France by Gerald Reitlinger in February 1925,[204] an exhibition of recent paintings of the Cotswolds and elsewhere by Alfred Thornton in March 1925,[205] and an exhibition of watercolours by Wyndham Tryon was held from March to 9 April 1925.[206]

During April and May 1925, Sir Michael Sadler's wife, Betty Sadler, exhibited her watercolour drawings. There were twenty-eight pictures and three designs for book covers for novels published by Constable. Sir Michael Sadler lent three pictures. Eva Gilpin, Mrs Crindall and Mrs Charles Napier lent one picture each.[207] Sir Michael Sadler also wrote the foreword to the catalogue of the *Exhibition of Hand-printed Silks and Other Fabrics designed by Alec Walker*, which was held in 1925.[208]

An exhibition of French paintings (Jean-Auguste-Dominique Ingres to Paul Cézanne) was held in May and ended on 6 June 1925. The exhibits included three Paul Cézannes, one Jean-Baptiste-Camille Corot, one Gustave Courbet, one Edgar Degas, one Eugène Delacroix, two Paul Gauguins, one Ingres, one Édouard Manet, two Claude Monets, one Camille Pissarro, four Auguste Renoirs, four Georges Seurats, two Alfred Sisleys, three Vincent van Goghs and one bronze by Jules Dalou.[209] Geoffrey Webb wrote in the *Burlington Magazine* that 'The exhibition of French nineteenth century painting, at the Independent Gallery, is one of the most important seen in London of recent years.'[210]

In June and July 1925, an exhibition of old masters and a few pieces of oriental pottery was held at the Independent Gallery. There were thirty-two pictures, six pieces of oriental pottery, a mirror decorated with birds and a thirteenth-century seated Buddha.[211] Thomas Gainsborough's *Portrait of Master Plampin* (around 1752), no. 13, was sold to Frank Hindley Smith,[212] but Percy had bought this picture back by 1927,[213]

Thomas Gainsborough, *Portrait of Master Plampin,* oil on canvas, 50.2 x 60.3 cm, *c.* 1752

and it was bequeathed it to the National Gallery after Percy's death.[214] *Portrait of the Archduke Albert,* no. 30, considered to be by Peter Paul Rubens was bought by Percy and then bequeathed to the Ashmolean Museum after his death.[215]

By September 1925 Percy and his family had moved into their family home: Oxnead, Marsham Way, Gerrards Cross. A letter written by Paul Jamot on 21 September was redirected to this address. In this letter, Jamot asked a favour. He knew, through Percy, that Captain Archibald Morrison of Basildon Park had a picture by Poussin which was similar to Jamot's *Le Triomphe de Pan* and Jamot hoped that Morrison could lend his picture to an exhibition at the Petit Palais in Paris that he was organising.[216]

The exhibition 'Embroideries from New Designs by Vanessa Bell, Roger Fry, Duncan Grant and Wyndham Tryon' was held at the Independent Gallery from 7 to 26 October 1925.[217] Herbert Furst in the *Apollo* wrote that 'The exhibition disappoints; it smacks too much of art

Peter Paul Rubens, *Portrait of the Archduke Albert*, oil on canvas, 78 x 57 cm, *c.* 1615

and not enough of craft.'[218] This would be last time these artists exhibited at the Independent Gallery for seven years.

Percy had held exhibitions of British artists such as Sickert, Fry, Grant, Vanessa Bell, Adeney, Porter, Baynes, Seabrooke and Dobson with some success but at a financial loss to himself. The artists were obviously embarrassed so they evolved a system whereby each artist in the group would be guaranteed a small income. They approached Maynard Keynes, Leopold Hamilton Myers, Samuel Courtauld and Frank Hindley Smith to finance the scheme that became the London Artist's Association. Frank Hindley Smith informed Percy of their approach, but Hindley Smith knew that a disastrous result was inevitable, for which he was prepared.

Percy received a round robin letter from the British artists, in which they sacked him. The note was couched in friendly terms and was appreciative of all that Percy had done in their interest over the years. They went off to the Cooling Galleries, but the venture was short-lived and the London Artist's Association was dissolved in 1933.[219]

On 9 January 1926, in New York, Percy bought John (Old) Crome's *The Willow Tree* for a Norwich citizen, James Hardy, for £9,700.[220] This picture was exhibited from 9 February at the Castle Museum, Norwich, for one month.[221] It would appear that it was exhibited at the Independent Gallery before it went to Norwich, as Anthony Bertram wrote at the beginning of February 1926 that 'For five days this week the Independent Gallery, the stronghold of modern art, has filled its bare walls with one picture, Crome's *The Willow Tree*, and we have done homage to this returned masterpiece, that was likely to have been exiled in America for ever.'[222]

In March 1926 Russell James Colman purchased fifteen John Sell Cotman watercolours from Percy who had purchased them from the Palser Gallery, London.[223] Colman had become the head of manufacturing for the family business, J. & J. Colman, famed for its mustard. Russell chaired the Norfolk News Company on the death of his father, Jeremiah James Colman, in 1898.[224] Colman also inherited his father's enthusiasm for the Norwich School.[225]

It has not been possible to pinpoint how Percy first met Colman. However, Percy was one of the prime movers in the organisation of the 'Crome Centenary Exhibition' at the Castle Museum in Norwich, which opened on 6 April 1921 (see Chapter 5). Colman took a leading part, both as the principle contributor of pictures and as a member of the committee of the Castle Museum. Percy was also responsible for introducing Russell

Colman to Kennedy North, a 'conservator of pictures', who worked on both the oils and watercolours by Cotman that Colman owned.[226]

In 1926 Percy held four exhibitions at the Independent Gallery. From 11 to 27 February twenty-eight pictures by Simon-Levey were shown. Three of these were lent by Sir Michael Sadler, two by Paul Lucien Maze and one by the Hon. Mrs Maurice Glyn.[227] From 11 March to 1 April, fourteen paintings and nineteen watercolours and drawings by John Joseph Wardell Power were exhibited.[228] The art historian and writer Anthony George Bertram wrote in the *Saturday Review*, 'The most interesting exhibition I have been to this week is that of he works of J.W. Power at the Independent Gallery.'[229] An exhibition of paintings and drawings by Lily Converse was held in May,[230] and following on from the success of an exhibition of fifty-two paintings by Paul Lucien Maze held from 18 November to 5 December 1925 at the Independent Gallery,[231] an exhibition of watercolours by Maze was held in December 1926.[232] Anthony Bertram wrote in the *Saturday Review* in December, 'The water-colours of M. Paul Lucien Maze are immediately attractive. They have freshness, spontaneity, a windswept, clean, care-free way to them that cannot fail to win the love of all but the most gloomy header-bound.'[233]

In September 1926 Percy brought Russell Colman's attention to a picture in the Fitzgerald collection that had been shown by Vincent George at the Royal Academy in 1823. Percy had been unable to trace its provenance between 1823 and when it became part of the Fitzgerald collection. Largely, Percy thought, as a result of the Norwich shows, these fine examples from the Norwich School were gradually coming his way.[234]

When Percy was in New York at the end of October, staying at the Hotel Algonquin, he spent a thoroughly enjoyable day with Dr Barnes visiting his gallery and collection. Percy was left wishing that there were people with such enthusiasm in England. As Percy had quite by accident seen a portrait by El Greco, probably of the Escabo family, during his stay in New York, he brought it to Dr Barnes's attention.[235]

In January 1927 the art dealer César Mange de Hauke wrote to Percy from Paris. He and the Parisian art expert Paul Ebstein met up with Percy and told him that they had two customers who were looking for fine examples of Bonnard and Matisse. Could Percy send to New York Matisse's *Open Window* and Bonnard's two *Paysage du Midi* as they had a good chance of selling these pictures and they hoped that Percy would be able to co-operate with their activities in America.[236] Although Percy was

reluctant to send the pictures to America on approval, in February 1927 he arranged the shipment of two Bonnards and then a third to America.[237]

In February 1927 Percy met up with Augustus John to discuss the New Chenil Gallery. Business for the New Chenil was slack from the start and John Knewstub consistently ignored John's advice and had further misappropriated £1,700 of John's money. Augustus John was convinced that the business could be restarted under a capable management but Percy was reluctant to shift his business. Knewstub was made bankrupt in 1927 and Charles Chenil & Co. Ltd was voluntarily wound up.[238]

It was also in February that Percy let Russell Colman know that the National Gallery of Scotland was not able to buy Cotman's *Merton* [Moreton] *Hall* (around 1807–8) and Percy could offer him the picture for £1,050. Percy had heard from Frank Leney, Curator at the Castle Museum, Norwich, that Mr Batchelor had been through the Cotmans and had suggested *The Ravine* and the drawing *St Botolph's Priory*. Percy offered Colman *Boats on Yarmouth Beach* for £400, *The Ravine* for £200 and *St Botolph's Priory* for £25.[239]

An exhibition of recent oil paintings by Jean Marchand was held at the Independent Gallery in March 1927. There were twenty-five pictures with two loaned by Paul Maze, one anonymously and one by M.L. Justice Esq.[240]

Sir Charles Holmes, Director of the National Gallery, telephoned Percy on 1 March 1927 about Cotman's *Silver Birches* (around 1824–8), which the gallery wanted to acquire. Percy was anxious to act in the best interests of the Cotman Estate in deciding its ultimate destination. Percy had been asked to organise certain exhibitions in which this picture would represent a phase of British art in an international setting. Percy had decided to bequest the picture if possible. His association with the painting was long standing. Twenty years before, when it had come on to the market, Percy, in association with Holmes and the art scholar Laurence Binyon, had tried in vain to induce the National Gallery to acquire it. The second time it came on the market, he was able to acquire the picture. On 15 March 1927 Percy promised Holmes that, as soon as he could, he would make a codicil in his will relating to the picture.[241]

At the end of March and the beginning of April 1927, as Percy was on the continent, his assistant, C.W. Adams, sent the invoice for the two Bonnards to de Hauke, in New York, and acknowledged the receipt of a cheque for £1,200.[242]

Percy loaned *Silver Birches* to the Castle Museum, Norwich, for two

John Sell Cotman, *Silver Birches,* oil on canvas, 76.2 x 62.7 cm, *c.* 1824–8

years, where it was exhibited with Cotman's two contemporary pictures, *The Baggage Wagon* (around 1924–8) and *The Mishap* (around 1924–8), previously given by the late J.J. Colman, in May 1927.[243] It was also in May that Percy made Russell Colman aware of the codicil he intended to add to his will regarding *Silver Birches*.[244] It was, however, not until 27 August

1927 that Percy finally found the time to make the codicil bequeathing Cotman's *Silver Birches* to the National Gallery but, if the National Gallery declined it, he wanted it to be offered for sale to Russell Colman.[245]

Percy held an exhibition of works by André Dunoyer de Segonzac at the Alpine Gallery in June 1927. Forty-one oil paintings, twenty-eight watercolours and six etchings were shown. The exhibits were lent by Princess Bassiano, Lord Henry Bentinck, Henry Bernstein, Lord Ivor Spencer-Churchill, Madame Desjardins, Mademoiselle Dorny, Matthew L. Justice, Luc-Albert Moreau, Charles Pacquement, Paul Poiret, Claude Roger-Marx, Sir Michael Sadler, Frank Hindley Smith, Mrs P.M. Turner, Jean Patou, Paul Maze, Leon Delaroche, Jean-Arthur Fontaire and the City of Norwich Art Gallery.[246] Percy thought that the exhibition had been a resounding success.[247]

On 1 July 1927 Percy purchased at Christie's, on behalf of the Louvre, Franz Xaver Winterhalter's *Empress Eugénie Group* (*The Empress Eugénie surrounded by her Ladies*; around 1855) for 3,750 guineas out of funds bequeathed by a French lady.[248]

At the end of October 1927 de Hauke let Percy know that he was interested in pictures by Bonnard, Dunoyer de Segonzac, Matisse, Derain and Braque. He was also still interested in the watercolour by Cézanne that he had seen in January.[249] In November, Percy thanked de Hauke for his cheque for £600 in payment for the Bonnard oil painting. Percy had intended not to sell the painting for less than £650 but, as his assistant had agreed £600, Percy had to let it go. Percy also sent de Hauke details of three Bonnard still lifes, a Bonnard landscape *Temps gris*, according to his letter, and a Segonzac, *Nature Morte au Choux* (1919–20), from the Collection of Lord Henry Bentinck, MP. Percy would send these to New York if de Hauke would pay for the carriage. Percy asked de Hauke not to ask for any pictures unless he would buy them.[250]

Percy's article 'Gainsborough Discoveries at Ipswich' was published in the November edition of the *Burlington Magazine*. While Percy was researching and organising the 'Bicentenary Memorial Exhibition' of Thomas Gainsborough held in Ipswich in November and December 1927 (see Chapter 5), he discovered three pictures by Gainsborough that were new to him: a long-lost landscape (*Languard Fort*, no. 23) painted while Gainsborough was still in Suffolk, the property of Colonel A.M. Grenfell, and two portraits (nos 24 and 34) of a lady and a gentleman, the property of the Hon. T. St V.B. Saumarez of Broke House, Nacton, near Ipswich, which were to be exhibited publicly for the first time.[251]

An exhibition of paintings by Alfred Sisley opened on 23 November at the Independent Gallery. There were twenty pictures. Two were lent by Lord Berners, one by the Hon. Mrs Oliver Brett and one by Samuel Courtauld (*Effet de neige à Louveciennes*).[252] De Hauke was sent an invitation to the private view held on Tuesday, 22 November 1927. The exhibition closed on 22 December.[253]

On 14 January 1928, de Hauke, who was in Paris, confirmed that he had bought, with Percy's agreement, the Degas for £2,000 and asked Percy to make arrangements to ship it to New York, where they intended to sell it for $20,000. Percy and de Hauke had also agreed to offer a third share on the Degas to Francis Zatzanstein of Gallery Matthiesen in Berlin. Percy and de Hauke had decided between them to acquire Matisse's *Symphonie en Rose* for 63,000 francs. Percy would try to sell it for £4,000 in Europe, and if it had not sold by May, the intention was to ship it to America.[254]

Two days later Percy confirmed to the art dealer Germain Seligman that he and de Hauke had jointly bought Degas's pastel *Deux Danseuses,* now *Two Dancers Entering the Stage* (around 1877–8) (see page 76), for £2,000. Percy would try to sell it in London. A day later Percy telegrammed de Hauke asking him to withhold the third share of the Degas pastel until he had received his letter in which he had pointed out that Gallery Matthiesen were apt 'to give very long credit' which, in the case of the pastel, would be unacceptable to Percy.[255] Meanwhile, Percy was asked to make arrangements for four Segonzac watercolours, a Matisse drawing and an Ingres to be packed and shipped to New York.[256] The Degas was shipped separately to New York on 24 January.[257]

De Hauke, Seligman and Percy met at the Independent Gallery in the first week of January and de Hauke asked for written confirmation of what they had discussed: what purchases was Percy contemplating and if Percy had definitely decided on a Segonzac exhibition in New York.[258] They were also hoping that Percy would be able to entice three or four English collectors with good Bonnards for their Bonnard show in New York, which they wanted to open on 15 March 1928.[259] This presented Percy with difficulties, as the Bonnard exhibition at the Independent Gallery would not open until 9 February and closed on 22 February, so the earliest he could get the pictures to New York was 29 February.[260] Percy, however, had secured loans from Lord Churchill, Lord Bentinck and Courtauld.[261]

In February 1928, de Hauke met a man on board the SS Paris who claimed that the Degas *Danseuses* was a *monotype-rehaussé* (enhanced monotype).[262] Percy confirmed, when he was in Berlin, that the Degas

Edgar Degas, *Two Dancers Entering the Stage*, pastel over monotype in black ink,
38.1 x 35 cm, *c.* 1877–8

was a *monotype-rehaussé* but that it was equal in value to a pure pastel.[263] By the end of February, Percy had found out that the art dealer Paul Durand-Ruel knew the Degas and that it had been reproduced in Paul Lafond's book *Degas* (Paris, 1918). Percy felt strongly that they should get £4,500 for it. At the same time Percy confirmed that he was willing to take a half share on a fine Matisse that he had seen (in his letter he identified it as having a 'woman playing a violin in the foreground, an open window giving a view to sea and promenade').[264]

At the beginning of March 1928, Percy told de Hauke that a Segonzac exhibition was out of the question for now, but that next time he was in Paris, he would mention an exhibition in New York to Segonzac. Percy was also sorry that Galerie Bernheim-Jeune had not sent the Bonnards it had promised to New York. Next time de Hauke was in London, Percy had several important points to discuss with him. Meanwhile, Percy had bought Cézanne's *Venus and Cupid* (around 1873–5), a painting that had been in the Degas Collection in Paris, from Hugo Perls, which de Hauke could have for £4,000.[265]

On 16 March 1928 Percy's mother died in Norwich.[266] His unmarried sister had lived with their mother at 42 Mill Hill Road, Percy's old family home. Percy set up two trust funds for his sister, Maud, to enable her to remain in the family home.[267] Later, on 28 March, Percy signed an agreement with the renowned auctioneer Alphonse Bellier to sell seventy-eight items (watercolours, drawings, including red chalk, and bronzes). There were six Bonnards, one Boudin, one Cézanne, two Henri-Edmond Crosses, three Derains, two Dufresnes, thirteen Frieszs, one Lotiron, three Matisses, one Pissarro, three Renoirs, one Rouault, one Seurat, twenty-three Signacs, one Maurice Utrillo, four Henri Vergé-Sarratts, nine Vuillards and two Maillol bronzes. The sale was held in Room No. 6 at the auction house Hôtel Drouot on Thursday, 2 April 1928 at 3 pm and the catalogue stated that the collection belonged to 'M. T. ...' of London. The sale raised 636,865 francs.[268] What is not clear is why Percy decided to sell this collection. He, undoubtedly, needed money to support his sister and he had had to spend £1,100 out of his own pocket on the Gainsborough 'Bicentenary Memorial Exhibition' in Ipswich in 1927 (see Chapter 5).

At the end of March 1928, de Hauke sent Percy a catalogue of the Bonnard exhibition that was to be held from 6 to 28 April. De Hauke informed Percy that he would be unable to obtain the prices that Lord Churchill had wanted for his Bonnards, as Bonnard was virtually unknown. However, de Hauke had put on an exhibition of watercolours just before

the Bonnard exhibitions, and the Segonzac drawings and watercolours had attracted a great deal of attention.[269]

As the season was coming to an end in New York and de Hauke was sailing to Europe on 21 April 1928, de Hauke arranged for the unsold Degas pastel to be shipped back to Percy on 18 April. Percy, in turn, asked for all the unsold pictures that belonged to him and his clients to be returned.[270] Percy met with Seligman and de Hauke in London in May 1928 to discuss various important matters, which were probably too confidential to be mentioned in their correspondence.[271]

During May 1928 Percy continued to do business with de Hauke. He kept the Segonzac drawings and a Matisse watercolour in New York, as they had clients interested in them, and had Matisse's *Symphony in Pink* sent back to Percy from New York. The Paris office of de Hauke advised Percy to rub out the stamp of de Hauke & Co. on the back of the Degas pastel if he showed it to the gentleman of whom he had spoken (presumably Martin Birnbaum, a partner in Scott and Fowles, another New York art company, to whom Percy later sold it).[272] In addition, Percy held an exhibition of early English watercolours and drawings at the Independent Gallery. There were fifty exhibits.[273] The *Daily Telegraph* also published an article and a photograph of Percy's *Madonna del Baldacchino* by Giovanni Bellini. The picture was hailed as a new discovery.[274]

An exhibition of paintings and pastels by nineteenth- and twentieth-century French masters was held at the Independent Gallery in June 1928. There were thirty-two pictures and the artists included Bonnard, Cézanne, Corot, Daumier, Degas, Gaugin, Ingres, Marchand, Matisse, Monet, Pissarro, Renoir, Segonzac, Seurat and Sisley. A number of the exhibits were lent by Lord Berners, Lord Ivor Spencer-Churchill, Sir Michael Sadler and Victor Reinaecker.[275]

The Matisse oil painting, *Symphony in Pink*, arrived back with Percy in June.[276] Percy managed to sell this picture in November 1928,[277] receiving £337.10s as his half share of the picture.[278] Percy sold their Van Gogh drawings[279] and in July Percy sold the Degas *Deux Danseuses* pastel for £2,500, giving only a negligible profit.[280]

On 23 July 1928, Percy sent his son a postcard from Switzerland showing a dog sleigh on the Jungfrau. In jest, he wrote, 'Poor little Brownie on the Jungfrau. Dad'.[281] Dogs regularly featured in photographs of Oxnead.[282]

In October 1928 Percy put on an exhibition of thirty paintings by Renoir at the Independent Gallery.[283] In December 1928 de Hauke bought Seurat's *Study for La Grande Jatte* from Percy for £900, and de

Hauke and Percy also jointly purchased a Seurat panel.[284]

Seligman and de Hauke were not the only art dealers with whom Percy took half shares in picture purchases. During 1928 the names of Bernheim-Jeune, Ehrich, Gooden and Fox, Palser and W.B. Paterson appear in the stockbook covering this period.[285] Percy would become a director of Gooden and Fox, now Hazlitt, Gooden and Fox, of 38 Bury Street, London. It has not been possible to identify when he took up the directorship but he certainly was a director by 1936.[286]

At the beginning of January 1929 Percy agreed to loan his painting, *Overhanging Trees* by Seurat, to de Hauke's exhibition in New York.[287] In February this exhibition was postponed until November, as there was an influenza epidemic,[288] but Percy was encouraged to send the picture as the chances of selling it there were good.[289] The picture had been handed over to the packers in January.[290]

At the beginning of 1929, Percy bought Russell Colman's attention to two pictures. In January he sent the particulars of a painting belonging to George Lindsay Holford, *Mountain Scene* by John Crome, which was included in the catalogue of the Holford sale at Christie's.[291] In April he learnt from Leney, Curator of the Castle Museum, Norwich, that Colman was asking for the pedigree and price of an oil painting by the Rev. Edward Thomas Daniell (a view of Tasburgh, Norfolk) which had been bought from the Gwyn family whose forebears were great friends of Daniell.[292]

An exhibition of thirty-seven watercolours and drawings by Frélaut, Friez, Marchand, Maze, Moreau, Segonzac, Dufresne and Signac was held at the Independent Gallery from 23 January to 9 February 1929.[293] At about this time, the name of Percy's sister-in-law's husband, Edward Lewis, began to appear in the gallery's correspondence as one of Percy's assistants.[294] In March 1929 Percy held an exhibition of recent paintings and drawings by Odette des Garets.[295]

At the beginning of April 1929, arrangements were made to ship the three Segonzacs and the Matisse watercolour back to Percy from New York. De Hauke's assistant thanked Percy for letting them have the pictures for so long and for not having better luck.[296]

De Hauke contacted Percy at the end of April, asking to meet up in London.[297] De Hauke and Seligman met Percy at the beginning of May, when they showed interest in a Sisley, a small Bonnard and some Maurice de Vlaminck pictures. Percy also told them about Gauguin's *L'Espirit veille* (*Manao Tupapau: l'esprit des morts veille*, 1892).[298] Percy then arranged for de Hauke to see the Gauguin at the gallery later in May

on de Hauke's return to London.[299] De Hauke bought the Gauguin for £6,000 in June and had it shipped to New York.[300] Percy seems to have been an intermediary in this sale, as he had to cable de Hauke on 25 June 'Owner Gauguin pressing me for payment please cable.'[301]

From 29 April 1929 to 5 October 1936, Percy was in correspondence with Mrs Colman with regard to the restoration of pictures in the Colman collection at the Colman's home, Crown Point, and the compilation of a catalogue of the collection. Judging from the letters, this work was carried out for insurance purposes and for the publication of a catalogue of the Colman collection in 1942.[302]

The Independent Gallery held an exhibition of paintings and pastels by modern French masters from 10 May to 1 June 1929. There were twenty-one pictures: two by Bonnard, two by Corot, one Thomas Couture, four Degases, three Gauguins, one Matisse, two Monets, two Pissarros, one Segonzac and one Vlaminck.[303] On 27 May 1929 Percy signed an agreement with Alphonse Bellier to sell sixty-one pictures (pastels, watercolours and drawings) and one bronze in Room No. 6 at Hôtel Drouot on Wednesday, 29 May 1929. There was one Dufresne, two Sonia Lewitskas, two Maillols, four Matisses, two Moreaus, one Signac, two Derains, four Frieszs, one Lebasque, two Lotirons, two Marquets, eleven Renoirs, one Rouault, one Seurat, two Sisleys, two Louis Valdo-Barbeys, one Vuillard and one bronze by Dalou. The sale made 1,524,500 francs for Percy.[304]

An exhibition of eighteen pictures by Maurice de Vlaminck was held at the Independent Gallery from 7 to 29 June; the Hon. Clare Stuart Wortley loaned one of the pictures.[305] At the same time, Percy was trying to sell Degas's *Lydia with Opera Glasses* (1875–6) for £1,500. Although de Hauke showed interest, he was not prepared to purchase it at that price.[306]

On 18 October 1929 Percy sailed to America on the RMS *Majestic*, returning home on 15 November.[307] During his trip, Percy visited de Hauke who had recently bought Bonnard's *Les Fraises* (1910) from Percy for 34,500 francs.[308] He also visited Dr Barnes and his wife on two Sundays. On one of these Sundays, Percy was accompanied by Samuel Courtauld who told Percy that it was one of the most enjoyable days of his trip.[309]

During Percy's absence, an exhibition of forty-four lithographs by Honoré Daumier was held at the Independent Gallery from 6 November to 14 December 1929.[310]

On Percy's return to London, he sent Dr Barnes photographs of a Spanish primitive, as promised for Barnes's opinion, and an extraordinary Hendrick Terbruggen, out of interest.[311]

Between 29 November and 10 December 1929, Percy and de Hauke completed negotiations for the sale of Toulouse-Lautrec's *Jeanne Avril sortant du Moulin Rouge et mettant ses gants* to Samuel Courtauld for £10,000. With the US stock market crash at the end of October, Percy was forced to accept a commission of only £600 for his client's sake.[312]

Henri de Toulouse-Lautrec, *Jane Avril in the entrance to the Moulin Rouge, putting on her gloves*, oil and pastel on millboard, 102 x 55 cm, *c.* 1892

In January 1930 de Hauke let Percy know that he and Seligman would be in London on Monday 20 January and that they would bring the Toulouse-Lautrec and particulars with them. They were both anxious to take advantage of Courtauld's offer to show them his collection.[313] Percy arranged the visit for the morning of 20 January, but insisted that the pedigree of the Toulouse-Lautrec was sent by return of post. The day following de Hauke's and Seligman's visit, Courbet's drawing, *L'homme à la pipe*, was dispatched to de Hauke in New York.[314]

However, the Toulouse-Lautrec does not appear to have arrived with de Hauke and Seligman, as Percy had to cable and write to de Hauke on 23 January 1930 to explain that Courtauld urgently needed the picture as the blank space on the wall, where the Toulouse-Lautrec was to go, would look terrible for the people coming to his house the next week. Courtauld was extremely annoyed with the delay.[315] The picture was delivered from Paris to Courtauld on 28 January,[316] but the payment for the picture was delayed by Mrs Courtauld being taken into a nursing home.[317] Payment for the picture was finally made in March 1930.[318]

Percy put on an exhibition of forty-two pictures by Esther M. Nelson at his gallery from 6 February to 28 February.[319] On 21 February, Percy wrote to Dr Barnes giving him details of Corot's *Fillette a l'étude, en train d'écrire* (around 1850–60), which had just come on the market at an asking price of £5,000. He also told Dr Barnes that he had seen Samuel Courtauld the other day and Courtauld had again told Percy how much he had enjoyed his visit to the Barnes's house that Sunday and wished to show him his collection when next over in England.[320]

Percy continued to hold exhibitions at the Independent Gallery over the next five months. An exhibition of nineteenth-century French masterpieces included one Cézanne, five Corots, one Courbet, two Degas, one Jongkind, one Manet, one Renoir and three Sisleys from 7 to 27 March 1930.[321] Ten drawings each by Walter Sickert and André Dunoyer de Segonzac were exhibited from 4 to 17 April,[322] and an exhibition of eighteenth- and nineteenth-century English paintings in May.[323] This was followed in June by a loan exhibition of twenty-three nineteenth- and twentieth-century French paintings, which included pictures by Bonnard, Cézanne, Corot, Courbet, Degas, Gauguin, Matisse, Renoir, Dunoyer de Segonzac, Seurat, Sisley, van Gogh and Vuillard. The exhibits were lent by William Boyd, Sir Michael Sadler, J. Maynard Keynes, Roger Fry, Lord Esher, Lord Ivor Spencer-Churchill, Paul Maze, F. Hindley Smith, William McInnes, Sir William Jowitt, the Earl of Sandwich, Percy Moore Turner, Lord Berners,

Samuel Courtauld, Sir Sykes and Mrs W. Jansen.[324] In July, forty-one paintings by Paul Maze were exhibited. Five of the paintings were lent by Lord Ivor Spencer-Churchill and one by Lord de la Warr.[325]

On 20 June 1930, Percy wrote to de Hauke as he was surprised to hear that the Courbet was at the New York branch of art dealer Dudley Tooth's gallery. Percy had hoped that the drawing would have been shown to Paul Sachs at the Fogg and the Boston Museum. Percy presumed that Tooth would pay him £650.[326]

In September 1930 Percy visited Greece and Turkey, returning via Venice. His postcards sent to his wife and son imply that he was not travelling alone.[327]

Percy wrote from Glasgow to Russell Colman in October 1930 to apologise for not being able to stay and discuss the Nutman pictures with him and Mrs Colman. The Nutman was the last important collection of the Norwich School pictures to come onto the market. The number of Wilsonian period John Cromes was unique for their quality. It is not clear from the letter how Percy had come to be involved with this collection but the letter mentions that, when arranging probate, experts at the National Gallery fully realised the significance of the pictures and had exempted from duty an unusual number including *The Temple of Venus, Baiae, Italy* and *Moonrise from the Gravel Pits* (now attributed to J. Crome at Norwich Castle Museum).

Percy had had some of the pictures cleaned and some were failures. *The Castle in Ruins* by Crome came out particularly well. This picture had been bought by the city, thanks to the assistance of the National Arts Collection Fund. Percy had eight pictures that he wanted Russell Colman to consider.[328]

John Runiff Nutman was born in Great Yarmouth and was a founder of Tower Curing Works.[329] He had lent four pictures to the 'Crome Centenary Exhibition' held at the Castle Museum, Norwich, in April 1921.[330] In one of Percy's stockbooks, there are twenty pictures listed as coming from Nutman in June 1930. Percy sold eight of these pictures (John Crome's *Temple of Venus, Mousehold Gravel Pits, Sprouston Mill* and *The Old Lazar House*, Robert Ladbrooke's *Yarmouth Harbour,* two Cotman figure subjects and Joseph Stannard's *Thorpe*) to Russell Colman for £2,500 in November 1930.[331] Sir Henry Holmes, who, according to Percy, would toss up with Colman as to who would have the privilege of buying pictures to ensure they should come to Norfolk,[332] bought five pictures (John Thirtle's watercolour *The Pool,* J. Crome's *Land with Knowle, Bishops Bridge, Norwich,* John Berny Crome's *View of Rotterdam,*

Samuel Palmer, *Landscape with Repose of the Holy Family*, oil on panel, 31 x 39 cm, *c.* 1824–5

Robert Ladbrooke's *Road through the Forest* and George Vincent's *The Travelling Pedlar*) for £1,600 in July 1930.[333]

There is evidence that five exhibitions were held at the Independent Gallery in 1931. There was an exhibition of lithographs by Toulouse-Lautrec between 26 January and 21 February.[334] In March there was an exhibition of paintings by John Maclauchlan Milne.[335] Thirty-seven oil paintings by H. de Buys Roessingh were exhibited from 15 April to 2 May. Some of the exhibits were lent by Prince V. Galitzine, T.M. McKenna and M. Adda.[336] From 28 May to 13 June there was an exhibition of twenty-one contemporary French paintings, including works by Pierre Bonnard, Jean-Louis Boussingault, Robert Lotiron, Jean Marchand, André Mare,

Luc-Albert Moreau, Charles Dequin, André Villeboeuf and Jean Édouard Vuillard.[337] In December, fifty-three eighteenth- and nineteenth-century English watercolours were exhibited.[338]

In February 1931 Percy wrote to Barnes, as he had given a letter of introduction to William George Constable of the National Gallery who was coming to America and wished to study the Barnes collection. Constable, a personal friend of Samuel Courtauld, had recently been appointed to the new Courtauld Chair of Art at London University. The object of the chair was to do all possible to remedy the deplorable teaching of art and to progress young and capable men along the right lines.[339]

In November 1931 Percy discovered a picture by Guérin, *Portrait of a Woman*, in his stock belonging to Barnes, which, on Barnes's instructions, Percy sent to M. Pierre Loeb of Galerie Pierre, 2 rue des Beaux-Arts, Paris, so that the picture could be sold.[340]

At the beginning of February 1932, Percy wrote to Kenneth Clark, the recently appointed keeper at the Ashmolean Museum, who had inherited the problem of the bequest of a drawing, *Sands End, Whitby*, from Frank Anderson. The drawing was thought not to be by the English etcher and painter Thomas Girtin after all. Percy had discussed the matter with the executors of Frank Anderson's will and Mr E. Bilcliffe of Messrs J. Palser and Sons, from whom the drawing had been bought, and Mr A.E. Anderson, Frank's brother, suggested substituting *Ouse Bridge, York* for *Sands End*. Percy's interest in the matter had been to simply help the executors, the Ashmolean and the reputation of his friend, the late Harry Tompkins of Palser and Sons.[341] From Percy's letter to Kenneth Clark at the beginning of March 1932, the Girtin situation had been settled satisfactorily and Percy's oil painting *Landscape with Repose of the Holy Family* by Samuel Palmer had been presented to the Ashmolean by the National Art Collection Fund.[342]

An exhibition of modern British painting was held at the Independent Gallery in February and March 1932. There were twenty-five pictures: two by Vanessa Bell, two by Allan Douglas Davidson, two by Fry, three by Gertler, two by Grant, two by James Bolivar Manson, two by Esther Nelson, three by Porter, one by Roberts, three by Sickert and three by Edward Wolfe.[343]

Percy's article, 'The Art of Devon', was published in *The Sphere* on 10 July 1932 to coincide with the opening of the 'Loan Collection of Works by Early Devon Painters Born before the Year 1800' at the Royal Albert Memorial Museum, Exeter (see Chapter 5). In the article, Percy discussed

the place of Devon artists as upholders of the tradition of British art in the context of the pictures included in the exhibition.[344]

In December 1932 Percy purchased Renoir's *L'Assommoir* (1878) for himself at Jules Strauss's auction; Germain Seligman congratulated Percy on the purchase.[345] At the end of December 1932, Percy admitted to Jean Frélaut that he had been forced to change the way he lived his life. During the good years, he had employed five people at the gallery, but now there was only one. Percy continued to lose money despite letting out half of the gallery. There was no business, the people who owed him money did not pay him and he had lost considerable sums in bad debts.[346]

Percy wrote to Germain Seligman in January 1933 about Seurat's *Study for La Baignade*, which they had bought jointly for £550 but now had little hope of selling for that price.[347] Percy sent the picture over to New York in February 1934.[348] In May 1934 C.M. de Hauke wrote to Percy saying that there had been no success with the Seurat and could Percy do something with it in London?[349] In December 1935 Percy's offer of £200 for Seligman's share of the Seurat was accepted.[350]

At the beginning of March 1933, Percy visited Jean Frélaut and his family in Vannes with his friend, Paul Ebstein. Percy then returned to Paris, staying at Hotel Angleterre. Here he found two small sketches that Frélaut had slipped into Percy's bag before he left Vannes.[351] Percy was seriously preoccupied with the question of Frélaut's exhibition in London, so while he was in Paris, he went to see Le Garrec of the gallery La Maison-Sagot-Le Garrec who gave an undertaking that he would do everything possible to make the exhibition a success.

Percy flew from Paris to London, where he went to see his friends at the Leicester Galleries as they were best placed to put on such an exhibition. The Leicester Galleries proposed a date in the first five months of 1934. The exhibition would have loan pictures from collectors, a picture from Leeds Museum, etchings, drawings and pictures from Le Garrec, pictures and drawings from Percy and drawings and etchings belonging to Jean Frélaut.[352]

On 14 March 1933, Percy was presented with the decoration of the Officer of the Legion of Honour by M. de Fleuriau, the French Ambassador in London, in recognition of his services to art and for fostering the appreciation of modern French art in England.[353] In a letter to Jean Frélaut, Percy wrote that France had accorded him a great honour and he could not tell him how flattered he was.[354] A friend, Marion Scarles, wrote to congratulate Percy and remarked, 'How delighted your mother would have been. I think that she was one of the sweetest women I knew.'[355]

At the end of May 1933, Percy attended a meeting of the Society of London Art Dealers with Dudley Tooth to report on their meeting with the Import Duties Advisory Committee and a representative of H.M. Customs. Percy was asked to become a member of the executive committee of the society.[356] The Society of London Art Dealers first met on 14 April 1932 at the Studio Offices, 44 Leicester Square, London.[357] The principle object of the society was to bring together a number of London firms engaged in the sale of paintings, drawings, prints and sculptures for the purpose of protecting the interests and of promoting discourse on joint action on all questions relating to their mutual interests.[358]

At the beginning of July 1933, Percy had a discussion with Ernest Brown, Cecil and Wilfred Phillips of the Leicester Galleries about Jean Frélaut's exhibition, which they wanted to mount in October with fifty exhibits.[359] The exhibition took place in October 1933 with the private view being held on 7 October.[360] In the end there were seventy-seven exhibits: forty-two etchings, thirteen drawings and twenty-two paintings, which included *La Chapelle*, lent by Lord Ivor Spencer-Churchill, *Mere et enfant*, lent by Sir Michael Sadler, and *Vannes* and *Repas de Noce de Bretagne* (1908), both lent by Percy.[361]

On 9 February 1934, Kenneth Clark, who was now Director of the National Gallery, met with Percy to discuss his intentions with regard to the Cotman's *Silver Birches*. Clark was anxious that the codicil in Percy's will still held good for this picture. Percy gave a long rambling account of various injuries he had received at the hands of the Royal Academy and other official bodies and then concluded by saying that he had made a new will omitting the codicil. No mention was made of a grievance against the National Gallery but Clark could not persuade Percy to reinsert the codicil. Percy admitted that his mind was entirely confused on the subject and he wanted time to think about it.[362] He sold the picture to Russell Colman in April 1935.[363]

Following their meeting, Clark made a note that Percy must be treated by the Officers of the Gallery as a private collector and expert on English art and not as an art dealer.[364] On 7 May 1934 Samuel Courtauld gave the Tate Gallery *Collection de tableau faite à Londres, 20 Portman Square par Samuel and Elizabeth Courtauld 1914–1931*, a limited edition from a very small run privately printed by Samuel Courtauld.[365] Paul Jamot and Percy Moore Turner wrote the text proving Percy's standing in the art world.

During 1934 Percy went to Paris rarely, finding the city enormously changed and not the Paris he had known. Percy's son was now

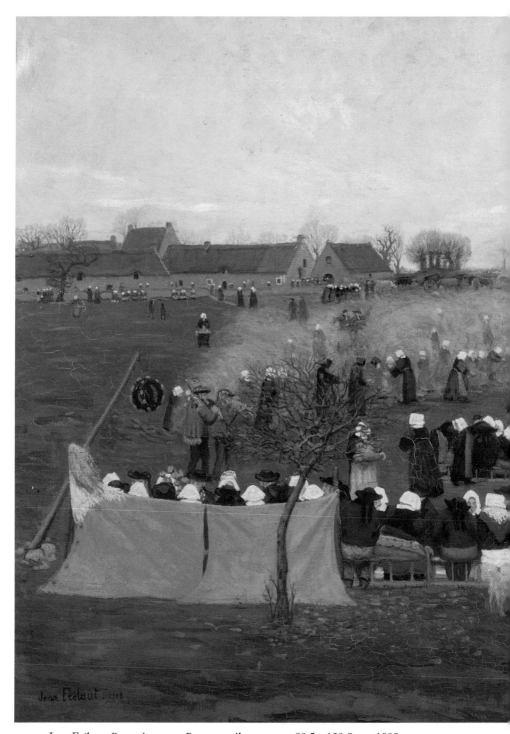

Jean Frélaut, *Repas de noce en Bretagne,* oil on canvas, 89.5 x 130.8 cm, 1908

twenty-two years old and was studying at Guy's Hospital in London. He had not decided whether he would be a dentist or a surgeon. Percy was content that his son was not following his profession. His son had almost completed two of the seven-year course. The course was very expensive for Percy but as it was what his son wanted to do and he only had one child, he managed.[366]

In April 1935 Percy wrote to Paul Vitry, Head of the Sculpture Department at the Louvre, enclosing a photograph of a statue that Percy describes as a companion sculpture for a French marble statue of a monk exhibited in the Louvre.[367] Percy would present this statue to the Musée des Beaux-Arts in Dijon on 10 December 1945 (see Chapter 7).

From May 1935 the handwriting of Winifred Beatrice Campbell-Orde appeared in the stockbooks.[368] She was the daughter of Sir Arthur John Campbell-Orde, fourth Baronet.[369] Percy employed her as his secretary and, with the exception of War service, she worked for him until his death.[370]

In June 1935 the Castle Museum, Norwich, received forty pictures by Old Crome, given by Percy through the National Art Collection Fund. Percy had written to Russell Colman, in his capacity as chairman of the subcommittee that governed the picture gallery, to offer these preliminary works by Crome. They were small and extraordinarily painstaking in detail, from which critics considered the larger works had evolved in one or two stages. The pictures had been collected by Percy and his father and included eight watercolours, twenty-three pencil drawings, four drawings in Indian ink and five in sepia. Six of the pictures had been shown at the Crome centenary exhibition in 1921.[371]

In October 1935 the seventh Duke of Buccleuch died and his son wrote to Kenneth Clark at the National Gallery for advice. 'Mr Percy Turner has been recommended to me by many friends as a reliable man able to help me with advice about pictures and also good at carrying out valuation for probate. I have met him once or twice and like him very much, but before committing myself concerning him or recommending him to my advisors, I feel that it is essential to make some enquiry first and endeavour to secure first some confirmation as to his merits, and can apply to no higher authority than you at the National Gallery. Perhaps you would rather say nothing.'[372] In his unpublished autobiography, Percy states that he was instrumental in the National Gallery acquiring Buccleuch's landscape by Rubens.[373] This picture is known as *The Watering Place* (1615–22),[374] and was bought from the Duke of Buccleuch's collection by the National Art Collection Fund in 1936.[375]

Peter Paul Rubens, *The Watering Place*, oil on oak, 99.4 x 135 cm, *c.* 1615–22

On 7 December 1935 Percy bought at auction the Old Hall Farm, East Tuddenham, Norfolk; Church Cottage and gardens; the Cottage adjoining Honingham School with gardens and approximately 235 acres of land for approximately £3,600. Hugh W. Allen had tenanted the Old Hall Farm prior to Percy buying it and continued as a tenant throughout Percy's ownership. In 1937 Percy's friend, Robert Worthington, painted two views of the Old Hall Farm and gave them to Percy as a Christmas present. Percy sold the whole estate to his son in 1949.[376]

At the beginning of January 1936, Percy was put on the subcommittee of the Society of London Art Dealers which had been set up to consider how the committee of the society organised itself and formulated its policy and plan.[377]

Old Hall Farm, East Tuddenham, Norfolk

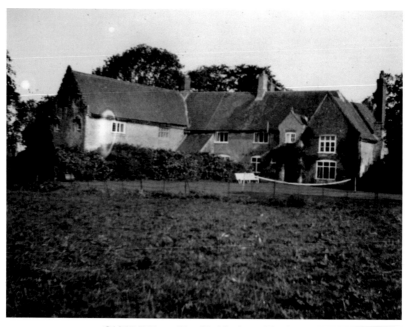

Old Hall Farm, East Tuddenham, Norfolk

In February 1936, the Trustees of the National Gallery purchased Constable's sketch for *Hadleigh Castle* from Percy out of the Sir Claude Phillips Fund and the Grant-in-Aid 1935. Percy had bought the picture from Messrs Legatt Brothers in 1930.[378] The acquisition was reported in the *Morning Post*, which stated that the picture was considered to be Constable's greatest painting.[379] The *Illustrated London News* reported that 'hitherto, the National Gallery has had no important example of Constable's painting in the manner which was most suited to his genius and was his most original contribution to the history of painting'.[380] 'At last, the National Gallery has got a real Constable' was printed in the *Sunday Times*.[381]

In April 1936 Percy wrote to Jean Frélaut to tell him that he had made a gift of *Repas de noce en Bretagne* to the Tate Gallery in London and the Trustees had accepted it with joy.[382] The picture was hung at the side with all the French School.[383] In 1936, Percy became a co-opted member of the subcommittee for Science, Literature, Archaeology and Art at the Castle Museum, Norwich.[384]

John Constable, *Hadleigh Castle*, oil on canvas, 122.6 x 167.3 cm *c.* 1828–9

On 31 March 1937 Percy bought *St Joseph, the Carpenter* (around 1642) by Georges de La Tour from Jenny Louisa Roberta Blaker, together with two nude studies by Constable. The painting was originally listed as by Gerard van Honhorst,[385] and Percy was the sixth or seventh art dealer that had been asked to see Miss Jenny Blaker.[386] Percy returned in December to see Jenny Blaker and bought a seascape.[387]

Jenny Blaker was the sister of Hugh Blaker who had died in 1936. Hugh Blaker is best known as the adviser to the Davies sisters, Gwendoline and Margaret of Llandinam, in the formation of their internationally renowned collection of French nineteenth-century painting and sculpture, which the sisters bequeathed to the National Museum of Wales, Cardiff.[388]

St Joseph, the Carpenter was sent to Paris for about a year. Paul Jamot's niece, Thérèse Bertin-Mourot, reported that she had seen the picture in her uncle's flat,[389] and, then separately, that the picture had been lent to her uncle for more than a year so that he could study it.[390] In January 1938 Percy had heard that Paul Jamot intended publishing the picture, if possible, in the *Gazette des Beaux-Arts*,[391] which duly happened in the gazette's May–June 1939 edition.[392] In July 1938 Curator René Huyghe informed Percy that David David-Weill, a French-American banker and President of the Council at the Louvre, was not going to purchase the La Tour.[393] In December 1938 Percy offered the picture to the National Gallery for £15,000 but it was not bought 'in view of the absence of funds'.[394] Percy would present this picture to the Louvre in June 1948 (see Chapter 7).

In September 1937 Percy let Russell Colman know that he wished to give Ranza Castle by Cotman to him for the Colman collection at Crown Point. Russell Colman and Percy's friendship went beyond art: for example, Russell Colman recommended a tool for getting rid of thistles which Percy had tried out for an energetic hour or two at the Old Hall Farm. Although it worked admirably, there were literally thousands of the tiresome weeds.[395]

On 7 December 1938 Percy gave a lecture at the Castle Museum, Norwich on 'East Anglia and European Culture' at the invitation of the Norfolk and Norwich Art Circle and the Friends of Norwich Museum with the Lord Lieutenant (Russell Colman) presiding.[396] This was not the first time Percy had lectured at the Castle Museum as he had given a lecture entitled 'The Development of Responsiveness to Art' in 1924,[397] and another lecture, 'The Evolution of Art From XVIIth Century to the Present Day' in 1925.[398]

In January 1939, while Percy was in Paris, he saw Paul Vitry who showed interest in Percy's Burgundian sculpture which was probably a companion

Georges de La Tour, *St Joseph, the Carpenter*, oil on canvas, 130 × 100 cm, *c.* 1642

sculpture for one in the Arconati Visconti room in the Louvre. Vitry asked Percy to send his statuette over for comparison. Percy would have been delighted to do so but he was concerned about the worsening political situation, so suggested that they waited until a more favourable moment.[399]

André Dunoyer de Segonzac spent three weeks in England visiting London and Norwich in April 1939. Percy seems to have arranged this visit during which Segonzac stayed at Oxnead for two nights. The beautiful things that Segonzac saw in the house reminded him of Percy and Segonzac's happy years. Segonzac also met Percy's son, who Segonzac found still had the eyes of the child that he had drawn in the rue d'Anjou many years ago. After this visit Percy did not meet Segonzac again until after World War II.[400]

André Dunoyer de Segonzac

On 21 June 1939, Percy was elected as the Vice Chairman of the Society of London Art Dealers.[401] With World War II approaching, Percy gave up his premises at 7a Grafton Street because his works of art were too vulnerable being situated so close to the Air Ministry. For safekeeping, he moved his artworks and business papers out of London and stored them at Elton Hall and Hinchingbrooke House in Cambridgeshire, in the neighbourhoods of Norwich and Exeter, and at his own house in Gerrards Cross.[402] Percy and his secretary, Winifred Campbell-Orde, moved to 38 Bury Street in St James's, London (the premises of Gooden and Fox).[403] From this address and Oxnead, Percy would try to run what remained of his business.[404]

Segonzac's sketch of Percy's son

Letters to Percy from André Dunoyer de Segonzac

5 OTHER EXHIBITIONS AND THE OXFORD ARTS CLUB

Percy did not limit his public activities just to the Independent Gallery and promoting modern art. He increasingly became involved in major national exhibitions and in the Oxford Arts Club. The exhibitions, undoubtedly, provided Percy with a platform to bring the art that he passionately admired to the attention of the wider public. The Oxford Arts Club, certainly, gave him the opportunity to exhibit and sell works of modern art.

In early 1920, at the instigation of Percy's friend, Robert Bagge Scott, Percy suggested to Frank Leney, Curator of the Castle Museum, Norwich, that, as the succeeding year was the centenary of the death of John Crome, it would be an opportune moment to bring together an important collection of his paintings and drawings at the museum to celebrate the occasion. Leney was very enthusiastic about the idea and had no difficulty in persuading his committee.

A subcommittee to arrange this event at the Norwich Castle Museum was appointed on 10 March 1920, members being drawn from the National Gallery (Sir Charles Holmes and Colin Baker) and others from London and Norwich. The commemoration of Crome's death in his native city was seen as unique in the history of art and, as a consequence, the Trustees of the National Gallery agreed to lend two of Crome's masterpieces (no. 1, *The Windmill near Norwich*, around 1816, and, no. 2, *Slate Quarries*) to the City of Norwich.

Percy was only consulted once in relation to *The Willow Tree*, which had formerly been owned by Sancroft Holmes of Brooke Hall, near Norwich, but had been sold to Mr Billings of Chicago, who kept it at his residence in California. Percy had kept track of the picture after it left Norfolk several years earlier and was aware of its whereabouts (see Chapter 4). The Lord Mayor asked Billings to lend the picture but the request was declined as Billings could not bear to part with it.

'The Crome Centenary Exhibition' was opened on 6 April 1921 by His Royal Highness the Prince of Wales, KG. Percy was invited to the opening and appears in the photographs taken at the dinner given at the opening of the exhibition. Forty-two of the 123 exhibits were lent by Russell Colman. Percy lent seven pictures anonymously (*Hautbois*

Common, Roadside with Pollards, The Glade, The Shed, The Road, Lane Scene
and *The Old North Gate, Yarmouth*). It has not been possible to find out
why he did this.

Percy records that the exhibition was a great success despite being
devoid of any logical scheme to show Crome's origin, development and
influence, which Percy would have liked to have seen done. His personal
catalogue of the exhibition also highlighted other deficiencies. At least four
of the exhibits had not been included in the catalogue; he did not admire
a number of the exhibits; others were poor examples or in a poor state of
repair; and some were wrongly labelled – one he attributed to J.B. Crome.[1]

The Oxford Arts Club seems to have been set up in 1920 to hold
regular art exhibitions in Oxford, with the first exhibition being held
in February and March 1921 at Barnett House.[2] In 1923 Sir Michael
Sadler became Master of University College, Oxford,[3] and subsequently
became the President of the Club.[4] Many of the exhibitions held by the
club promoted modern art. From 1937 the club held its exhibitions at 38
Beaumont Street, in close proximity to the Ashmolean Museum.[5]

The minutes of the Oxford Arts Club of 28 April 1921 record that
Percy had written to the club offering to lend more paintings from the
Independent Gallery. At this meeting, the committee decided to postpone
acceptance of this offer owing to the excessive cost of transportation and
insurance, and a lack of room.[6]

On 1 February 1923 the committee agreed to provide its rooms
for an exhibition of modern pictures that Percy had previously lent to
Cambridge.[7] 'Paintings and Etchings by Contemporary Artists', the
club's nineteenth exhibition, was held in May 1923 and included works
by Picasso, Derain, Gertler, Matisse, Lamb, Grant and Fry. The exhibits
were lent by Lady Ottoline Morrell and the Independent Gallery.[8]

In 1925 the artist Robert Bagge Scott died and, to mark his death,
the Castle Museum Art Galleries in Norwich mounted an exhibition of
his oil paintings and drawings. Percy was a member of the exhibition
committee and one of the guarantors for the catalogue. There were
eighty-seven pictures exhibited of which two were lent by Percy (no. 80,
The Wharf, Papendrecht and, no. 81, *The Great Church, Dordrecht*). The
exhibition was opened on 16 June 1925 by the Lord Mayor of Norwich.[9]
Percy wrote an appreciation of Robert Bagge Scott's life and a review of
the exhibition, which were published in the *Eastern Daily Press* on 17 June
1925. Bagge Scott had been profoundly influential during Percy's early
years in the art world.[10]

The year 1925 also marked the centenary of the Castle Museum, Norwich. Percy was asked whether he could suggest a scheme for a really outstanding exhibition that would embrace the Norwich School of Painting in all its facets. After prolonged contemplation, Percy suggested an exhibition demonstrating the evolution of European painting from the seventeenth century to the present day, chronologically arranged in a sequence of panels, each panel being filled with first rate examples, with a catalogue of explanatory notes for each panel in order to demonstrate the evolution and development of painting across the centuries. The scheme would begin with Rubens and van Ruisdael and end with Matisse, Segonzac and other important contemporary painters. Percy, however, insisted that he alone would be responsible for the scheme, the choosing of the works, the writing of the catalogue and the educational notes. There was to be no interference of any sort.[11]

'The Centenary of The Norwich Museum Loan Collection of Pictures Illustrative of the Evolution of Painting from XVIIth Century to the Present Day' opened on 24 October 1925 and closed on 21 November 1925. Percy was sole curator and it was the first time that an exhibition had been hung in a series of panels with explanatory notes.[12] The preface to the catalogue was written by Robert Rattray Tatlock, Editor of the *Burlington Magazine*.[13]

The pictures were arranged in eleven panels and were lent by the National Gallery, the Universities of Oxford, Cambridge and Glasgow, the Louvre, Galerie Bernheim-Jeune and a number of individuals, including Samuel and Mrs Courtauld, Russell Colman, Sir Charles Holmes, Lord Bentinck, Victor Rienaecker, Sir Michael Sadler, the Earl of Sandwich, Frank Hindley Smith and Percy's sister-in-law's husband, E.A. Lewis. Percy and his wife lent eight pictures. A total of eighty-one pictures were exhibited.

Paul Jamot, Associate Director of Paintings at the Louvre, and Jean Guiffrey, Director of Paintings at the Louvre, were among the many guests invited to the opening and, at the Mayor's Banquet on 23 October in St Andrew's Hall, Paul Jamot proposed the toast 'The Norwich School of Painting' and Jean Guiffrey responded to the toast 'Our Visitors'.[14]

The Duke of York, subsequently King George VI, visited the exhibition on its first day when Russell Colman was in attendance. (The Duchess was unable to attend as she had a violent cold.) The Lord Mayor presented the directors of the national and provincial museums and foreign galleries, including the Director of the Louvre, to the assembled guests in the castle's keep. After the Lord Mayor had welcomed the Duke of York and had

briefly explained the history of the museum, the Director of the Victoria and Albert Museum and the Director of the Louvre made speeches to which the Duke of York gave a reply.[15] The day following the opening at the Castle Museum, Percy and others took the British and continental visitors around some of Norfolk's artistic sights: the villages of Ranworth and Cawston, Blickling Hall and Holkham Hall. In the evening, Nugent Monck staged Ibsen's *Hedda Gabler* at the Maddermarket Theatre. Nearly 90,000 people visited the exhibition, coming not only from Norwich and East Anglia but also from all over the British Isles and the continent.[16]

Although the Oxford Arts Club's proposals for exhibitions for 1926 included an exhibition of modern painting by the Independent Gallery, this exhibition did not materialise.[17] It was not until February 1927 that Percy mounted his next exhibition – this time at Suckling House, Norwich. Although it mainly comprised works of the Old Norwich School, it also included five Gainsboroughs and seven Constables. The exhibition was only open for two days (11–12 February). About 85 per cent of the exhibits (twenty-eight paintings and twenty-nine drawings) had come from the Independent Gallery and the rest had been supplied by private owners.[18]

Before the close of the exhibition to mark the centenary of the Castle Museum in 1925, Ipswich approached Norwich to see if Percy would undertake the Gainsborough bicentenary show (Gainsborough had been born in 1727). Percy would have two years to organise it. Percy interviewed the Ipswich authorities and said he would accept the task on the same terms as those for Norwich, that he alone would be responsible for the organisation of the whole exhibition. They accepted these conditions.

It took Percy two years of hard work and considerable research to organise it. He again employed the chronological panel scheme. His endeavour was to interest the general public in a summary of the evolution of pictorial European art up to the beginning of the nineteenth century. Each panel would be filled by masterpieces and the explanatory notes would describe not only the contents of each panel but also how each panel evolved from its predecessor and how it influenced the succeeding panel, thus making the whole exhibition educative historically and aesthetically.[19]

The Gainsborough 'Bicentenary Memorial Exhibition' at Ipswich Museum had a somewhat chequered career. Percy did not have the same local status in Ipswich as he had in Norwich. In spite of the agreement to give the whole show to Percy, certain influential local people wanted to have a hand in the undertaking. In the case of one alderman, who

insisted in Percy's absence in re-arranging certain panels, Percy told him plainly that if he persisted in his interference, he would desert the show immediately and go back to London and leave them to it. Percy went to the Town Hall to complain to the Mayor who stressed the local importance of the alderman. The Town Clerk had to resolve the situation by producing the Corporation agreement that gave Percy a completely free hand with no interference whatsoever.[20]

The 'Bicentenary Memorial Exhibition' of Thomas Gainsborough had 208 exhibits. Loans were obtained from British galleries (Bradford Corporation; Ipswich Corporation; Leeds Art Gallery; the National Gallery; the National Gallery of British Art [later Tate Gallery], Millbank; the National Gallery of Scotland; the National Portrait Gallery; Norwich Corporation; the Royal Academy of Arts and Whitworth Gallery, Manchester), the Louvre, Oxford and Cambridge Universities, art dealers (P. & D. Colnaghi & Co., Gooden and Fox, Knoedler & Co., Leggatt Brothers, Palser and Sons, and Scott and Fowles) and private individuals (Samuel Courtauld, Russell Colman, Arthur Kay, Sir Charles Holmes, E.A. Lewis, Edward March, Henry Oppenheimer, Victor Rienaecker, Anthony de Rothschild, the Earl of Sandwich, Sir Philip Sassoon, Earl Spencer and Sir Robert Witt). Percy lent sixteen of the exhibits.

The ninety-three paintings were presented over nine panels, starting with the Dutch artists who had influenced Gainsborough and ended with pictures showing the trends of art in Britain and France in the years following Gainsborough's death. The 106 drawings, six soft ground etchings and two engravings were displayed across panels ten to eighteen, taking similar themes to those of the paintings. The exhibition catalogue included a preface written by Robert Rattray Tatlock and a memorial to Gainsborough written by Sir Charles Holmes, Director of the National Gallery.[21]

The exhibition was opened on 7 October 1927 by the Duke of Gloucester who appeared in a country suit, while everyone else wore morning coats. When Percy took him round the exhibition, the Duke of Gloucester did not utter a word. The Duke was followed by the President of the Royal Academy, the Director of the National Gallery, the British and foreign directors and the Mayor and Corporation and the Lieutenant Generals for the sections of Suffolk.

Percy described the opening of the exhibition as deplorable if not comic. One of the great 'high ups', as Percy called them, exclaimed, 'This wonderful exhibition of works of John Constable, so ably organised by

J.M.W. Turner.' This was before lunch and was so unexpected from such a quarter and so clearly devastating that a complete silence reigned among the large assembly.

The lunch at the Town Hall that followed was described by Percy as a sad tribute indeed to Gainsborough: a cold lunch of sorts washed down with a white Bordeaux of no vintage and execrable quality. In the evening, Ipswich had forgotten to provide any food for the guests coming from afar, so Percy had to go to the White Horse Hotel and persuade the manager to put on a dinner for them, which Percy had to guarantee. Ipswich issued, at the very last moment, the essential invitations and subsequently paid for it.

The following day the guests were taken by car around Gainsborough and Constable territory, including Hadleigh, Sudbury, Cornard, Stoke-by-Nayland, Bures, Stoke, Dedham, Flatford and Brampton. Percy had to pilot the party as the people from Ipswich seemed to know little about the places, the roads and the views. The exhibition closed on 5 November 1927, having been visited by 40,000 people. Despite costing Percy two years' work and leaving him £1,100 out of pocket, Ipswich, feeling magnanimous, voted Percy 100 guineas at the finish.[22]

Percy was also on the committee of a loan exhibition of oil paintings, watercolours, drawings, etc., illustrative of the work of the artists of the Norwich School of Painting who had died before 1900, excluding John Crome and John Sell Cotman. It was held between 6 October and 5 November 1927 at the Castle Museum, Norwich. Among the other members of the committee was Charles Aitken, Director of the National Gallery of British Art, Russell Colman and his two sisters, Campbell Dodgson, Keeper of the Department of Prints and Drawings at the British Museum and Sir Charles Holmes. Percy contributed £10 to the exhibition and six pictures (no. 14, *Landscape with Figures* by Samuel David Colkett; no. 76, *Landscape with Cottage* and no. 77, *Cottage and Mill* by Joseph Paul; and no. 284, *Cromer*, no. 285, *Unloading the Cargo* and, no. 286, *Portrait* by John Thirtle) to the exhibition of 288 works.[23]

On 8 December 1927, Percy let the Oxford Arts Club know that he would be only too delighted to let them have some of Dunoyer de Segonzac's work for their exhibition during the early part of the next year.[24] At the end of January 1928, C.W. Adams, Percy's assistant at the Independent Gallery, let the administrator Miss Price know that he could let her have eleven watercolours and drawings for the exhibition and included the prices in the letter.[25] The Oxford Arts Club's '65th

Exhibition of Oil Paintings and Drawings' by Dunoyer de Segonzac was held between 4 February and 5 March 1928. Sir Michael Sadler lent nine exhibits and Percy, now a member of the club, lent the other nine that were priced in the catalogue.[26] Percy sent some de Segonzac drawings to Oxford before the exhibition. Sir Michael Sadler had agreed to buy five of these drawings, some of which were in the exhibition. Sadler told Percy that Miss Price would accept £10 by way of remuneration, which he duly paid.[27]

In July 1928 Percy was proposed for the committee of the Oxford Arts Club by the Treasurer. His name was submitted to the Annual General Meeting,[28] and he was elected.[29] It would be about this time that Percy made the acquaintance of the Hon. Andrew Shirley who was on the committee of the Oxford Arts Club and was also Assistant Keeper of the Fine Arts Department at the Ashmolean Museum from 1925 to 1929.[30] They would become firm friends, with Shirley becoming Percy's artistic executor for his last will (see Chapters 6 and 7).

In 1930, just before Jean Guiffrey, Conservateur of the Louvre, returned to Paris, he introduced Percy to René Huyghe, Conservateur-adjoints at the Louvre. Huyghe was staying for several weeks in London and Percy offered to take him on a tour of major collections throughout Britain where Percy had assured access. Percy drove Huyghe in his own car to visit the collections of leading members of the aristocracy.[31]

Huyghe was a member of the executive committee of the French general committee which was organising an exhibition, 'Art Français 1200–1900', at the Royal Academy in London to be held from 4 January to 12 March 1932. Percy happened to be a member of the British honorary committee of the same exhibition, along with Samuel Courtauld, Sir Michael Sadler, Sir William Burrell, Lord Ivor Spencer-Churchill, the Earl of Sandwich and various directors of London galleries and museums. It was an extremely large exhibition with 1,027 exhibits. Percy lent four of the works: an Alfred Sisley (no. 530, *Un chemin, Seine-et-Oise*), a Georges Seurat (no. 555, Paysage) and two Honoré Daumiers (no. 917, *Études de Têtes* and, no. 947, *Le Rieur*).[32]

On 14 July 1932 a loan exhibition of works by Devon painters born before the year 1800 opened at the Royal Albert Memorial Museum and Art Gallery, Exeter. The exhibition was organised by the art collector Robert Worthington. The help that Percy gave the organisers is acknowledged in the foreword of the exhibition's catalogue. Percy wrote the introduction to the catalogue and lent three pictures (no. 150, *Two Coast Scenes and a Group of Figures* by Samuel Prout; no. 233, *A Landscape*

by Reynolds; and, no. 265, *Miss Pocklington, afterwards Lady Martin* by Richard Cosway).[33]

Worthington was born in Saltaire, Yorkshire. Both his parents were accomplished artists. Robert Worthington started his medical training at the London Hospital in 1900, then, after a number of posts in London hospitals and postgraduate study in Berlin, he moved to the Royal Devon and Exeter Hospital in 1911. Ultimately, he was appointed surgeon in charge of the ear, nose and throat department at the Royal Devon and Exeter Hospital in 1914. About 1923 his latent love of painting was reawakened. In 1925 he organised an exhibition of Devonshire artists in Exeter. He was subsequently appointed a governor of the Exeter Museum. Besides achieving considerable success as an artist himself, Worthington collected paintings, particularly English watercolours.[34]

The 116th exhibition of the Oxford Arts Club, 'Modern French Painters', was held between 30 May and 30 June 1933. Percy lent thirty-one pictures, which included works by Picasso, Matisse, Bonnard, Segonzac, Marchand, Frélaut and Moreau. Loans were also made by Sir Michael Sadler. [35]

On 3 January 1935, Percy gave a lecture, 'The Origin of Modern Art', at New College, Oxford under the auspices of the Oxford Arts Club.[36] Percy also made loans to the 132nd and 134th exhibitions of the club. Percy lent drawings by David Wilkie between 1 April and 10 May 1935. In the exhibition of drawings by Thomas Gainsborough (8 June to 15 July), loans were made by Lord Spencer, Percy, Leslie Wright and others.[37]

The year 1937 marked the centenary of the death of John Constable and Percy initially offered Ipswich the opportunity of hosting the memorial exhibition but it declined. Percy, therefore, arranged to hold it at the Wildenstein Galleries at 147 New Bond Street, London. This exhibition coincided with a more extensive exhibition of Constable held at the Tate Gallery, Millbank.[38] Percy, again, organised the exhibition in a series of thirteen panels, starting with some origins of modern landscape (seventeenth-century artists Claude, Jan Wijnants, van Ruisdael and Rubens) and finishing with Neo-Impressionism and Post-Impressionism (Seurat and Cézanne).

There were 171 exhibits lent by national and European museums and art galleries (The Cooper Gallery, Barnsley; Royal Albert Memorial Museum, Exeter; the Corporation of Ipswich; City Art Gallery, Manchester; Norwich Castle Museum; Musée Royaux des Beaux-Arts

de Belgique, Brussels and Musée du Mans, Le Mans, France), Oxford and Cambridge Universities, art dealers (P. & D. Colnaghi & Co. and Wildenstein & Co.) and private collectors including Lord Ivor Spencer-Churchill, H.G. Constable, Samuel Courtauld, J. Maynard Keynes, Paul Maze, Sir Michael Sadler, the Earl of Sandwich and F. Hindley Smith. Percy lent twenty pictures, including *Willy Lott's House*. The exhibition was held from 21 April to 29 May 1937. The Hon. Andrew Shirley wrote the foreword to the catalogue, which was sold for the benefit of the Artists' Benevolent Fund – John Constable had been the Vice-President of the fund and was dealing with its business the night of his death.[39]

In connection with the Constable centenary, Percy gave a dinner at the Café Royal in London to 120 people to mark his sense of appreciation for their support and kindness over the years. Among those attending were Samuel Courtauld, Professor Léo van Puyvelde, Russell Colman, Clive Bell, the Earl of Sandwich, Lord Ivor Spencer-Churchill, Paul Maze, André Dunoyer de Segonzac, Dr Tom Honeyman, Victor Rienaecker, Stanley Kennedy North, Kenneth Clark, Geoffrey Agnew and Dudley Tooth.[40]

The 150th exhibition of the Oxford Arts Club, 'Richard Wilson and John Constable', was held between 26 October and 18 November 1937. Percy lent thirty-six of the sixty-four exhibits; six pictures by Richard Wilson and thirty pictures by John Constable.[41]

Percy had suggested to Nottingham City Council that to celebrate the centenary of the death of Richard Parkes Bonington, a comprehensive and educational exhibition should be held there in 1928 and Percy offered to organise it on similar lines to the Gainsborough and other shows. Percy felt that there was a wealth of material, not only looking at Bonington's precursors, going back to the roots of modern landscape painting, but also illustrating the complete evolution of Bonington in oil, watercolour and black-and-white mediums. Bonington's relation to Géricault, Crome, Cotman, Turner, Constable, Delacroix and others could be examined and their influence on succeeding landscape painting in France and England: the Barbizon School, Corot, Courbet, the Impressionists and more recent painters. Percy's proposition was turned down.[42]

However, in December 1937, Percy, the comtesse Aymar de Dampierre of the Art et Tourisme-Association Franco-Britannique and Henri Verne, Director of the Louvre, had a conversation about mounting a Bonington exhibition in the Orangerie between March and June 1939. The exhibition would be sponsored by the association and would be under the auspices of

A Centenary Memorial Exhibition for Constable held at Wildenstein Gallery, London,
21 April to 29 May 1937

the Louvre. Percy was only too delighted to collaborate with his French colleagues, but he would act alone on the British side in connection with the exhibition. Personnel from the Louvre were to be made available to help Percy, including René Huyghe, who was now Chief Curator of Paintings, Charles Stirling and Marie Delaroche-Vernet.[43]

At the end of January 1938 Percy saw the comtesse de Dampierre in Paris and he had a meeting with René Huyghe and Charles Stirling.[44] At that meeting, it was arranged that Percy would block out a plan and send it to Huyghe. Stirling offered to go through the catalogues of the French museums to see what they contained attributed to Bonington, which, in turn, would inform Percy of what travel would be involved.[45] Percy was able to tell Stirling that his plan for the projected Bonington show was well underway. He had gone through the catalogues of the English galleries but he had only very old catalogues from American galleries and wondered if the Louvre had up-to-date ones.[46] Although Percy had been unable to remember the title of the exhibition that the comtesse de Dampierre had suggested when they had both met in London in 1937, by February 1938 she confirmed that the title was *Bonington et son temps*.[47]

By mid February Percy was able to send a plan of the exhibition to Huyghe, consisting of one large gallery with five smaller galleries. Bonington's oils would hang in the large gallery. Percy suggested all the lithographs and etchings by Bonington and his contemporaries would be displayed in the first two small galleries. Oil paintings by Bonington's contemporaries would be shown in a small gallery to the left and, opposite on the right, would hang the oil paintings by Bonington's immediate predecessors. In the two following galleries, on the left would be the watercolours and drawings of Bonington's immediate predecessors and, on the right, Bonington's watercolours and drawings would be exhibited. Then, in the farthest gallery, would hang the oils and watercolours of Bonington's followers. Once the general plan had been confirmed, Percy would give the details of the artists to be represented.[48]

Towards the end of February 1938, Percy visited Nottingham Art Gallery and Museum and the Art Gallery in Leicester to view their pictures attributed to Bonington. Two of Nottingham's pictures had been exhibited in 1937 at the Burlington Fine Arts Club's exhibition of pictures and drawings by Richard Bonington and his circle where Percy had lent five oil paintings by Bonington and one by Paul Huet, ten watercolours and seven drawings by Bonington and one by Victor Marie Hugo.[49] He also went to Paris to meet up with Huyghe and Stirling.[50]

At the end of March 1938 Charles Stirling sent Percy a list of seven French museums containing pictures attributed to Bonington.[51] This was followed up with a letter signed by Henri Verne, Director of the Louvre, to be used by Stirling to approach each museum and to introduce Percy and also to ask each museum if they knew of any private collections that included Boningtons in their region.[52]

At the beginning of April 1938 Percy wrote to Huyghe asking if they could look at two pictures together to progress the exhibition: a large view of Paris at the Ministry of Venezuela and a picture belonging to Monsieur Boreux. Percy had the pictures in English collections well in hand and after a long talk with Percy, Stirling sent out the circular letter signed by Henri Verne to all the provincial museums in France. Percy would handle the appeal for Boningtons in America and would get in touch with Knoedlers in New York. Percy asked if Huyghe could insert an advertisement in *Gazette des beaux-arts* asking for Bonington pictures. Percy would contact the Canadian museums and Charles Stirling was asked to contact the museums in Denmark, Sweden, Norway, Holland and Belgium. Percy would also ask the art collectors Maurice Gobin and Georges Aubry to meet him and Huyghe for lunch when he was next in Paris.[53]

Towards the end of April 1938 Percy travelled to the museums of Scotland and the north of England to investigate the pictures attributed to Bonington.[54] He also contacted Charles Stirling as he was anxious to start visiting the French museums.[55] In May 1938 Percy had a meeting with the exhibition's secretary, Marie Delaroche-Vernet, who updated Percy on the replies from the French museums but there were still a few outstanding. Percy thought that he would be available to come to Paris in the last week in June once the exhibition on modern art that he was organising in Norwich had opened. René Huyghe and Percy could then go round the collections in Paris and its neighbourhood. Percy was also pressing Madame Delaroche-Vernet for answers to questions from Andrew Shirley who was in the process of writing a biography of Bonington, which would eventually be published in 1940.[56]

In May 1938 Percy wrote to Henry P. McIllhenny, Pennsylvania Museum of Art, Philadelphia; Ella S. Siple, Cincinnati Art Museum and Jere Abbott, The Smith College Museum of Art, Northampton, Massachusetts, to ask if they knew of any museums and private collections that contained work in any medium attributed to Bonington.[57] McIllhenny suggested that Percy contact the Frick Art Reference Library for details of Boningtons in America but pointed out that there may be difficulties in

borrowing some pictures due to the terms of their bequests.[58] Ella S. Siple furnished Percy with a tentative list of works attributed to Bonington in American collections.[59] Percy also wrote to a private collector in Montreal, Robert W. Reford, who had lent pictures to the Burlington Fine Arts Club's Bonington exhibition in 1937.[60]

Percy wanted to visit Paris to see works in private collections with Huyghe between 24 and 27 June 1938. However, Huyghe was unable to make these dates as he would be in South America.[61] Percy, therefore, decided to defer his visit to Paris until Huyghe's return at the end of September.[62] Meanwhile, he visited Amsterdam and Rotterdam in July and Besançon and Dijon in in September.[63]

In August 1938 Reford wrote to Percy to express his concern about lending his pictures due to the deteriorating political situation in Europe.[64] A number of English owners had also raised this matter with Percy, so he wrote to Henri Verne suggesting the show be deferred for some months.[65]

By 3 October 1938 the political situation in Europe moved very rapidly and Percy requested a meeting in Paris to include the comtesse de Dampierre and René Huyghe. Percy was quite prepared to come to Paris on the Friday to meet at the Louvre that Saturday, despite being preoccupied with moving works of art from London to safe places in the event of war.[66] At the Louvre meeting, the exhibition was postponed until an indefinite date towards the middle of 1939 and, even then, only if the political atmosphere calmed down. On 13 October 1938 Percy wrote to Siple and Reford to confirm this decision.[67]

'The Loan Exhibition of Pictures illustrative of Contemporary British and French Art' was held at the Norwich Museum and Art Galleries from 18 June to 27 August 1938. Russell Colman, Chairman of the Art Subcommittee, wrote in the preface of the exhibition catalogue 'To Mr. Percy Moore Turner the Committee owes a special debt of gratitude, for without his enthusiastic help and active co-operation the project illustrating Contemporary Art in a manner worthy of the City of Norwich would have presented considerable difficulty. Mr. Turner has also written an explanatory foreword with the idea of helping the public to understand the Exhibition.'[68] 'The Contemporary Art Exhibition of 1938 gave the citizens and others an opportunity of seeing the trend of the Art movements of our time in England and France. The work of accepted masters, such as Matisse, Picasso and Dufy, was shown side by side with those of Braque, Ben Nicolson and the Surrealists. The organisation of the Exhibition was in the hands of Mr. Percy Moore Turner, whose

special knowledge of the subject and whose influence with the owners of modern pictures enabled a remarkable and probably unique Exhibition to be held in Norwich.'[69]

There were sixty-seven pictures in the exhibition, with Percy lending nine pictures. Loans were made by Lord Ivor Spencer-Churchill, Samuel Courtauld, Sir Kenneth Clark, Sir Michael Sadler, the Earl of Sandwich and Frank Hindley Smith.[70]

As with the Independent Gallery, the imminent threat of war would seriously curtail Percy's activities in presenting art exhibitions.

6 THE WAR YEARS 1939–45

The War had hardly begun when Frank Hindley Smith died on 5 October 1939.[1] He had been frail for about three years.[2] Since Percy's and Hindley Smith's first meeting in May 1920 (see Chapter 4), Hindley Smith had gradually built a third art collection which, at his death, was hanging in his house, Chyngton Way, Eastbourne Road, Seaford, Sussex, which had been designed by the architect and craftsman J.H. Sellars of Manchester in around 1927. Its interior had been decorated under the supervision of Roger Fry.[3]

Frank Hindley Smith had not bought pictures exclusively from Percy but there is evidence that, between May 1920 and January 1937, he bought forty-seven pictures from Percy and Percy gave him three pictures as gifts.[4]

Hindley Smith had had a number of ideas as to whom he would bequest his collection. In 1937 he was proposing to leave his whole collection to the Atkinson Art Gallery in Southport.[5] However, at his death, Percy was left with a completely free hand to allocate the whole of Hindley Smith's artistic possessions in directions that benefitted the educational good.[6] Percy, temporarily, took up residence in Hindley Smith's house in Seaford in order to accomplish his task, as the sole artistic executor, in a manner that Percy he felt would meet Hindley Smith's wishes.

Percy invited the directors of the National Gallery, London; the Tate Gallery, London; the Ashmolean Museum, Oxford; the Fitzwilliam Museum, Cambridge; and the Barber Institute, Birmingham, along with others, to Hindley Smith's house to hear their views and, as a consequence, to decide which examples should go where. The National Gallery and the Tate Gallery allocations were comparatively and necessarily meagre. The Barber Institute, much as it would have appreciated the acquisition of certain pictures, was precluded by the terms of the Barber will from accepting either gifts or legacies.

It was evident to Percy that the Ashmolean Museum in Oxford and the Fitzwilliam Museum in Cambridge were eminently desirable recipients of the modern French and English works. There was nothing of this modern movement in either museum and, if they wished to acquire examples at this late stage, anything worthy had become rare thanks to international competition and, in consequence, values had become prohibitive for their meagre funds. So by arrangement with Dr Parker of the Ashmolean and

Louis Clark at the Fitzwilliam, Percy decided to apportion the cream of the collection to the two museums. In making this decision, Percy hoped that it might also prove to be an incentive to others to make similar bequests.[7]

Lawrence Haward, Curator of the Manchester Art Gallery, wrote to Percy at the end of October 1939 as he wanted to talk to Percy about the Hindley Smith estate.[8] Haward and Hindley Smith had seen Roger Fry's *The Church Interior* at the Mansard Gallery and Hindley Smith had offered this picture to the gallery in June 1922.[9] Percy had arranged with Lawrence Haward for the picture to be sent to the Manchester Art Gallery.[10] Unfortunately, the Corporation committee had turned the picture down once they knew it was by Roger Fry. Hindley Smith had borne no grudge but had, subsequently, made no further offers of gifts to the gallery, which had been a great disappointment to Haward.[11] Haward visited Seaford in early November 1939 to talk to Percy about pictures in the collection suitable for Manchester Art Gallery.[12]

Percy had included Peterborough in the museums and galleries to be considered for allocations from the collection, as Granville Proby of Elton Hall had reminded Percy that they were in the class of the 'deserving poor'. The Curator of Peterborough Museum and Art Gallery, Frank Dobbs, visited Seaford on 14 November 1939 where Percy helped Dobbs make a selection from the English pictures.[13]

On 2 December 1939 Percy wrote to Eric Hendy, Curator of Bolton Museum and Art Gallery, to thank him for showing him around the museum and to tell him that Percy would do what he could in regard to matters relating to Frank Hindley Smith and Bolton.[14] By 19 December 1939 Percy was able to write to the eleven museums and galleries with his decisions on their allocations from the 280 paintings, watercolours, drawings and bronzes.[15] A portrait of Samuel Rogers by John Linnell was given to the National Gallery (now in the Tate) and fourteen works and eighty-seven books were given to the Tate Gallery. As nineteenth- and twentieth-century British and French painters were sparsely represented at the Ashmolean and the Fitzwilliam, works by Constable, Corot, Courbet, Manet, Toulouse-Lautrec, Sisley, Monet, Pissarro, Cézanne, Segonzac, Matisse, Bonnard, Picasso, Vuillard, Sickert, Duncan Grant, Vanessa Bell, Roger Fry, Porter, Wilson Steer and others were distributed between the two museums (twenty-eight oils, fourteen watercolours and drawings, one print, two sculptures and fourteen books to the Fitzwilliam; sixty-one oils, four sculptures, seventeen watercolours and twenty-five books to the Ashmolean).

The British Museum received forty-one items, including twenty-six watercolours and drawings, one engraving and seventy-three prints, many of which were contained in albums (eighteen of the items were dedicated to Frank Hindley Smith). The Bolton Museum received thirty-six paintings, two pieces of sculpture and forty-one pieces of oriental ware. Norwich received fourteen works, including landscapes, both oil and watercolour, by Constable and Wilson Steer, four pieces of Chinese porcelain and a red Chinese lacquered box. Eleven works for Exeter included a watercolour, *Great Orme Head* (around 1797–1800) by J.M.W. Turner. The Manchester Art Gallery received six pictures and one bronze. The Whitworth Gallery in Manchester received three watercolours. Peterborough Art Gallery acquired sixteen pictures and three lithographs, including works by Buxton Knight and Wilson Steer.[16]

Percy's time during the last months of 1939 was not exclusively taken up by the Frank Hindley Smith bequests. While he was at Seaford working on the bequests on Saturday 18 November 1939, Percy received a telephone call from Lord Ivor Spencer-Churchill in which he told Percy that James de Rothschild was having serious trouble with regards to his collection at Waddesdon Manor, Buckinghamshire, and asked whether he could put Rothschild in direct communication with Percy. Naturally, Percy said that he should be only too pleased, so, in a very short while, Rothschild telephoned Percy and asked whether he could come to Waddesdon at once as the matter was most pressing. Bombs were falling on Newhaven, Percy had no transport and he had to finish the job at Seaford. However, Percy promised to come to Waddesdon on the following Monday morning.

In the first weeks of the War, all the pictures at Waddesdon, including those on panels, had been removed from their frames and placed in specially fitted wooden cases made by the house carpenter, Mr Chapman. The boxes had been transferred to the vault that had steel doors, which hermetically sealed the area where the boxes were stored. With a combination of the stone floors and walls, and the manor's steam heat, condensation had occurred and a 'green house' degree of moisture and warmth had developed. Two weeks after the boxes had been placed in the vault, Mr Chapman noticed a blue haze creeping over the surface of every picture.

On Percy's first visit to Waddesdon Manor on Monday 20 November 1939, he found all the pictures covered with mould – back and front – and completely saturated. Percy was not hopeful of saving the collection but he resolved to take the risk despite the fact that he would be blamed by

his numerous enemies if he did not succeed. Mr and Mrs de Rothschild agreed that Percy was to be placed in full charge and that they would foot any expenses that Percy considered necessary to accomplish the task. Percy also stipulated that he could not accept any responsibility for anything that might happen.

Percy returned on Wednesday 22 November 1939 with his 'helpers'. He had induced his friend, William John Morrill, the eminent restorer, to come to Waddesdon with his assistant, Mr Barnes. They were joined by the restorer Mr Holland. They were all housed in a local inn for weeks and carried out Percy's instructions to the letter. Orders were given to construct a large number of racks to Percy's specifications in the Grey Drawing-room where light and ventilation were available. The pictures, drawings, prints and manuscripts were transferred from the vault to the new environment and carefully dried out by natural means, the steam heat of the Manor house having been turned off in the Grey Drawing Room.

The unframed panels were the cause of great anxiety. The mould was carefully removed and seasoned oak surrounds were used to 'replace the control which the frames had exercised' and keys of oak were introduced in order to regulate the tendency to warp or, perhaps, split in the process of drying, which would happen over a long duration. These keys were adjusted daily, counteracting the inevitable swelling and contraction as the moisture disappeared. To Percy's astonishment and joy, during that long and terrifying period, not a single panel was lost or split.

Percy returned on Friday 24 November 1939 and then, on Monday 27 November, he was accompanied by a 'Pastel Man' as Mrs de Rothschild called him. Percy discussed the manuscripts with Mrs de Rothschild on 4 December. Thereafter, Percy visited Waddesdon Manor twice weekly until the end of December 1939 and then approximately once a week until the beginning of June 1940 to supervise the work. There were a further three visits, with his last visit on 19 December 1940. Mrs de Rothschild recorded in her diary the departure and return of pictures after treatment during 1940.[17]

Committee work continued to take up some of Percy's time. He was on the subcommittee safeguarding the collection at the Castle Museum, Norwich, with the responsibility of placing the collection in the places of safety for the duration of World War II.[18] The museum's Curator, Miss G.V. Barnard, also sought Percy's advice on the restoration of the Norwich School pictures.[19] In November 1939 Percy attended a committee meeting of the Society of London Art Dealers in his capacity as Chairman of

the Society. The committee discussed the society's concerns about the embargo on foreign pictures entering the country, consular invoices and declarations for works by contemporary artists exported from the USA and the forced early closure of galleries due to the wartime 'black out'.[20]

In December 1939 Granville Proby's 'The Supplement to the Catalogue of the pictures at Elton Hall' was published. Since Percy had assisted Proby in his research, in the preface to the supplement, Proby wrote 'I am under special obligation to Mr. A.P. Oppe and Mr. P.M. Turner for advice, help and sympathy and criticism.'[21]

At the end of December 1939, Percy admitted, in a letter to Miss Barnard, that he had not sent any Christmas cards or presents, as he could not afford them nor had the stomach to send them. There had been bad blood over the Hindley Smith bequest but he was used to it. The year 1939 had certainly been a bad year for him.[22]

At the beginning of January 1940 Percy made each museum and gallery offered pictures from the Frank Hindley Smith art collection aware of the conditions set out in the will.[23] Percy arranged with the Hindley Smith executors to leave the pictures in the house in order that they should have the advantage of the house being furnished. The executors, initially, tried to sell the house by private treaty, which caused Percy problems as he was unable to arrive at a date to distribute the pictures. This was disappointing for the Ashmolean and the Fitzwilliam, as both were anxious to hold exhibitions of the works allocated to them.[24]

At the end of January 1940 Percy replied to a letter from Jean Frélaut, letting him know that he and Segonzac had hoped to visit Vannes at the start of 1939. They had said nothing to Frélaut as they wanted it to be a surprise, but they had been forced to abandon their plans thanks to Hitler. Percy had not forgotten *Les Saisons* and very much wanted to have them but it was impossible to send them to England. He also mentioned that through Segonzac, Percy was aware that Frélaut was illustrating *The Fables of Jean de la Fontaine*. In a letter to Frélaut, Percy wrote that he did not know what they had done to merit two great wars in the same generation. He believed that the war was against Christianity: 'Our civilisation is founded on Christianity,' and while the struggle would be long and bloody, the British would ultimately win.[25] Percy was unable to get another letter to Jean Frélaut until November 1944.[26]

On 7 February 1940 the Norwich Museum's committee decided to purchase John Thirtle's *St Benet's Abbey* from Percy.[27] In the second week of February 1940, Percy went to Seaford with Woolcot to make the

preliminary arrangements for moving the pictures. Percy was pressing the executors to allow the pictures to be released as he would like the Norwich pictures to be available for the Friends' meeting on 16 March 1940.[28]

By 14 February 1940 Percy had to admit that his attempts to get the pictures released from Seaford had met with such opposition from the executors that he had had to fall in with their wishes. The executors wanted the house to be left furnished until all chances of a private sale had been exhausted. Meanwhile, on the Friday and Saturday morning, he was in Norwich doing the probate for Sir Nicholas Holmes's estate.[29]

On 22 and 23 February 1940, Percy confirmed with Miss Barnard that the press viewing of the Frank Hindley Smith collection at Seaford would be on Tuesday 5 March 1940. He was extremely keen that either Miss Barnard or Frank Leney, the former Curator of the Castle Museum, should attend and he offered to meet part of their expenses of coming to Seaford.[30] Miss Barnard confirmed that Leney would be attending and that he was keen to write two articles for the *Eastern Daily Press*.[31]

The press view of the collection of pictures formed by the late Frank Hindley Smith on 5 March 1940 was attended by art critics of leading London and provincial newspapers and the monthly art magazines.[32] Just after the press view in March 1940, the executors suddenly decided on a sale of the house and furniture at Seaford by auction on 17 April 1940. Percy therefore had to clear the pictures between 28 and 30 March. To add to Percy's problems, he had just lost his secretary, Miss Campbell-Orde, at a few hours notice as she had been called up to work for the Red Cross.[33]

On 21 March 1940 Haward wrote from Manchester Art Gallery to Percy about the furniture at Seaford that had been designed by J.H. Sellars. Sellars was anxious to know if his furniture could be classified as 'works of art' considered worthy of being preserved in public collections and offered as such to Manchester.[34] Sellars had been in to see Haward about three weeks previously and had wondered if the Manchester Art Gallery's committee could attempt to acquire several pieces of his furniture in order to make a group to illustrate the work of a local architect and craftsman.[35]

Percy telegrammed Haward on 23 March 1940 to tell him that the removal was in full swing and he suggested that they both meet at Seaford.[36] Haward arranged for someone to bid for the furniture on 17 April.[37] However, by the end of April 1940, it would appear that the executors had agreed that the eight lots of furniture that Manchester Art Gallery had bid for had been included in the bequests to the gallery.[38]

All the bequests were sent out from Seaford at the end of March and

the beginning of April 1940.[39] The bequests to Manchester Art Gallery were transported together and, on the way, a small easel and gramophone records were dropped off at Oxnead.[40] The Sellars' furniture arrived separately.[41] Miss Barnard's letter and telegram confirming the arrival of the Frank Hindley Smith bequest to Norwich was received by Percy when he was at Elton Hall.

Percy was unable to attend the meeting of the museum's committee at Norwich on Wednesday, 3 April 1940, as he had accepted to serve on the selection committee for the forthcoming Red Cross sale at Christie's and the meetings were on Wednesdays.[42]

Leney's article 'Constable Pictures for Norwich. The Hindley Smith Bequest' was published by the *Eastern Daily Press* on Thursday 4 April 1940. 'The importance of the pictures selected for the Castle Museum from the Hindley Smith bequest by Mr. Percy Moore Turner was emphasised in a previous article. The thirteen oil paintings and watercolour drawings were bought before the recent meeting of the Museums Committee and are at present on view in one of the art galleries. They comprise representative works in oil and watercolours by John Constable and Wilson Steer.'[43]

Percy was having lunch at Crown Point on Saturday, 6 April 1940 and hoped to visit Miss Barnard either on the Friday afternoon or Saturday morning.[44]

Percy received a letter of gratitude from the University of Oxford and a charming personal letter of appreciation for the bequest from Lord Baldwin of Bewdley, Chancellor of the University of Cambridge. However, the pleasure that Percy had experienced from the Cambridge letter was subsequently tempered by certain passages, recounting the bequest in 'Letters from Cambridge', a periodical letter sent out to Cambridge graduates all over the world at intervals during the War. These letters were subsequently published in book form in 1945; Percy's attention was drawn to them by numerous friends who, naturally, took umbrage on behalf of Hindley Smith, his inheritors and Percy.[45]

Later in April 1940 Miss Barnard called at Bury Street with Quintin Gurney's picture. Percy was not there as he had been called to assess the damage following the disastrous fire that had taken place at Newton Ferrers in Cornwall, the seventeenth-century house owned by the avid art collector and dealer, Sir Robert Abdy.[46]

By 19 April 1940 Percy was able to put the Frank Hindley Smith bequests behind him.[47] Percy received a legacy of £100, gramophones and a library of records from the Frank Hindley Smith Estate. The pictures

and works of art that Percy distributed to various public galleries were valued at £8,483.10s.[48]

During the early part of the War, Percy was engaged on requisitioning valuations in various parts of the country, the majority being carried out under extreme conditions of discomfort, appalling travelling, inadequate food and very bad hotel and other accommodation. In spasmodic periods at home, he took a hand in the local Air Raid Precautions (ARP) organisation as a warden.[49]

On 15 May 1940 Percy chaired a committee meeting of the Society of London Art Dealers. The society had received a letter from the Home Office asking for views on a reapplication for a lady to act as an art adviser in England. A letter had also been received from the Syndicat des Négociants en Objets d'Art of Paris about the export of valuable works of art from enemy to neutral countries. Percy had written to the Minister of Economic Warfare offering the services of the Society with a view to identifying some if they were stopped by the Allies in transit.[50] In June 1940 Percy was re-elected as chairman of the society.[51]

In a letter to Laurence Haward, Curator of Manchester Art Gallery, Percy reported in September 1940 that he had not gone to London since there was nothing special to take him there and the authorities discouraged travel to London. He was a warden and more or less always on duty. Working on successive nights was particularly trying as he was no longer young but he was, nevertheless, delighted to be of some use during this tragic period.[52]

At the end of 1940 the committee of the Society of London Art Dealers discussed the Government Insurance Scheme.[53] At their meeting in March 1941, they were unable to discuss the War Damage Bill as printed copies were unavailable.[54] However, in April, it had become clear that the members of trades that were exempted from 1939 War Insurance Act would be able to insure under the War Damage Bill.[55] In June 1941 Percy was re-elected as Chairman at the Annual General Meeting.[56]

On 25 August 1941 Percy purchased *A Landscape with Battle* by Géricault from Rothschild. This picture would be presented to the Louvre in June 1948.[57]

In October 1941 Percy organised a 'Loan Exhibition of Pictures Representative of Modern Art' by invitation of the Art Gallery Committee of the City of Norwich in Bury St Edmunds. Percy wrote a two-page foreword on modern art. There were fifty-nine exhibits (forty-four oils, twelve watercolours and three drawings) by thirty-five artists

including Vanessa Bell, Jacob Epstein, Mark Gertler, Duncan Grant, Augustus John, Paul Klee, Paul Maze, Paul Nash, C.W.R. Nevinson, Picasso, John Piper, André Dunoyer de Segonzac, Richard Sickert, Gilbert and Stanley Spencer, and Maurice de Vlaminck.[58] The Report of the Norwich Museums Committee stated that 'The most stimulating exhibition in 1941, "Modern Art", arranged by Mr. Percy Moore Turner to illustrate the work of Sickert, Eurich, Epstein, Piper, Spencer, Paul and John Nash, John, Picasso, Klee and others, evoked much comment and a public discussion on the subject of Modern Art proved very popular.'[59]

In January 1942 Kennedy North died when he was in the process of completing the catalogue of the Colman collection at Crown Point. Nevertheless, the catalogue was published in 1942 with Percy's help. Thanks are given to Percy for the detailed information in the body of the work in Russell Colman's foreword.[60] The probate valuation for Berkeley Castle, which commenced at the beginning of February 1942, also kept Percy busy. Lady Berkeley told Percy that Kenneth Clark had spoken highly of him. Percy found the place fascinating, despite there being only a few outstanding pictures.[61]

In the Baedeker raid on Exeter on 4 May 1942, Robert Worthington's house was hit by incendiary bombs, destroying it along with his whole collection. Percy would never forget the heroic efforts, at the risk of his own life, that Worthington made to rescue Percy's most important drawings that Worthington was kindly housing at East Southernhay. Percy was convinced that this tragic night, with its inevitable repercussions on his highly emotional temperament, laid the foundation of Worthington's comparatively early demise in 1945.

The subsequent two Blitzes at Holloway Street, Exeter, at the premises of Wilson Steer, Worthington's great friend, were equally serious. The first, despite the immediate surrounding devastation, left Worthington's and Percy's things unharmed, but the second practically destroyed Steer's premises. For several days, nobody except those involved in heavy demolition could get near. It was raining all the time and the outlook felt sinister. All these things had been transported to Exeter in extremis. They had previously been housed at the premises of Gooden and Fox in Bury Street, St James's, London, with adequate lists, until the Blitz destroyed Christie's auction house, along with much of King Street. Gooden and Fox was untouched by the bombing and its subsequent fires but the National Fire Services established themselves in its premises, pouring water on the surrounding fires. Percy was away, engaged on valuations of requisition for

the government, when he was telephoned with the news.

Percy asked Woolcot to clear his possessions, having previously arranged with Worthington that they should go to Exeter and, under further bombing, Woolcot recovered them with their lists and took them to Exeter. When Percy subsequently came to check his belongings, he considered himself to have been very lucky. Nevertheless, he had lost practically all his documents, many irreplaceable books and most of his photographs brought together over long years. Many of his pictures and drawings needed expert attention and this took years.[62]

In June 1942 Percy was re-elected as Chairman of the Society of London Art Dealers at their Annual General Meeting. Percy and Ernest Proctor Dawbarn, a member of the Fine Art Trade Guild, agreed to see Sir W.M. Lamb, Secretary to the Royal Academy, to see if the Royal Academy would support the society if it tried to increase the quota of moulding allowed for frame making.[63]

In August 1942 Percy attended a meeting with Mr Walsh at the Board of Trade Offices that had been called to consider the Fine Art Trade Guild's position regarding the prohibition of frame-making proposed to take effect from 1 October 1942. The prohibition of frame-making was strongly opposed by the representatives from the Society of London Art Dealers and the Fine Arts Society – it proposed that men over the age of military service or unemployable in essential war work should be allowed to continue making frames.[64]

Percy purchased *Portrait of a Man with a Blind Eye Holding a Flute* by François Clouet from Robinson and Foster on 27 August 1942.[65] He obtained a detailed report about this picture from Professor Léo van Puyvelde, which he sent to Kenneth Clark at the National Gallery on 2 January 1943. On 17 February 1943, Percy was told that the picture had not found favour with the Trustees of the National Gallery.[66] This picture would be presented to the Louvre in 1948 (see Chapter 7).

On 28 September 1942, Percy wrote to Kenneth Clark as he wanted to move the Géricault portrait from London to the country where it might be safer but Percy would not do this if Kenneth Clark thought that the National Gallery might be interested. Mr Basil Gray of the Department of Oriental Antiquities and Ethnography at the British Museum believed that the person in the portrait was a Nubian from Algeria.[67] Percy had purchased the picture from P. & D. Colnaghi on 10 August 1942 and sold it to the National Gallery on 31 December 1942.[68]

From 12 October 1942 Percy began to receive payments from Sir Robert

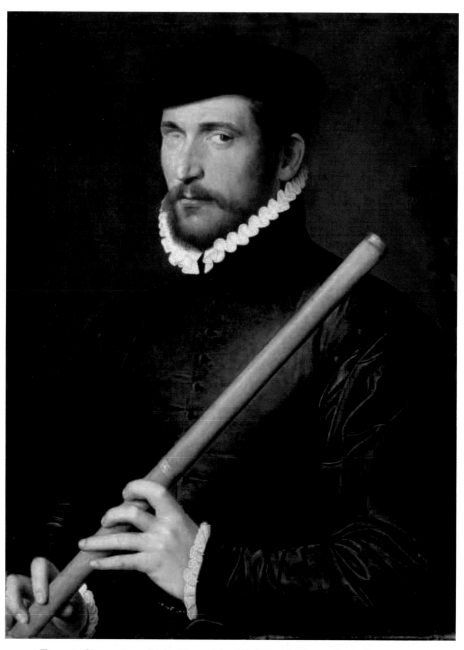

François Clouet, *Portrait of a Man with a Blind Eye Holding a Flute,* oil on canvas,
27.6 x 20.7 cm, 1566

Sainsbury either quarterly or six monthly until 20 September 1945.[69] Robert and Lisa Sainsbury's house in Smith Square, close to the Houses of Parliament, suffered bomb damage and the paintings and sculptures were stored in several places outside London during the War.[70] Percy looked after the collection kept initially in Oxford and later in Amersham.[71]

At the beginning of December 1942, Kenneth Clark had to go to Cumberland, but he let Percy know that he wanted to show him 'The Exhibition of Nineteenth-Century French Paintings' on his return, as Kenneth Clark hoped that Percy could improve it.[72] Following Percy's visit to the National Gallery,[73] he confirmed to Kenneth Clark that he had written to Lord Sandwich about the Delacroix and the two Bonnards (*Les Coquelicots* and *Nature Morte*) and the Vuillard (*Tristan Bernard dans le jardin de Vuillard*) would be ready for collection from Oxnead on the 9th. Percy asked Kenneth Clark not to remove the hook plates on the back of the pictures. Percy's pictures were all hung on chains and the hooks had been adjusted to the hanging.[74] The exhibition catalogue shows that Percy also lent *Odalisque* by Delacroix and *Romantic Landscape with Battle* by Géricault to this exhibition.[75] After the closure of the exhibition, Percy asked Kenneth Clark if he could hold on to his pictures for a short time until they went to Glasgow. Tom Honeyman was organising an exhibition of French pictures in Glasgow at the Art Gallery and had asked for the loan of the Bonnards and the Vuillard.[76]

In January 1943 Percy wrote to Kenneth Clark about a picture he had owned for many years. This picture was the original study for the National Gallery's portrait of *The Hon. Mrs Graham as a Housemaid* by Gainsborough. Percy's picture was in black chalk heightened with white and was on blue-grey paper and came from the collection of the Earl of Northbrook. It had been shown at three Gainsborough exhibitions, the first at Ipswich in 1927, and the others at Park Lane, London, and the Oxford Arts Club in 1935. Percy wanted to give it as a gift and wanted it to hang besides the oil painting.[77] Later that month Percy offered to send the drawing to the gallery so that it could be shown to the Trustees. Percy appreciated the point about the condition of permanently hanging the drawing alongside the picture but he was anxious to prevent the drawing being permanently buried in a portfolio.[78] In February the Trustees accepted the drawing that could be kept on exhibition in the small room adjoining the large English Room.[79]

In February 1943 Percy sent Kenneth Clark a photograph of the drawing of *Toma Keke*, the celebrated Moari Chief, by Charles Meyron.

Meyron made the drawing on the occasion of his visit to New Zealand in 1842. Meyron also did a portrait of Edward Folly, one of his companions on this voyage. It appeared that Meyron gave the *Toma Keke* to Folly in whose family it descended until Percy acquired it in 1939.[80] Kenneth Clark was willing to write to Sir Cyril Newall about it but needed to know if Percy wanted to offer it for sale or, as in Percy's generous habit, to present it.[81] Percy felt that New Zealand should buy the *Toma Keke* as it was a historical document for them, but it would not be available for some weeks as it was under treatment for fox marks.[82]

At the end of February 1943 Percy let Kenneth Clark know that when he had received the photographs of the drawings, he would send them together with a large photograph of Constable's *Devil's Dyke*. Percy also asked Kenneth Clark if he only wanted nineteenth-century and modern drawings (French and English) or whether he was he interested in Italian, Dutch and Flemish works and ones from earlier periods. Percy would be in East Anglia for the next week as he had committee meetings and various other things to do.[83]

In mid March 1943 the photographs arrived, so Percy offered to take them to the National Gallery if Kenneth Clark had the time to talk over the matter. Percy also wanted to speak to Clark about another important matter at the same time.[84]

On Percy's return from East Anglia on the evening of 9 April 1943, he had found a letter from Jeremy Hutchinson asking Percy to do the probate for his late father's pictures. Kenneth Clark had recommended Percy to Hutchinson. The pictures were in Cambridge and Percy had suggested the beginning of the week commencing the 19th as this was the soonest he could do.[85]

At the Annual General Meeting of the Society of London Art Dealers in May 1943, Percy was re-elected as Chairman. At this meeting there was considerable discussion about the possibility of taking steps to prevent the large number of spurious pictures being sold, particularly at auctions. Percy, as Chairman, was empowered to take counsel's opinion as to the legal position.[86]

In June 1943 Percy asked Kenneth Clark if there was any chance of Constable's *Helmingham Dell* or the *Devil's Dyke* entering the Ashmolean or the Fitzwilliam.[87] At the end of September 1943 Percy received a letter from Kenneth Clark suggesting they met on 7 or 12 October to look through the drawings. Kenneth Clark could have anything that he thought desirable and Percy could make 12 October. There were quite a

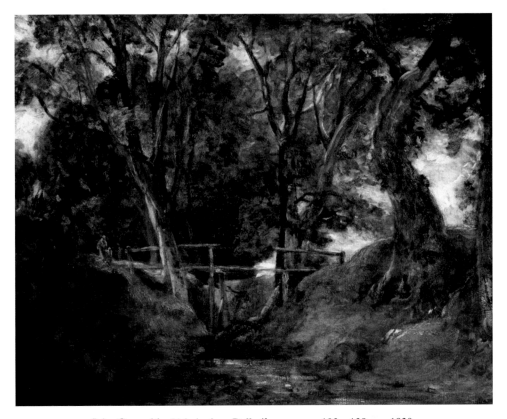

John Constable, *Helmingham Dell*, oil on canvas, 103 x 129 cm, 1830

quantity of drawings at Oxnead, others at Wildensteins in Bond Street and still others at Elton (near Peterborough), with Lord Sandwich and at the Fitzwilliam, and Percy had photographs of most of them.[88] Kenneth Clark and Percy met at Wildensteins at 12.15 pm on 12 October; after lunch at Percy's invitation, they went by train to Oxnead. After looking at the drawings at Oxnead, Kenneth Clark called in on friends.[89]

In 1943 Russell Colman had intimated to Norwich City Council that he was prepared to bequest his collection of Norwich School pictures to the city and that, if such a bequest proved acceptable, he would also give to the Corporation a sum of money for the erection of new galleries at the Castle Museum to house the collection. This magnificent offer was accepted by the City Council at its meeting on 5 October 1943 and approval given to the building plans which had been prepared for Russell Colman.[90] In October 1943 Percy gave two lantern lectures in the Stuart Hall, Norwich, on the Colman bequest.[91]

In November 1943 the committee of the Society of London Art

Dealers met to consider counsel's opinion on the sale of spurious pictures that Percy had obtained for the society. The committee also discussed the question of the rebuilding of the Bond Street area and the need for the society to be represented on the committee considering this.[92] Percy subsequently approached Mr Dawbarn who agreed to represent the society in the Bond Street Association.[93]

In January 1944 Percy was anxious to get the matter of the Cotman drawings settled with the Castle Museum, Norwich. There was not enough money available either in the Southwell Fund or the Becchano Fund at the time and Mr Colman thought that it was better not to place the drawings before the Museums Committee. The drawings were returned to Percy.[94]

In May 1944 Percy was re-elected as Chairman at the Annual General Meeting of the Society of London Art Dealers. The committee received reports on two meetings of the Reconstruction Committee of the Bond Street Association and they also discussed import and export control and book sales at the National Gallery. Percy and Mr Dawbarn, on behalf of the society, would attend a meeting on 17 May to discuss import and export control that referred to the restoration of facilities to import and export antiques and original works of art free from restriction at the end of the War. The society disapproved of the so-called Gallery Books sold at the National Gallery published by Lund Humphries, as the term Gallery Books conveyed to the public that the publications were official. It was agreed that Percy would interview Andrew Shirley and arrange to meet with Sir Kenneth Clark.[95]

At the society's July 1944 meeting, Percy reported on his meeting with Andrew Shirley, who felt that it would be difficult for the Book Publishers Association to protest against the sale of unofficial publications at the National Gallery. Percy had also met with Sir Kenneth Clark on 14 July who refused to withdraw the books. As a result, Percy wrote to the Director of the National Gallery to communicate that members of the society were disturbed that unofficial publications were on sale there and Percy, also, agreed to see Andrew Shirley again and urge him to protest.

There had been a debate in the House of Lords when Lord Hinchingbrooke had suggested various drastic and restrictive measures to prevent the export of valuable works of art from the United Kingdom. The matter had been given prominence by the *Manchester Guardian*, and a letter from Mr Robson of Sotheby's in response to it was published along with an article by Christopher Norris in the *Evening Standard*.

It would be impossible to obtain an export licence if a picture exceeded

£100, unless the Board of Trade was satisfied that the picture would not be better placed in a national or provincial gallery. As a consequence, after Percy had obtained a Hansard report of the debate, he invited Lord Hinchingbrooke to lunch with members of the society to obtain Lord Hinchingbrooke's observations on the members' views.[96]

The September 1944 committee meeting of the Society of London Art dealers included individuals representing other bodies and was mainly about the problems facing the fine art trade on the cessation of hostilities. These included the export and import of works of art, immigration (whether foreign dealers were to remain in the country after the cessation of hostilities), a private and confidential report on arguments presented by Percy at a meeting with Lord Hinchingbrooke and the questions to be submitted to Lord Hinchingbrooke for a meeting to be held on 24 October 1944.[97]

In November 1944 Percy was able to re-establish contact with Jean Frélaut and give him all his news. He told him that his son was working in a hospital in Exeter, and that although he was married, he was waiting for the end of the War to settle down. Percy had definitely left the Independent Gallery. Percy was distressed to hear that Frélaut had lost one of his sons, and was anxious to obtain news of their friends: Segonzac,

Percy, his wife, his sister-in-law and her husband at the wedding of Percy's son,
12 April 1944

Moreau, Bonnard, Guiot, Barba (Henri Barbazanges) and others. Percy also reminisced about a Sunday in Vannes when he had fallen into the mud and would have stayed there had Frélaut and a priest not saved him. Percy would not forget that Madame Frélaut had kindly cleaned and dried his clothes and, with a large portion of Cognac, all was well.[98]

Percy also received a letter in November 1944 from Paul Quarre, Curator of the Musée des Beaux-Arts in Dijon. In 1935 Percy had written to Paul Vitry, Head of the Sculpture Department at the Louvre, about his medieval statuette (see Chapter 4). Vitry had subsequently told Quarre about the statuette and that, before the War, Percy had been willing to discuss the possibility of it coming to the Louvre. Quarre was very keen to have a photograph of the statuette and its dimensions.[99]

In December 1944 Percy replied to Quarre. Vitry had been interested in Percy's statuette that was variously called a choirboy, an altar boy or a *pleurant* (mourner). It was of the Burgundian school and of the same dimensions as the *pleurant* in the Louvre. This was why Vitry had asked Percy to give his statuette to the Louvre, either as an acquisition or a bequest. Unfortunately, relations had broken down with the War and with the death of Paul Vitry. Percy was not able to send Quarre a photograph, owing to the postal regulations, but he would send one as soon as it was possible. His small statuette was being kept outside London.[100]

At the beginning of January 1945 Paul Quarre wrote to Percy to thank him for his information about his small statuette. If the statuette resembled the one in the Louvre, it may have been from the tomb of Jean de Berry or Philippe le Hardi. Paul Quarre was attending a conference on the tombs of the Dukes of Burgundy at the Louvre on 15 March and asked for a photograph and the dimensions of the statuette.[101] At the end of January 1945, Paul Quarre obtained a photograph of Percy's statuette from Madame Charlet in Paris,[102] but Percy was still unable to give Quarre the dimensions, as he could not access the box where it was packed.[103]

In February 1945 Percy had received a long letter from Segonzac in Saint Tropez giving Percy news of Frélaut and many of his friends in France. Frélaut still had Germans soldiers either side of him but he had finished illustrating a book *Fables de la Fontaine* and Percy would have very much liked to have had a copy but it was impossible to send one at that time. Percy wanted to go to France but that was also not possible.[104]

In February 1945 Percy was also busy with the probate for the Lonsdale estate. With the uncertainty as to whether any of the pictures would come to the market, Percy undertook to keep Kenneth Clark up to date with the

Jean de La Huerta and/or Antonie Le Moiturier, *Pleurant no. 42, choirboy carrying a candlestick from the tomb of Jean sans Peur, duc de Bourgogne*, alabaster, *c.* 1443–69

Lonsdale pictures. Although the probate needed to be completed as soon as possible, this would not be for some time.[105] Percy had been entrusted with the probate valuation of Lowther Castle and the house at Oakham by the Trustees of the Earl of Lonsdale. Only when Lord Lowther took Percy round the castle did he realise the enormity of the job. In the afternoon, Percy told Lord Lowther that he thought it would be more satisfactory for him, the Trustees and Percy if the usual schedules were ignored and Percy gave an 'all in price' for the undertaking. It was a considerable gamble.[106]

At the end of February 1945 Percy responded to Paul Quarre's suggestion that Percy could give his statuette to the Musée des Beaux-Arts in Dijon. Percy had a dozen sixteenth-century sculptures, mostly French, some pieces Burgundian, but the medieval *pleurant* was the only example of its type in his collection. Percy, if he could, intended to give or bequest this collection to a museum in his country, perhaps the Ashmolean in Oxford or the Fitzwilliam in Cambridge, where there was very little sculpture of high interest. Percy was certain that there was no other *pleurant* in England or an example of Burgundian sculpture from this era. Hence Percy wanted time to reflect.[107]

In the latter half of March 1945 Paul Quarre wrote to Percy, setting

out the case for the small statuette to enter the Musée des Beaux-Arts in Dijon. Quarre went further and offered Percy an alabaster *pleurant* from the tomb of Philippe le Hardi, duc de Bourgogne, which had been made about 1820 at the time of the restoration of the tombs.[108]

By the end of March 1945, Percy was receiving many letters from France, Belgium and certain regions of Holland, giving him current news of his friends and their situations during the War. He had been kept abreast of the situation of the art world in Paris during the War by a French journal published in London. This journal, from time to time, published news of collaboration with the enemy which was not believed possible at the time but was later confirmed as true.

Percy was finding life very strange with shortage of commodities and the spiritual want was difficult to endure. All the museums, if not closed, had a few second-rate artefacts on show. Percy believed that it would be years before the Louvre, the National Bibliothèque, the National Gallery and the British Museum and others would be re-established.[109]

Even though the War had not ended, Percy realised that there would be a scramble for office space when it was over. The bombing had not lessened in intensity but Percy thought that it was a risk worth taking. He secured two small offices at Golden House, 29 Great Pulteney Street, Soho, London and, with the help of his packer, Woolcot, managed to furnish these offices and get them into tolerable working order. Percy was still working alone, and for months on end he could not find time to go to the office.

Percy was still undertaking a considerable amount of valuation work for probate and insurance. The strain was considerable for his age and the appalling amount of travelling, inadequate food and poor accommodation were beginning to take its toll on his energy.[110]

Albert Henraux, President of the Society of Friends of the Louvre, saw Percy in London in early April 1945. At this meeting Percy confirmed that he had decided to give his statuette to Dijon, but that he would need Henraux's help with obtaining permission to export it from London.[111] At the end of April, Percy asked Quarre that if his statuette went to Dijon, would it then be possible for the Louvre's statuette to be returned to Dijon? Percy was also concerned about the impossibility of exporting his statuette from England without it being passed by the Board of Trade.[112]

7 THE FINAL YEARS

*'During the war I used to Lunch almost fortnightly with Turner,
and the future of this picture [Georges de la Tour's* St Joseph, the
Carpenter*] was a frequent topic of discussion. He frequently used to
say to me: "We are only trustees for life of these things."*

*'During his life and by his will he was a considerable benefactor to
national and provincial museums both here and in France. He took
pleasure in finding the appropriate permanent home for such works
of art – whether paintings, etchings or medieval sculpture – which
he could spare.'*

Hon. Andrew Shirley, letter to the *Daily Telegraph*, 12 March 1958

At the end of the War Percy was faced with the task of emptying
his numerous 'funk holes' and getting what he could into the two
small offices at Golden House in Soho, London. Woolcot, Percy's packer,
stepped into the breach and gradually the things in Hinchingbrooke and
in Norwich and what remained in Exeter were transferred to the new
offices in London. Eventually, Percy had to stop due to lack of space.
Everything was bundled in haphazardly and Percy had no time to sort it
out. It would only be when Miss Campbell-Orde was demobilised that
the chaos was put into order.[1]

In June 1945 Paul Quarre wrote to Percy to update him on his activities
regarding Percy's gift of his statuette to Dijon. Quarre had visited Paris
and made Georges Salles, the Director of the Museums of France, aware
of Percy's wish to avoid the formalities of exporting the statuette and
Percy's desire to see the Louvre's statuette reunited with his. Salles was
in favour of the Louvre statuette going to the Musée des Beaux-Arts
in Dijon and this would shortly come before the museums' council. It
would be possible to send Percy's statuette in the diplomatic bag. The
Guard Room where the tombs of the Dukes of Burgundy were situated
was under renovation. Quarre hoped that the tombs could be shown to
the public in November.[2]

On 14 June 1945, Percy was re-elected as Chairman of the Society of

London Art Dealers. The society remained concerned with export and import control. They decided to take no further action but felt that it would be helpful if individual members of the society continued to have conversations with MPs. However, the society did decide that its interests would be better served in export matters if the society became identified with the Fine Art Trade Export Group.[3]

At the beginning of July 1945 Percy apologised for the delay in replying to Paul Quarre's letters. Percy was in the process of finding transport so that he could remove his pictures, drawings and sculptures from where they had been stored outside London during the War. Lack of transport made it very difficult but a friend had given him hope during the last weeks. Percy would write to Quarre when the small pleurant had arrived in London.[4]

In August 1945 Percy spent a few days at his farm, the Old Hall Farm. This was the first rest he had had since the start of the War. He had been preoccupied with probate valuations and was still working on his own. He had been told that it would be a long time before his secretary would be released from War work. Percy longed to go to France but visas were difficult to obtain, travel was expensive and staying in Paris was not easy.[5]

In September 1945 Percy was able to tell Paul Quarre that the difficulties over the small statuette were now resolved and it would arrive in London on 4 October.[6] Percy confirmed that he had taken the statuette to the French Embassy on 5 October 1945,[7] and Quarre gave an undertaking to let Percy know when the statuette arrived in France.[8]

At the end of September 1945 Percy wrote to Kenneth Clark who had just resigned the directorship of the National Gallery. Percy had organised an exhibition of English Painting at the Fine Arts Society in New Bond Street. The pictures were all Percy's but were exhibited anonymously. Percy enclosed a card for the private view. Percy was showing Richard Parkes Bonington's *Man with a Top Hat* (now attributed to John Scarlett Davis). Percy and Kenneth Clark had discussed the future of this picture some time ago. Percy felt that it should go to the National Gallery. Percy was prepared to give it to the National Gallery as soon as the exhibition ended so that it would arrive while Kenneth Clark was still in office. Percy wondered if the Trustees would accept it. The acquisition could be announced during the period of the exhibition.

Percy was, in fact, arranging the destinations of a number of his artworks and asked Kenneth Clark for advice. He suggested meeting for lunch one day to discuss this matter. However, he was going to Norwich

John Scarlett Davis (previously attributed to Richard Parkes Bonington),
Man with a Top Hat, oil on canvas, 63.5 x 52.7 cm, *c.* 1838

the next day to settle an estate (probably his sister Maud's; she had died on 21 September 1945 at Hellesdon Hospital in Norwich)[9] and would be at 42 Mill Hill Road until Thursday.[10] Kenneth Clark suggested meeting on 17 or 21 October for lunch. 'I think almost the first thing I did when I came to the Gallery was to have lunch with you, and it would be appropriate to close my career in the same way. You have been a good friend to the Gallery during the intervening period.'[11]

From 17 October to 17 November 1945 an exhibition of 'Masterpieces by British Landscape Painters of the 18th and 19th Centuries' was held at the Fine Arts Society. The exhibition had been organised by Percy and while all the exhibits were his, they were exhibited anonymously.[12] The catalogue's foreword was written by the Hon. Andrew Shirley. Thirty-one pictures were exhibited: four by J. Crome, three by P. de Wint, one by W.J. Muller, one by J. Baker Pyne, one by J. Ward, four by Gainsborough, one by Turner, five by Bonington, three by Constable, two by J.S. Cotman, one by W. Havell, one by George Morland, one attributed to Thomas Gritten, one by J.B. Crome, one by J.C. Ibberson and one by Richard Wilson.[13]

At the end of October 1945, with Percy's statuette on its way to France in the diplomatic bag, Paul Quarre reminded Georges Salles that Percy's gift of his statuette to Dijon had been made on condition that the Louvre statuette was loaned long term to Musée des Beaux-Arts in Dijon. He also took the opportunity to raise the issue of the two *pleurants* then kept at the Musée de Cluny in Paris, which Quarre hoped could be returned to the tombs where they had been 150 years ago in time for the inauguration of the renovated Salle des Gardes in the Musée des Beaux-Arts in Dijon.[14] Percy would have been familiar with the two *pleurants* at the Musée de Cluny, as they had been exhibits nos. 580h and 580t in an exhibition held in London in 1932, the 'Exhibition of French Art 1200–1900' for which Percy had been a member of the British Honorary Committee[15] (see Chapter 5). However, Percy was not aware of Paul Quarre's decision to have the Cluny *pleurants* returned to Dijon.

On 30 October 1945 the Society of London Art Dealers sent out a letter from Percy, as its Chairman, to all its members about import and export control. The letter told its members that the society had withdrawn its representation to the Executive of the Antique Dealers' Group and that Mr van Duzer and Harold Wright had been appointed to the Executive of the Fine Art Trade Export Group. A further meeting between representatives of the export groups and the Board of Trade, the

Treasury and Customs and Excise was being arranged to discuss the points in the Memorandum of July 1944 further (see Chapter 6). Preliminary discussions among members of the export groups would take place on 1 November 1945 and the deputation to the Board of Trade was expected to take place on 6 November 1945.[16]

On 21 December 1945 Paul Quarre wrote to Percy to tell him about the inauguration of the Salle des Gardes by Georges Salles, the Director of the Museums of France, on 10 December 1945. The Musée des Beaux-Arts in Dijon had been closed since before the War, following the evacuation of its collections. Percy's statuette had resumed its place on the tomb of Jean sans Peur (John the Fearless), duc de Bourgogne.[17] Georges Salles wrote to Percy on 27 December 1945 to thank him for his magnificent gift to the Musée de Beaux-Arts in Dijon. The small choirboy with the candlestick made a charming pair with the other choirboy from the Louvre.[18]

At the end of December 1945 Percy thanked Paul Quarre for the statue, which had arrived at his packer, and for the photograph of the part of the tombs where his statuette had been returned. Percy wanted to meet Quarre and to see the tombs in Dijon when he could. He had unforgettable memories of the food and the wine of Burgundy and of Dijon.[19]

Towards the end of 1945 Percy admitted to Jean Frélaut that he was starting to feel very old. With all the materialism, he was concerned about England's future. He found solace in looking at his art collection.[20]

On 9 January 1946 *The Times* published an article about *Man in a Top Hat* by Bonington that Percy had gifted to the National Gallery. The picture was hung in Room XII and labelled as 'attributed to' Bonington and *The Times* article claimed that this phrase meant that the attribution was in doubt.[21] On 9 January Percy was inundated by telephone calls and visits from indignant people. Andrew Gow, a classical scholar at Trinity, Cambridge, had published the previous week *Letters from Cambridge*, in which Gow questioned Hindley Smith's motives for making this bequest to the Fitzwilliam. This led Percy to speculate that such publicity would certainly not encourage people to give or bequest pictures to galleries or museums. Percy was more than hurt, but he would recover. He wrote to the Curator of the Castle Museum, Miss Barnard, 'Humanity is not a nice Commodity. Norwich has been the one and only bright spot – except for the clerics [Norwich Cathedral].'[22]

It appears that Miss Barnard had asked Percy for his help with the

restoration of *The Despenser Retable* at Norwich Cathedral (around 1380–90). Kenneth Clark suggested that Percy turn to the new Director of the National Gallery who could send one of his staff to look at the picture and advise, but had found the Vice-Dean and the Chapter closed to such an idea: 'It is really very shocking that the Chapter of Norwich Cathedral should grudge paying Morrill's fee with such an important monument of English painting in danger.'[23] In his reply, Percy thanked Kenneth Clark for his professional help in this important matter. Percy was coming to the conclusion that it was well nigh hopeless to attempt to help such people as they had evidently decided to transport *The Despenser Retable* to London despite Percy and Miss Barnard's warnings given its frailty.

Percy would take no further action but, based on this incident and many others over many years, Percy concluded that the Church should be debarred from treating, at its will, the priceless monuments that were then under its jurisdiction. He wrote despairingly to Clark, 'If you had seen the repeated happenings in the diocese of Norwich alone, even you would be shocked.'[24]

At the end of January 1946 Percy, as Chairman of the Society of London Art Dealers, wrote to the members of the society enclosing the paper produced following the meeting between the export groups, the Board of Trade, the Treasury and Customs and Excise on 6 November 1945. The Board of Trade would consider the suggestion that the same kind of export arrangements which existed with Australia, Canada, New Zealand and South Africa should apply to other countries. The Import Licencing Department was happy to license the importation of anything that would make money. Applications to reimport goods that had been sent abroad by dealerships with branches in different countries would be looked at sympathetically.[25]

The Deputy Mayor of Dijon, Felix Kir, wrote to Percy on 9 February 1946. At the meeting of Municipal Council of Dijon on 22 December 1945, Percy's gift had been officially accepted and he had been publically thanked for his generosity. This letter also confirmed that not only the Louvre *pleurant* had returned to Dijon but also the two from the Musée de Cluny, Paris.[26] Percy replied to Felix Kir on 4 March thanking the Noble Assembly for their fine regard. For Percy it was the least he could do in appreciation of the good years among their countrymen.[27]

A 'Memorial Exhibition of Watercolours of Dartmoor and Elsewhere by Robert A. Worthington OBE, FRCS' opened on 20 March 1946 at the Fine Art Society in New Bond Street. Robert Worthington had died

on 11 July 1945 from a severe cerebral haemorrhage.[28] Percy wrote the foreword to the catalogue. This exhibition was the first occasion in which the full gamut of Worthington's art had been brought before the general public and Percy felt that it should place Worthington, as was his due, in the very first flight of contemporary English watercolour painters.[29]

Paul Quarre was asked to write an article for *Le Bulletin Monumental* on the two choirboys that had been restored to the tomb of Jean sans Peur. He, therefore, wrote to Percy on 17 April 1946, saying that he wanted to give precise information on the two small clerics and also asking Percy where his small statuette had been before it entered his collection.[30] The stockbook entry for the statuette shows that it was bought on 22 May 1935 from Taillemas,[31] but this date is over a month later than the date of the letter that Percy wrote to Paul Vitry about his statuette (see Chapter 4). There is no evidence that Percy ever gave Quarre the details of the provenance of the statuette.

On 21 April 1946 Percy wrote to Jean Frélaut to tell him that it was very probable that he was going to Paris during the last days of May. Percy's reason for coming to France was vague and he would only say that the journey had become an obligation on his part. However, he very much wanted to see Frélaut when he came to France.[32] On 22 May 1946 Percy again wrote to Jean Frélaut to let him know that he was crossing the Channel on Sunday 26 May and would be staying at Hôtel Brighton, 218 rue de Rivoli, Paris. Percy invited Jean Frélaut to meet him one afternoon at his hotel. It was not going to be possible to go to Vannes, as Percy's time was very limited in France.[33]

At the May 1946 committee meeting of the Society of London Art Dealers, Percy expressed his fears that the power the government-sponsored bodies, such as the Arts Council, might acquire would be detrimental to the Fine Arts Trade in general. It was agreed that Percy would inform Lord Hinchingbrooke that his Memorandum would be submitted to the whole trade after which a reply would be communicated.[34]

On 10 May 1946 Percy wrote to Kenneth Clark to say that he was grateful that he had put McKenna & Co. in touch with Percy regarding the Keynes probate valuation. He also congratulated Clark on his appointment as buyer for National Gallery of Victoria in Melbourne and wondered if he would consider Constable's *Helmingham Dell* suitable for them.[35] Kenneth Clark, in reply, would suggest the Constable to Daryl Lindsay, the Director of the National Gallery of Victoria, and, if he approved, would put it to the Trustees of the Felton Bequest, set up by Alfred Felton, an Australian

entrepreneur. Half of the Felton Bequest was to be used to acquire and donate works of art to the National Gallery of Victoria.

Percy went from Paris to Dijon by train on 31 May 1946. Paul Quarre had organised a series of receptions in honour of Percy to testify to Dijon's gratitude for his gift of the small choirboy carrying the candlestick, permitting the restoration of the two choirboys to the head of the funeral cortège on the tomb of Jean sans Peur.

Percy was met at the station by Paul Quarre and M. Pageaux, wearing the uniform of the head guardian of the museum, and was taken to the best hotel in Dijon, La Cloche. Quarre found that Percy spoke French very well, with a quaint accent sprinkled with the slang that he had learnt from artistic circles when he lived in France. The next morning, Saturday 1 June 1946, Percy visited the museum and had lunch at the home of M. Fyot, the Deputy Mayor. Percy then went to the bibliothèque where an exhibition had opened of the treasures from Châteauneuf (the château in the Côte d'Or where they had been stored during the War), among which were those belonging to the dukes of Burgundy.

At the museum, in the Salon Condé, adorned with the English flag, the Society of the Friends of the Museum had organised a reception in Percy's honour. Felix Kir and Paul Quarre each gave a speech. In response, Percy outlined how Quarre's skilful diplomacy had restored his statuette to the tomb. They then went into the Salle des Gardes where Percy was photographed next to his small choirboy. At the dinner provided by the city at the restaurant Racouchot, Percy was surrounded by the Mayor, his deputies, Georges Connes and Paul Quarre. During the excellent dinner, Percy was presented with the Medal of Honour of the City of Dijon. On Sunday, in the company of Georges Claudon, President of the Chamber of Commerce, and Henri Commandant Charrier, Secretary of the Academy of Dijon, Percy went to Beaune where, after visiting the Hôtel-Dieu and Notre-Dame, they lunched with Louis-Noël Latour where Percy tasted the fine wines Corton-Grancey and Corton-Charlemagne. Percy was enchanted and had not expected to be received in this way.[36]

On 3 June 1946 Paul Quarre wrote to Percy enclosing the newspapers relating to his visit to Dijon, the Bulletin of the Society of the Friends of the Museum of Dijon 1944–45 and a list of the people that Percy had met during his visit.[37] Percy was listed as a member of the Society of Friends in the Bulletin.[38]

On his return to England, Percy wrote to Felix Kir on 7 June 1946 to express his sincere thanks for the warm welcome and magnificent

Percy photographed next to his small choirboy at the Salles des Gardes in 1946

hospitality during his visit to Dijon. He also wanted to thank the City of Dijon for the great honour that they had accorded him in giving him the Medal of Honour of the City. The medal marked a great step in his life, which Percy would never forget.[39] On 14 June 1946 André Dunoyer de Segonzac wrote in reply to Percy's letter of 8 June. Segonzac considered that it had been very stylish and generous of Percy to restore the statuette to the tomb of Jean sans Peur, duc de Bourgogne – a true gesture as a great friend of France and of art.[40]

Percy was re-elected as Chairman of the Society of London Art Dealers on 14 June 1946. At the committee meeting it was agreed that he would write to Lord Hinchingbrooke, setting out the Trade Associations' reasons for strongly opposing the control of exports and imports in any form. The committee was also made aware of an interview that a trade member had had with the Controller of the Import Licencing Department. If confirmation was forthcoming, the import of works of art would be prohibited.[41]

Percy wrote, in confidence, to Kenneth Clark on 15 June 1946 to seek advice on Percy's present dilemma. Clark had long known that it was Percy's intention to leave a number of important pictures and works of art to museums in England by bequest. The discouragement that Percy had received in the past, with rare exceptions, had caused him to most

reluctantly to renounce such ideas. Furthermore, the Louvre would be liable for death duties unless they were waived. Percy could see that he would have to sell all but he still clung to the idea of placing as many as possible of the outstanding examples in environments where he felt that they best suited during his life time. Percy was in his seventieth year and certain disquieting symptoms (heart failure) had caused him to seriously take stock of his position.[42]

Paul Quarre wrote to Percy on 17 June 1946, confirming that he had sent three examples of each of the Dijon newspapers to the Museum of Norwich. Quarre hoped that Percy would return and see them in Dijon.[43]

On 22 June 1946, in reply to Percy's letter, Kenneth Clark had thought initially that the whole of Percy's collection could be given to a place or institution without a gallery such as Reading University; however, he was inclined to favour the idea of a sale of the whole collection with the exception of the La Tour, as he was one of the few important artists still not represented in the National Gallery.[44]

At the end of June 1946 Percy wrote gratefully to Kenneth Clark, agreeing with his advice that the assemblage should be dispersed. Reading was an idea but it had no gallery and works needed constant supervision. Percy would consider the matter further but he could not see any way out of the La Tour going to the National Gallery. It was not likely to have an opportunity of acquiring another example of his work. Percy would considerably reduce the collection and concentrate on the more important items.[45]

Percy invited Paul Quarre to lunch at l'Hôtel du Louvre on 21 October 1946. Percy was distressed not to be able to attend the inauguration of the new galleries at the Musée des Beaux-Arts in Dijon on 16 November 1946. Percy showed Quarre photographs of his pictures, leading Quarre to wonder whether Percy was going to make a new gift to the museum in Dijon.[46]

The January 1947 committee meeting of the Society of London Art Dealers continued to be concerned about imports and exports. The society had obtained copies of Hansard with the debate on the Exchange Control Bill giving the efforts of David Eccles on behalf of the Fine Art Trade. Before his speech in the House, Eccles had received a copy of the Memorandum that concisely stated the problems that affected the art dealers of Britain. As a result of correspondence from the society, an exhibition of original paintings at Harrods had been closed.[47]

On 28 January 1947 Quarre sent Percy photographs of the visit of the British Ambassador, Duff Cooper, to the Musée des Beaux-Arts in

Dijon.[48] The Ambassador had visited the museum on 18 November 1946 and had been accompanied by Lady Diana Cooper. Paul Quarre had taken them through the new galleries. The Ambassador was particularly interested in the tombs of the Dukes of Burgundy and Quarre showed him the statuette given by his compatriot, Percy Moore Turner.[49]

In June 1947 Percy spoke to René Varin, Cultural Attaché at the French Embassy. Following this conversation, Percy wrote to Varin on 20 June 1947. Percy proposed to give three pictures to the Louvre as a token of gratitude to France for all the never-failing assistance and sympathy, which she had extended to Percy throughout his career. These pictures were *St Joseph, the Carpenter* by Georges de La Tour, *Portrait of*

Percy pictured by the Abbot's Kitchen, Glastonbury Abbey, showing his increased frailty

a Man with a Blind Eye Holding a Flute by François Clouet and *Romantic Landscape with Battle Scene* in the foreground by Géricault. This was on condition the transfer of the pictures from Percy to the Louvre incurred no expenses whatsoever either to Percy or to his Trustees in the case of his death. This proposition was valid until 1 October 1947, as Percy wanted an early a solution as possible due to the state of his health. In addition, Percy offered to the French government his French School portrait of *Toussaint L'Overture* for £400 and John Constable's *Helmingham Dell* for £5,500.[50]

It would take René Varin and Percy's solicitor and accountant until 6 May 1948 to obtain a satisfactory ruling whereby the Louvre was exempted from paying British death duties on the three pictures.[51]

In August 1947, Percy wrote to Jean Frélaut to tell him that he had been rather ill for the previous six months. He had fluid in his feet and legs. He could not walk much and the doctors had advised him to rest at home and do almost nothing. He was allowed to go to London once or twice a week so that he could see to his business affairs, but only if he went door to door by car. From time to time, he was forced to rest in bed all day.

The doctors were unable to reduce the fluid, and it continued to build up in the other parts of his body. Percy had to say goodbye to all his journeys to France and elsewhere, but he always had his pictures, drawings, etchings, other works of art and his memories of times past to console him. Life was difficult, especially for his wife, as food was so scarce due to rationing.[52]

Percy wrote again to Jean Frélaut in December 1947. Obtaining food continued to be a problem and Percy had been forced to stay in bed and undergo two operations to try to take the fluid away but it was not certain that it would not return. Percy's doctors had forced him to stay in his house for weeks. Percy accepted that we lose friends with age, however, he was sad that Bonnard, Marquet, Asselin and Tristan Bernard were all dead. He was over seventy years old, but he had had a magnificent life and he had nothing to regret.[53]

René Huyghe wrote to Percy in December 1947 to ask for the price of Constable's *Helmingham Dell* and if Percy would agree for the painting to go to the Louvre.[54] The painting had arrived at the Louvre by the beginning of February 1948 and had come before the Committee of the Directors and the Council of the French Museums who had agreed the necessity to acquire it. However, the price exceeded all the resources for all the departments at the Louvre for the first three months of the year.[55] Percy then reduced the price to £5,000.[56] This price was accepted unanimously by the Committee of the Council.[57]

On 11 February 1948 Percy was re-elected as the Chairman of the Society of London Art Dealers. The committee meeting was attended by Ben Levey and the Vice-Chairman of the Antique Dealers' Association. Percy expressed the society's appreciation of the efforts that Levey had made and was still making on behalf of the Fine Art Trade in allow the importation of works of art on a basis that satisfied British art dealers.[58]

Percy wrote to Kenneth Clark on 22 February 1948, as he had learnt that Clark was ill. Percy had also been very ill with dropsy. For ten months he had been confined to Oxnead with four months in bed. He was recovering, to the doctor's amazement. Twice they thought he would die but he recovered. Percy was still very weak and could not do what he did in the past. 'After all, I am now past 70 and have not had an easy life, but a more interesting one, I certainly cannot grumble.'

Constable's *Helmingham Dell* had gone to the Louvre. 'They set their heart upon it and this is the second time they have tried to acquire it.' It was only the rapid disintegration of the frame that impeded their first attempt and so, thanks to Kenneth Clark, the National Gallery received Constable's *Hadleigh Castle* and the Louvre *Helmingham Dell*. Percy was delighted.[56]

Kenneth Clark was delighted to see Percy writing again, as he had had many alarming accounts of Percy's health and let him know that 'we cannot spare you at this time'. Kenneth Clark was now on the Conseil Artistique at the Louvre and was glad they had bought *Helmingham Dell*.

Clark wanted Percy to meet his friend, John McDonnell, who was buying for the Felton Bequest.[60] Percy was only too pleased to meet him. He had a number of pictures at Gerrards Cross and others at Golden House in Soho, London, still to be fully sorted out following the confusion of the War.[61]

Percy wrote to René Huyghe on 31 March 1948 updating him on the negotiations with the British Treasury over the three pictures. He also enclosed a photograph of a picture that had come into his hands. Percy was certain that it was not a copy but a picture of the period of Georges de La Tour, either by the master himself or by one of the painters in his immediate circle.[62] The picture was of great interest.[63] René Huyghe thought that the picture did show similarities with La Tour but it revealed other differences. When Thérèse Bertin-Mourot, Paul Jamot's niece, saw it in September 1948, she thought that the picture, now referred to as Percy's Jerome, was not by La Tour. A painting of an old man reading by candlelight by Giovanni Serodine was also found along with other small European masters.[64]

Percy wrote to Jean Frélaut on 8 May 1948 to give him his news. Percy's

wife needed a surgical operation for her varicose veins and would have to be hospitalised for at least twelve days but he was making progress.[65]

Miss Barnard, Curator of the Castle Museum, Norwich, wrote to Percy on 15 May 1948 to congratulate him on his second miraculous recovery and the outcome of the prolonged negotiations with the Treasury. She also thanked Percy for the gift of a shagreen case. Percy had always been very kind to her and it would be a memento of not only a good friend but was a symbol of all the good shows he had put on at Norwich and all the 'fights' they had had down the years. 'And what a fighter you are!'[66]

Percy also sent a gift of a cigarette box to Geoffrey Eastwood, who thanked Percy by letter on 24 May 1948, saying that he would treasure it as a reminder of their long friendship. They were both Yorkshire men and they had travelled together in England. Geoffrey Eastwood was so glad to hear that the problem of the three pictures – by Le Tour, Clouet and Gericault – had been settled and he offered to buy the Toussaint for £175. He also begged Percy to take things a bit slower for the sake of his friends.[67]

On 14 June 1948 Kenneth Clark wrote to let Percy know that he had had his summons to a special meeting of the Conseil Artistique at the Louvre where Percy was presenting three splendid pictures. Kenneth Clark could not be there as he had whooping cough but 'I must write to tell you how greatly I admire your generosity in giving the Louvre these masterpieces. I wish I could be present at the meeting to thank you in person.'[68]

On 17 June 1948, Georges Salles, Director of the Museums of France, in the presence of Sir Oliver Harvey, the British Ambassador, gave the address on the occasion of the donation of the three pictures to the Louvre.[69] Percy arrived in Paris at the same time as his pictures,[70] and was accompanied to the ceremony by his wife, his secretary, Miss Campbell-Orde, and his doctor.[71] Among Percy's friends that attended were André Dunoyer de Segonzac, Thérèse Dorny, the French film actress, Thérèse Bertin-Mourot, Alphonse Bellier and his wife, and Claude Roger Marx.

Two days later, on Saturday 19 June 1948, Percy held a dinner at the Hotel Louvre for his friends, André Dunoyer de Segonzac, Thérèse Dorny, Claude Roger Marx, Alphonse Bellier and his wife.[72]

Percy returned to England on the Sunday. André Dunoyer de Segonzac intended to see Percy off at Gare du Nord but he missed the 10 am train at Chaville and arrived too late. Segonzac wanted to tell Percy again how much his visit had touched them all and how they had been moved that he had not hesitated to make the effort to come himself to make this magnificent gift to France.[73]

Percy in 1948

At the end of June 1948, Percy sent Kenneth Clark photographs of the three pictures he had given to the Louvre. Percy wished that Kenneth Clark had been at the ceremony that Percy considered went well.[74] Percy wrote again to Kenneth Clark at the beginning of July 1948 to give him a report on the ceremony at the Louvre. 'The handing over of the pictures at the Louvre was really a marvellous show. Everybody was there, including the British Ambassador and his wife. Speeches galore – I had to make an improvised one naturally in French. A most excellent lunch at the Louvre followed.

'The French could not have done more. Rosewood seats, reserved rooms at my old hotel and a Government Chantilly opened specially for us and its charming and erudite Conservateur, Monsieur Malo, devoted four hours to show us the hidden treasures.'

It was an anti-climax arriving home and Percy was tired, so he spent a few days in bed. The doctors decided on another operation, the third in fifteen months. The fluid had menacingly returned. Although he recovered from the operation, the doctors told Percy that he must resign himself to a future of very limited activity and, as the fluid returned, further operations would be needed. Percy found the operations demoralising but, fortunately, not painful.[75]

On 4 July 1948 Paul Quarre hosted a visit to the Musée des Beaux-Arts in Dijon of the foreign curators who had taken part in the International Council of Museums (ICOM) Congress in Paris. Quarre had explained to them how Percy's generosity had allowed the pair of choirboys from the tomb of Jean sans Peur to be restored to their original position. Taking the floor in the Salle des Gardes, in the name of his colleagues, M. van Puyvelde proposed that a mark of gratitude should be expressed to Percy by the ICOM for Percy's handsome gesture, which had international significance.[76]

George Salles wrote to Percy on 2 August 1948 about the decision to inscribe Percy's name on the Grand Donateurs's plaque in the Apollon Rotonde in the Louvre. Unfortunately, this could not be carried out during the holiday period. Percy's name would also be engraved on a bronze medal, as was the custom the museum presented to its benefactors.[77]

At the end of September 1948 Georges Salles wrote to Percy, as the Museum of Decorative Arts, which was in the same building as the Louvre and under the control of Salles, was organising an exhibition of arts from Alsace and Lorraine at the instigation of M.R. Schuman, the Minister of Foreign Affairs. Georges Salles sought Percy's consent to move the La Tour that Percy had given from the Pavilion Denon to join the other La Tours in the exhibition.[78]

At the beginning of November 1948 Georges Salles sent Percy an invitation to a lecture on 'Les Nouveau Trésors du Musée du Louvre' to be given by Pierre Verlet, Chief Curator of Objets d'art at the Louvre and Curator of the Musée de Cluny, at the French Institute in London on 4 November 1948. Salles had asked M. Verlet, on his behalf, to present Percy with the Medal of the Grand Donateurs of the Museums of France, engraved with Percy's name.[79] Percy does not seem to have attended this lecture. Instead, Percy went to the French Embassy at the end of May 1949, where the French Ambassador presented him with the medal; Percy was surprised and pleased that Kenneth Clark was also at the presentation.[80]

At the end of November 1948, Thérèse Bertin-Mourot let Percy know that the three pictures he had given to the Louvre would appear in her *Bulletin* (*de la Societé Poussin*). The La Tour had two tablets, 'Donne par Mr. Percy Moore Turner en Memoire de Paul Jamot' and 'Georges de La Tour Saint Joseph Charpentier'. This is the only document in which it is implied that the La Tour was given in memory of Paul Jamot.[81]

At the December 1948 meeting of the Society of London Art Dealers, Percy stepped down from the Chairmanship on medical grounds. 'Members referred to the able manner in which Mr. Turner had conducted the chair for many years and it unanimously resolved to record the sincere thanks and appreciation of Mr. Turner's services.'[82]

On 11 December 1948 Percy wrote to Jean Frélaut in a very reflective mood. Percy found the world very troubled and discontented. The struggle between religion and pure materialism was very grave. In one way or another, Percy had enough faith to believe that the spiritual side would win in the end.

Percy's health was a little better and his doctors were happy with his progress. Three times his doctors had condemned him to death but, with the grace of God, he was still here. His activities had to be very limited which was difficult for Percy to follow as he was used to an active life. However, Percy continued to have successes in 1948.[83]

Jean Frélaut sent Percy an exquisite etching at the end of December. Percy would keep it among his Frélaut collection which was becoming very large. The etchings were in good company: Rembrandt, Van Dyck, Goya, Meyron, Ostade, van Ruisdael, Toulouse, Segonzac and others. Percy looked at them often. They gave him great joy and blotted out, momentarily, all thoughts on the terrible situation of the entire world. Percy often thought of his visits to Vannes and the welcome that Madame Frélaut, Frélaut and his family always gave Percy.[84]

The last article that Percy would have published before his death appeared in the *Apollo* in February 1949 and was entitled 'John Sell Cotman. A recently discovered early work in oil.' Dr Geoffrey Bourne had discovered by accident a view of the beach at Folkestone in oil on canvas with a frame bearing the name 'John Sell Cotman' in a secondhand shop in London. Subsequently, Dr Bourne came across a picture by William Marlow, the property of Mr John Borthwick, which was almost identical to that of Cotman. Marlow was in much demand by the collectors of the period and Percy suggested that Cotman was so impressed by it that he adopted the theme, with important modifications, for his own picture. Percy considered the Cotman to be not only an important oil painting by the artist but also, perhaps, the earliest effort in the oil medium from his brush yet known and Percy, on technical grounds, dated Cotman's *Folkestone* to between 1806 and 1807.[85]

In May 1949 Percy was in the process of arranging his affairs, following the advice of his doctors. Percy could live on for several years or he could pass away at any moment. He proposed to bequest most of his collection of Frélaut's drawings, etchings and watercolours to the British Museum and the Museums of the University of Oxford and Cambridge.[86]

On 1 July 1949 Percy bought a *Portrait of a Girl*, French School, head and shoulder portrait of a sixteenth-century young girl, from P. & D. Colnaghi.[87] Judging from a letter Percy sent René Huyghe on 26 May 1949, Percy had met René Huyghe at the French Embassy when he had been presented with his medal by the French Ambassador and Percy had shown Huyghe the picture's photograph.[88] In reply, on 3 June 1949, René Huyghe thanked Percy for showing him the picture. René Huyghe was happy to study the picture in Paris and to show it to his colleagues.[89] René Varin arranged for the picture to be sent to the Louvre.[90] *La Petite Princesse* arrived at the Louvre in August 1949 for authentication as a François Quesnel.[91] This picture would be exhibited in the Louvre in November 1950 after Percy's death, having been attributed to Quesnel by René Huyghe.[92] It would eventually be returned to England in 1953 to be sold to a private collector.[93]

On 1 September 1949 Percy wrote to Jean Frélaut to report that his health was slowly declining. More and more, he was forced to rest at home with an injection once a week, which left him weak. However, he was able to tell Jean Frélaut that, as from the previous day, France had conferred on Percy the Commander of the Légion d'Honneur. Percy could not tell Frélaut how this had touched him.[94]

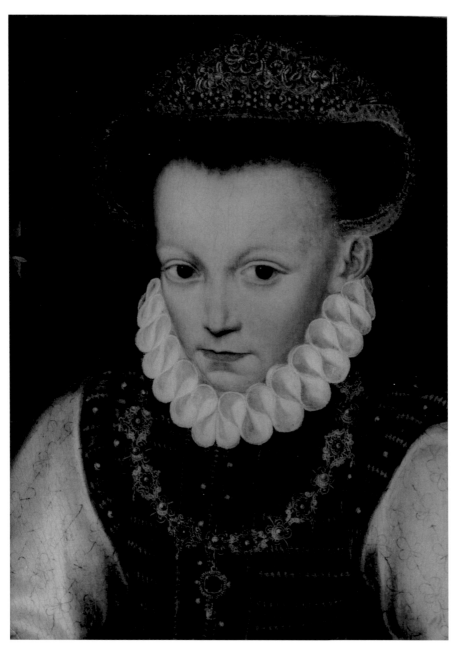

Attributed to François Quesnel, *La Petite Princesse* (photograph of the original painting)

On 29 October 1949 the French Ambassador presented Percy with the Commander of the Légion d'Honneur. Percy had been admitted to St Bartholomew's Hospital where he had to stay for a month while they extracted a very great quantity of fluid from the region of his heart in two operations. As a consequence, while he was being presented with his decoration, he was put on oxygen to give him enough strength to cope with the excitement.[95] His promotion to Commander was in recognition of his sustained promotion of French Art internationally, and as a gesture for having presented three oil paintings of the French School to the Louvre.[96]

In December 1949 Percy won a libel case against the *Daily Mail*. In 1946 and 1947 Percy had been commissioned by the Trustees of the late Lord Lonsdale to catalogue for sale by auction the collection of paintings at Lowther Castle. Among these was one that Percy had identified as *The Resurrection of Christ* by Paul Veronese and so described it in the catalogue. In June 1949 the *Daily Mail* had published an article stating that another London art expert had recently made the discovery that this picture was a Veronese that had been lost for centuries. The article went on to say that the catalogue of the Lowther Castle sale did not state that the picture was by Paul Veronese. Percy had regarded this as a serious libel on his competence as an art expert.[97]

After Christmas 1949 Percy became very ill and was forbidden from doing anything. In consequence, he was not able to write and thank Jean Frélaut for the etchings that he had sent to Percy, his wife and son until 4 February 1950 when he had felt a little better but he was only able to write a short letter.[98]

In February 1950 Percy was asked if he would lend further works by Constable to the Venice Biennale to be held later that year. He had already agreed to lend the *Mother and Child*. The Director of the Fine Arts Department of the British Council asked to borrow *Summer Evening after Shower, Distant View of Salisbury* and *Devil's Dyke, Brighton*.[99]

Percy also bought the print, *Stoning of Stephen* by Rembrandt, from the printmaking firm Craddock & Barnard. Harold Wright of P. & D. Colnaghi looked at it for Percy at Craddock & Barnard and then took it away. Colnaghi was not in a position to help Percy with his duplicate prints, so Harold Wright suggested that Sotheby's was the solution.[100] In September 1950 Wright made a list of prints that Percy had proposed to send to Sotheby's for auction and sent it to Percy for his perusal and agreement, and a draft letter to accompany them to Sotheby's requesting that they were sold as 'Property of a gentleman'.[101]

In May 1950 the art dealer and art historian Germain Seligman wrote to Percy asking if he could meet Percy during his visit to Europe.[102] Percy replied that he had been ill. He had given up 7a Grafton Street and his pictures had been stored in two rooms in London where they were cared for by his secretary.[103] Seligman had been looking forward to seeing Percy but postponed a meeting until another visit to England. He wanted to see the pictures in London.[104] While Seligman was staying at Claridges, Miss Campbell-Orde offered to show him a fifteenth-century painting of St George and a painting of two Saints by Lorenzo Monaco.[105]

On 5 June 1950, an exhibition, 'Quelques Artistes Français de la collection P. M. Turner', opened at Maison Français, 72 Woodstock Road, Oxford. The twenty-six pictures had been chosen from Percy's collection by René Varin and included three Géricaults, three Millets, one Signac, five Segonzacs, five Daumiers, one Maillol, two Corots, one Marchand, one Delacroix, one Degas and one Despiau.[106] René Varin wrote to Percy on 14 June 1950 to tell him that the opening had been a great success and sent Percy a copy of *En Vedette*, the journal of the French Club, Oxford, in which the preface of the catalogue was reproduced. In the same letter, René Varin confirmed that the Exchange Office at the Louvre had agreed to the transfer of money due to Percy for the sale of three still-life pictures.[107]

On 17 June 1950 Percy replied to a letter from the art dealer Dudley Tooth about Goya's *The Nude Maja* and Delacroix's *Odalisque*. Percy wanted to sell *The Nude Maja* if he and Tooth could do reasonably well out of it. Percy had paid a large sum of money for the Delacroix and had refused to sell it several times but circumstances were different now. Percy suggested that either Tooth or Smart show the photograph and particulars to John McDonnell, the buyer for the Felton Bequest, Melbourne. The price would be substantial. The doctors had been kindness itself but did not seem to hold out much hope of improvement in his condition, so Percy was impelled to attempt to put his affairs in the best order that he could.[108] Percy had also again been giving consideration to the fate of his collection and had been discussing this with Harold Wright.[109]

In July 1950 Percy tried to sell Gainsborough's *Autumn Landscape*, which he had obtained from the Ernest C. Innes collection when it was sold at Christie's in 1935 and which had, at one time, been the property of the British watercolour landscape painter Francis Towne. Percy offered the picture to the Castle Museum, Norwich, for £2,000. He wanted Miss Barnard to treat this as confidential as, if Percy sold it elsewhere, he would not be prepared to accept such a sum. However, Percy wanted it to go to

a place and collection close to his own heart and that fact put his mind at rest regarding its permanent destination. If funds were inadequate at that time, Percy was quite prepared to wait a reasonable time for the money. Percy placed an embargo on asking the National Arts Collection for aid in its purchase for personal reasons. Percy suggested that Miss Barnard came to lunch on Monday 24 July. He could arrange for the picture to be brought from the Golden House and Miss Barnard could take it back with her if she thought the picture desirable.[110]

Percy proposed to write his memoirs with the help of Andrew Shirley. On 23 August 1950 he wrote to André Dunoyer de Segonzac to ask if Shirley could see Segonzac so that he could arrange to see Segonzac's memorabilia. Segonzac confirmed on 2 September that he would be delighted to see Andrew Shirley when he came to Paris.[111]

In August 1950, Percy consulted his solicitors, Messrs Boodle, Hatfield & Co., with a view to altering his will of 5 October 1949. He had realised that he had made a grave miscalculation in making the number of bequests in his will which would leave his wife, Mabel, with an inadequate income after his death. The intention was to revoke a number of bequests and Percy's solicitors did send him a letter to remind him that they still awaited his instructions to alter the will, crossing out the pictures to certain museums. Percy partly drafted a letter on 5 September 1950 to his solicitors in which he prepared instructions to them with a list of cancellations. Mabel, thinking that there was only a temporary worsening of Percy's condition, persuaded Percy to set aside all correspondence and business matters until he felt more able to cope with them. Unfortunately, he died quite suddenly very shortly after, and before he could carry out his intention to alter his will.[112]

Percy died at his home, Oxnead, in Buckinghamshire on 19 September 1950.[113] His life had become extremely difficult and he wanted it to end and to find peace. The end was gentle and peaceful, and Mabel sensed that he, in the end, achieved his wish.[114] He was cremated on 22 September 1950 at Woking Crematorium and his ashes were dispersed in the grounds of the crematorium.[115]

It was Percy's wish that there should be no flowers or letters,[116] but his friends in France were unaware of this. Georges Salles was deeply moved by the news of the death of his great friend, Percy Moore Turner. The sincere and sad condolences were addressed to Percy's wife in the name of the Museums of France.[117] André Dunoyer de Segonzac was also profoundly affected by the loss of his unique friend.[118] René Huyghe

was overcome with grief: he had lost not only a friend but also, as the Conservator of Paintings for the Louvre, the constant interest and support that Percy brought to the museum.[119]

At the November 1950 meeting of the committee of the Society of London Art Dealers, a silent standing tribute was paid to Percy's memory.[120]

POSTSCRIPT

Percy's will of 5 October 1949 was legally binding and probate was granted on 5 February 1951.[1] The three executors then had to raise the monies to meet the liabilities of his estate which included death duties, legacies and the Appropriated Fund which was to be set up to provide Percy's widow with 'adequate maintenance and comfort'.[2]

The relationship between the executors and Mabel were strained, as she had to accept the decisions of the executors in selling Percy's collection and parting with pictures of which she was particularly fond.[3] The Appropriated Fund of £10,000 was not set up until March 1952.[4] In the interim, Percy's widow had to draw on her own capital.[5]

The executors continued to sell Percy's collection at what Mabel considered to be at unnecessarily low prices.[6] In April 1956 the executors had to sell some of the investments held in the estate to pay off the overdraft that would have hung over Percy's son in the future.[7]

By October 1956, Mabel was unable to afford the insurance on the pictures in which she had a lifetime interest under Percy's will.[8] Her son, Geoffrey, had become terminally ill in 1955 and she was providing financial help as he was unable to work. Letters were sent out to the museums that were to receive pictures listed under Schedule II of the will, asking if they wished to accept the pictures in the event of her waiving her lifetime interest. The letters made the museums aware of Percy's widow's and son's private circumstances.[9] A number of the museums surrendered their rights to the pictures bequeathed to them.[10]

Miss Campbell-Orde continued to work at Golden House after Percy's death. At the beginning of October 1951 she had to undergo a major operation and took about two months to recuperate.[11] She did return to work,[12] but she then had to have a second operation.[13] She died on 31 July 1952 at Knaresborough Nursing Home, Sawbridgeworth, Hertfordshire.[14]

St Joseph, the Carpenter by Georges de La Tour was loaned by the Louvre to the Royal Academy in 1958 for its Winter Exhibition. Percy was criticised for not having given it to the nation. A letter from Andrew Shirley to the *Daily Telegraph* was published on 12 March 1958 explaining the circumstances in which the picture had been given to the Louvre.[15]

Percy's son, Geoffrey, died on 29 April 1958 at Stoke Mandeville Hospital, Aylesbury,[16] leaving three children: Sarah Annabel (1951–), Penelope (1952–2001) and Roger (1955–).

The Hon. Andrew Shirley had had periods of ill health throughout the period of his executorship.[17] He died at his home in Beaconsfield on 20 June 1958.[18]

André Dunoyer de Segonzac continued to correspond with Percy's widow until his death in 1974.[19]

Mabel died on 20 October 1978 at Oxnead.[20]

In July 2012 Dimitri Salmon, Collaborateur Scientifique at the Musée du Louvre, made contact with Percy's two remaining grandchildren. He had been searching for them since 2011. From this date, Dimitri Salmon and Percy's granddaughter worked collaboratively to piece together the life of Percy Moore Turner. This joint research culminated in the exhibition 'Le Saint Joseph charpentier de Georges de La Tour, histoire d'oeuvre' (3 July–2 October 2016) in the Museum of Georges de La Tour in Vic-sur-Seille with its accompanying catalogue, both of which pay homage to Percy's life, and this biography by his granddaughter.

ACKNOWLEDGEMENTS

Above all, I would like to thank Dimitri Salmon for working with me to research the life of my grandfather. If he had not contacted our family in 2012, I would have never embarked on this venture.

My research has taken me to many places to glean information about my grandfather. I therefore want to thank the people who have helped me. These include Ceri Brough (National Gallery, London), Dr Jon Whiteley and Dr Caroline Palmer (Ashmolean Museum, Oxford), John Madin (Royal Albert Memorial Museum and Art Gallery, Exeter), Mathew Watson and Kirsty Haikney (Bolton Library and Museum Services), Rebecca Milner (Manchester City Galleries), David Morris (Whitworth Art Gallery, Manchester), Dr James Peters (The University of Manchester Library), Glenys Wass (Peterborough Museum), Dr Georgia Bottinelli and Fiona Ford (Castle Museum, Norwich), Martin Brown (great, great nephew of Frank Hindley Smith), Nicola Euston (The Atkinson Art Gallery, Southport), Pat Hewitt (Robert Sainsbury Library, University of East Anglia), Christopher Battiscombe (Society of London Art Dealers), Catherine McIntyre (Archives, British Library of Political and Economic Science) and the staff of the Courtauld Institute Library, Tate Library and Archives and the National Art Library in London.

Finally, I would like to thank Tessa Card and Jacky Statham for reading my manuscript and making helpful suggestions.

ABBREVIATIONS

Frequently Cited People

ACB	Dr Albert Coombs Barnes
CLF	Charles Lang Freer
FHS	Frank Hindley Smith
GMT	Geoffrey Moore Turner
JF	Jean Frélaut
RJC	Russell James Colman
JQ	John Quinn
MGT	Mabel Grace Turner
PMT	Percy Moore Turner

Organisations and Selected Sources

AMN	Archives des Musées Nationaux, Paris
BFA	Barnes Foundation Archives, Philadelphia, PA
BM	*Burlington Magazine*
CIL	Courtauld Institute Library, London
JFA	Jean Frélaut Archives, Vannes (France)
JQMC	John Quinn Memorial Collection, New York, NY
JS&Co	Jacques Seligmann & Co. Records, 1904–78, Archives of American Art, Smithsonian, Washington, DC
LSE	London School of Economics and Political Sciences Library, London
NAL	National Art Library, Victoria and Albert Museum, London
NYPL	New York Public Library, New York, NY
SLAD	Society of London Art Dealers
TFPs	Turner Family Papers
TL	Tate Library, London
TLA	Tate Library Archives, London

ENDNOTES

1. CHILDHOOD – FROM HALIFAX TO NORWICH

1. Hargreaves, John A., *Halifax* (Carnegie Publishing, Lancaster, 2003), p. 127.
2. Ibid., p. 128.
3. Ibid., p. 131.
4. Censuses, England, National Archives.
5. *Kelly's Directory of the West Riding of Yorkshire*, 1867.
6. *Kelly's Directory of the West Riding of Yorkshire*, 1971.
7. *Slater's Royal National Commercial Directory of Yorkshire*, 1887.
8. *Kelly's Directory of the West Riding of Yorkshire*, 1889.
9. TFPs: unpublished autobiography PMT, p. 1.
10. 1851 Census, England, National Archives.
11. West Yorkshire, England, Marriages and Banns 1813–1935.
12. England and Wales Free BMD Birth Index 1837–1915; West Yorkshire, England, Births and Baptisms 1813–1900.
13. 1881 Census, England, National Archives.
14. TFPs: unpublished autobiography PMT, p. 1.
15. *Catalogue of Miscellaneous Engravings and Watercolours*, including the properties of Thomas Turner Esq. of Norwich sold by Auction by Sotheby, Wilkinson and Hodge (National Portrait Gallery, London, 1895), pp. 6–7.
16. CIL: Catalogue of the valuable collection of oil paintings, drawings, prints, etchings, coins, books, microscope, musical instruments, etc. with Maddison, Miles and Maddison held at 42 Mill Hill Road, Yarmouth, on Monday 5 April 1897.
17. PMT military service history, 8 December 1915; scrapbook concerning school events. Norfolk Records Office D/ED 23/11/746X3.
18. Rawcliffe, Carole and Richard Wilson (eds), *Norwich since 1550* (Bloomsbury, London, 2004), p. 305.
19. 1891 Census, England, National Archives.
20. Education leaving age. Accessed 17 August 2017, http://www.politics.co.uk/reference/education-leaving-age 21. Scrapbook concerning school events, Norfolk Records Office D/ED 23/11/746X3.
22. Raban, Sandra (ed.), *Examining the World* (CUP, Cambridge 2008), pp. 38–40.
23. TFPs: unpublished autobiography PMT, p. 1.
24. Norfolk and Norwich Millennium Library NL00031609.
25. Moore Turner, Percy, 'Bagge Scott Exhibition', *Eastern Daily Press*, Wednesday, 17 June 1925.
26. *Norfolk and Norwich Art Circle 1885–1985: a history of the Circle and the Centenary Exhibition 1985* (Circle, Norwich, 1985), p. 27.
27. See above, n. 25.
28. TFPs: unpublished autobiography PMT, pp. 1–2.

2. GETTING STARTED

1. *Who's Who in Art* (The Art Trade Press, Havant, 1927), p. 239, and *Who's Who in Art* (The Art Trade Press Ltd, Havant, 1929), p. 464.
2. TFPs: unpublished autobiography PMT, pp. 2–3.
3. 1901 Census, England, National Archives.

4. *Art Record*, vol. I, 17 August 1901, pp. 406–8, and vol. II, 31 August 1901, pp. 438–40. The *Art Record* was published weekly at this point, later monthly.

5. *Art Record*, vol. II, 1 September 1901, pp. 481–2; 28 September 1901, pp. 497–8; 5 October 1901, p. 515; 12 October 1901, pp. 539–40; 2 November 1901, pp. 597–8; 9 November 1901, pp. 607–8; 16 November 1901, pp. 628–9; 23 November 1901, pp. 661–2; February 1902, pp. 706–8.

6. *Art Record*, vol. II, 19 October 1901, text pp. 545–8 and 565–8, illustrations pp. 549–64.

7. TFPs: unpublished autobiography PMT, p. 3.

8. Tomasi, Michele, 'Émile Molinier'. Institute national d'histoire de l'art, France. Accessed 14 September 2017, https://www.inha.fr>publications>molinier

9. Bos, Agnes, 'Émile Molinier, the "incompatible" roles of a Louvre curator', *Journal of the History Collections*, December 2014.

10. Tomasi, Michele, 'Émile Molinier'. Institute national d'histoire de l'art, France. Accessed 14 September 2017, https://www.inha.fr>publications>molinier

11. Dossier de Personnel d'Émile Molinier F2 4036. Archives nationales, France.

12. TFPs: unpublished autobiography PMT, p. 4.

13. *BM*, vol. 5, no. 18, pp. 544–5.

14. TFPs: unpublished autobiography PMT, pp. 4–5.

15. LSE: DELL/7/3, *Manchester Guardian*, 22 July 1940, states 1905 but the first exhibition at Galerie Shirleys did not take place until December 1905.

16. TFPs: unpublished autobiography PMT, p. 5.

17. *Dictionary of Art Historians*. Accessed 14 September 2017, https://dictionaryofarthistorians.or>dellr18. *BM*, vol. X, no. 43, October 1906, p. 6.

19. *Dictionary of Art Historians*. Accessed 14 September 2017, https://dictionaryofarthistorians.or>dellr

20. TFPs: unpublished autobiography PMT, pp. 5–6.

21. England and Wales Free BMD Death Index 1837–1915; England and Wales National Probate Calendar 1858–1966.

22. Robert Dell archives DELL/7/15, LSE.

23. TFPs: Stock Book A3, PMT 2149-2181; Report of Museums Committee 1929–39, Castle Museum, Norwich.

24. 'English Water-colours in Paris', *The Times*, Monday, 24 December 1906, p. 13.

25. 'Les aquarellistes anglais à Paris', *L'Aurore*, 4 January 1907, p. 2.

26. London, England, Marriages and Banns 1754–1921.

27. Robert Dell archives DELL/7/15, LSE.

28. *BM*, vol. 11, no. 49, April 1907, np.

29. Paris, Bibl. Des Arts Deco Br. 2213/50.

30. *BM*, vol. 12, no. 57, December 1907, p. ii.

31. *BM*, vol. 12, no. 59, February 1908, p. ii.

32. *Bulletin de l'Art ancien et moderne*, no. 375, 14 March 1908, p. 85.

33. *BM*, vol. 13, no. 6, April 1908, np.

34. *BM*, vol. 10, no. 48, March 1907, pp. 340–43, 346–7.

35. *BM*, vol. 11, no. 51, June 1907, pp. 136–9,142–3.

36. *BM*, vol. 14, no. 72, March 1909, pp. 328, 360–61, 364–5.

37. Published by T.C. and E.C. Jacks in London and Frederick A. Stokes in New York.

38. Published by Chatto and Windus, London.

39. Published by T.C. and E.C. Jack in London and Frederick A. Stokes in New York.

40. TFPs: unpublished autobiography PMT, p. 5.
41. LSE: Robert Dell Archives, DELL/6/2. *The Aberdeen Free Press*, 11 October 1906.
42. LSE: Robert Dell Archives, DELL/7/3. *Manchester Guardian*, 22 July 1940.
43. TFPs: unpublished autobiography PMT, p. 6.
44. *BM*, vol. 19, no. 102, September 1911, pp. 326–2.
45. Norwich Castle Museum Committee Report 1910.
46. CIL: PMT archives, PMT-3-06, *Eastern Daily Press*, 30 September, 11 and 17 October 1911.
47. JFA: Letter Henri Barbazanges to Jean Frélaut, 11 September 1911.

3. GALERIE BARBAZANGES

1. Papers of the Galerie Barbazanges, Bibliothèque de l'Union Centrale des arts décoratifs, Musée du Louvre, France.
2. TFPs: unpublished autobiography PMT, p. 6.
3. LSE: Robert Dell archive, letter 7 July 1912, DELL/1/2/62.
4. Unpublished autobiography PMT, TFPs. p. 6.
5. TFPs: unpublished autobiography PMT, pp. 6–7. LSE: Robert Dell archive, letter 7 July 1912, DELL/1/2/62.
6. Alexandre Louis Philippe Marie Berthier, 4th Prince of Wagram (1883–1918) was the son of Bertha Clara von Rothschild of the German branch of the Rothschild family and Louis Philippe Marie Alexander Berthier. Alexandre Berthier was an active collector of Impressionist paintings. He was killed in action at Barento-sur-Cère on 30 May 1918.
7. TFPs: unpublished autobiography PMT, pp. 7–10; Dunbarton Oaks, Research Library and Collection, Washington. DC. Accessed 15 September 2017: https://www.doaks.org/resources/bliss-tyler-correspondence/.../charles-vignier
8. Sutton, Denys (ed.), *Letters of Roger Fry* (Chatto and Windus, London, 1972), p. 44.
9. England and Wales, Free BMD birth Index, 1837–1915.
10. Roux-Frélaut, Cecile, *Jean Frélaut, l'oeuvre peint* (Éditions Apogée, Rennes, 1977), p. 152.
11. John Quinn (1870–1924) was a wealthy second generation Irish-American corporate lawyer in New York City and a collector of modern art.
12. Box 3, JQMC, NYPL: letter PMT to JQ, 17 February 1913; letter JQ to PMT, 21 February 1913.
13. *BM*, vol. 22, no. 119, February 1913, pp. 269–75.
14. Box 3, JQMC, NYPL: letter JQ to PMT, 2 March 1913.
15. Box 3, JQMC, NYPL: letter PMT to JQ, 4 May 1913, letter Levesque and Cie to JQ, 5 May 1913.
16. Box 3, JQMC, NYPL: letter PMT to JQ, 12 June 1913.
17. JFA: Letter Henri Barbazanges to Jean Frélaut, 27 June 1913.
18. Box 3, JQMC, NYPL: letter JQ to PMT, 2 August 1913.
19. Box 3, JQMC, NYPL: letter PMT to JQ, 22 August 1913.
20. TFPs: unpublished autobiography PMT, p. 11.
21. Box 3, JQMC, NYPL: JQ to Levesque and Co., 7 November 1913.
22. Sadler, Michael, *Michael Ernest Sadler (Sir Michael Sadler KCSI) 1861–1943* (Constable, London, 1949), p. 250.
23. Box 3, JQMC, NYPL: letter PMT to JQ, 8 February 1914.

24. BFA: AR.ABC 1914,125, letter ACB to PMT, 5 February 1914.
25. Roger-Marx, Claude, *Dunoyer de Segonzac* (Pierre Cailler, Geneva, 1951), bibliography p. IV.
26. Distel, Anne, *A. Dunoyer de Segonzac* (Flammarion, Paris, 1980), p. 93.
27. Letter Andre Dunoyer de Segonzac to PMT, TFPs: 2 September 1950.
28. TFPs: unpublished autobiography PMT, pp. 11–15.
29. BFA,AR.ABC 1914.125, letters PMT to ACB, 23 November 1914; PMT to ACB, 23 December 1914; ACB to PMT, 7 December 1914; TFPs: unpublished autobiography PMT, p. 15.
30. Letter Henri Barbazanges to Jean Frélaut, 17 January 1915, JFA.
31. BFA: AR.ABC 1915.98, letter PMT to ACB, 5 March 1915.
32. Box 3, JQMC, NYPL: letters PMT to JQ, 23 March 1915, JQ to PMT, 15 April 1915.
33. Inventaire du Fonds Barbazanges ODO 1996–52, no. 1, Musée d'Orsay, Paris.
34. TFPs: unpublished autobiography PMT, pp. 15–16.
35. BFA: AR.ABC. 1915.98, letters PMT to ACB, 1 June 1915, ACB to PMT, 16 June 1915.
36. BFA: AR.ABC.1915.98, letter PMT to ACB, 13 July 1915.
37. Collection WO 339, National Archives, Kew, Richmond, Surrey TW9 4DU.
38. BFA: AR.ABC 1916.90, letters PMT to ACB, 27 February 1916, ACB to PMT, 15 May 1916.
39. Collection WO 339, National Archives, Kew, Richmond, Surrey TW9 4DU.
40. TFPs: preface to the unpublished autobiography PMT, written by his wife, MGT.
41. Collection WO 339, National Archives, Kew, Richmond, Surrey TW9 4DU.
42. Ibid.
43. BFA: AR.ABC 1917.95, letter PMT to ACB, 26 October 1917.
44. JFA: Letter Henri Barbazanges to Jean Frélaut, 17 November 1917.
45. Collection WO 339, National Archives, Kew, Richmond, Surrey TW9 4DU.
46. BFA: AR.ABC 1918.125, letter PMT to ACB 7 December 1918.
47. Sutton, Denys (ed.) *Letters of Roger Fry* (Chatto and Windus, London, 1972), pp. 441–2; Collins, Judith *The Omega Workshop*s (Secker and Warburg, London, 1983), pp. 161, 170, 295; Knights, Sarah, *Bloomsbury's Outsider, A Life of David Garnett* (Bloomsbury Reader, 2015), p. 137.
48. Collection WO 339, National Archives, Kew, Richmond, Surrey TW9 4DU.
49. BFA: AR.ABC 1919.108, letter PMT to ACB 23 January 1919.
50. Sutton, Denys (ed.) *Letters of Roger Fry* (Chatto and Windus, London, 1972), pp. 445–6.
51. Collection WO 339, National Archives, Kew, Richmond, Surrey TW9 4DU.
52. JFA: letter PMT to JF, 6 June 1920.
53. TFPs: unpublished autobiography PMT, pp. 16–20.
54. Box 4, JQMC, NYPL: letter PMT to JQ, 8 January 1923.
55. TFPs: unpublished autobiography PMT, p. 20.

4. STARTING AGAIN – THE INDEPENDENT GALLERY

1. Advertisement for the Independent Gallery, *BM*, vol. 253, April 1924, gives the opening date of 1919.
2. JFA: letter PMT to JF, 25 February 1920.
3. BFA: AR.ABC.1919.108; Charles Lang Freer Correspondence, Box 24, Folder

3, Smithsonian Institute, Washington, DC: letter PMT to ACB, 19 April 1919; letter PMT to CLF, 11 May 1919; letter PMT to CLF 26 June 1919; letter PMT to CLF, 4 September 1919; Box 3, JQMC, NYPL: letter PMT to JQ, 13 May 1919; letter JQ to PMT, 28 May 1919; letter PMT to JQ, 19 June 1919.
4. BFA: AR.ABC.1919.108 letter PMT to ACB, 19 April 1919.
5. TFPs: unpublished autobiography PMT, p. 8.
6. Charles Lang Freer Correspondence, Box 24, Folder 3, Smithsonian Institute, Washington, DC: letter PMT to CLF, 11 May 1919.
7. Ibid., letter PMT to CLF, 26 June 1919.
8. Ibid., letter PMT to CLF, 4 September 1919.
9. Box 3, JQMC, NYPL: letter PMT to JQ, 13 May 1919.
10. Box 3, JQMC, NYPL: letter JQ to PMT, 28 May 1919.
11. Box 3, JQMC, NYPL: letter PMT to JQ, 19 June 1919.
12. BFA: AR.ABC.1919.108 letter PMT to ACB, 4 July 1919.
13. JFA: letter PMT to JF, 21 October 1919.
14. TFPs: preface to unpublished autobiography PMT, written by his wife, MGT.
15. JFA: letter PMT to JF 25 February 1920.
16. TFPs: unpublished autobiography PMT, p. 20.
17. NAL: *Exhibition of Modern French Painting and Drawing*, exh. cat. (London Independent Gallery, London, 1920).
18. *BM,* vol. 36, no. 207, June 1920, pp. 130–32.
19. *Study for 'Homage to Watteau'*, no. 27 in 'Exhibition of Modern French painting and Drawings'. Now at Tate, NO5073.
20. *Landscape* by Pierre Bonnard, no. 26 in 'Exhibition of Modern French Painting and Drawings'. Now at The Fitzwilliam, Cambridge, Object 2377.
21. TFPs: unpublished autobiography PMT, pp. 21–4; Manchester Art Gallery, Councillor Tylecote's report, July 1937, p. 3.
22. *Eastern Daily Press*, 14 March 1940, article 'Pictures for Public Galleries, Generous Bequest to Norwich' by Frank Leney.
23. TFPs: unpublished autobiography PMT, p. 24.
24. Sutton, Denys (ed.), *Letters of Roger Fry* (Chatto and Windus, London, 1972), letter no. 475, 9 May 1920, p. 480.
25. TLA: Charleston Trust, letter Roger Fry to Vanessa Bell, 10 May 1920, TGA 8010.5.810.
26. JFA: letter PMT to JF, 6 June 1920.
27. NAL: *The Exhibition of Recent Paintings and Drawings by Roger Fry*, exh. cat. (London Independent Gallery, London, 1920).
28. *BM,* vol. 37, no. 208, July 1920, pp. 52–7.
29. Sutton, Denys (ed.), *Letters of Roger Fry* (Chatto and Windus, London, 1972), letter no. 476, June 1920, p. 480.
30. Ibid., letter no. 477, p. 481.
31. Sutton, Denys (ed.), *Letters of Roger Fry* (Chatto and Windus, London, 1972), letter 478, pp. 484–5.
32. JFA: letter PMT to JF, 25 July 1920.
33. TLA: Charleston Trust, letter Vanessa Bell to Roger Fry, 26 August 1920, TGA 8010.8.311.
34. JFA: letter PMT to JF, 9 August 1920.
35. JFA: letter PMT to JF, 29 August 1920.
36. Sutton, Denys (ed.), *Letters of Roger Fry* (Chatto and Windus, London, 1972), letter no. 486, Roger Fry to Pamela Fry, p. 492.

37. *BM*, vol. 37, no. 212, November 1920, p. 264.

38. TL: *Pictures by Robert Lotiron and Watercolours by Duncan Grant and Vanessa Bell*, exh. cat. (Independent Gallery, London, 1920).

39. *BM*, vol. 37, no. 213, December 1920, pp. 325–6.

40. Sutton, Denys (ed.), *Letters of Roger Fry* (Chatto and Windus, London, 1972), letter 489, Fry to Marie Mauron, 12 November 1920, p. 494.

41. JFA: letter PMT to JF, 17 November 1920. Report of the Castle Museum, Norwich, 1920, p. 5.

42. *Pommier en Fleurs* bequeathed by FHS to the Ashmolean Museum, WA1940.1.30.

43. JFA: letters PMT to JF 15 December 1920 and 22 December 1920.

44. Louvre: TURNER (PERCY MOORE) Z-62-E correspondence with M. Jamot.

45. *BM*, vol. 38, no. 214, January 1921 pp. 48–9.

46. Louvre: TURNER (PERCY MOORE) Z-62-E correspondence with Paul Jamot.

47. JFA: letter PMT to JF, 5 January 1921; Hotel bill, TFPs.

48. JFA: letter to JF, 15 January 1921.

49. TL and NAL: *Paintings, Drawings and Sculpture by Some Independent Painters and Sculptors*, exh. cat. (Independent Gallery, London, 1921).

50. TL: *Some Contemporary English Artists* (Birrell and Garnett, London, 1921).

51. *BM*, vol. 38, no. 216, March 1921, pp.146–9.

52. JFA: letter PMT to JF, 12 March 1921.

53. Ibid.

54. Whitely, Jon, *Catalogue of the Collection of French Drawings, vol. VII, French School, Ashmolean Museum* (Oxford University Press, Oxford 2000), vol. 1, p. 14.

55. *The Nation and the Athenaeum*, vol. 28, 12 March 1921, p. 834.

56. JFA: letter PMT to JF, 12 March 1921.

57. TFPs: PMT, *The Appreciation of Painting* (Selwyn and Blount, London, 1921).

58. JFA: letter PMT to JF, 12 March 1921.

59. Probably *Boats on the Beach, Etrétat*, now in the Fitzwilliam, Cambridge. *BM*, vol. 38, no. 217, April 1921, pp. 200, 205.

60. JFA: letter PMT to JF 20 April 1921; JFA: letter PMT to JF, 22 April 1921.

61. NAL: *Pictures by Othon Friesz*, exh. cat. (Independent Gallery, London, 1921)

62. *The Nation and the Athenaeum*, vol. 29, 4 June 1921, pp. 376, 378.

63. JFA: letter PMT to JF, 29 May 1921.

64. *BM*, vol. 38, no. 218, May 1921, pp. 221–9.

65. JFA: letter PMT to JF, 15 June 1921.

66. Roux-Frélaut, Cecil, *Jean Frélaut, l'oeuvre peint* (Éditions Apogée, Rennes, 1977), p. 146.

67. Ibid., pp. 41 and 145, given to the Tate Gallery, 1937. Now known as *Wedding Feast in Brittany*.

68. Ibid., p. 61 bequeathed to Fitzwilliam, Cambridge, 1939. *The Brigantine* is now in the Fitzwilliam, Cambridge.

69. JFA: letter PMT to JF, 9 July 1921.

70. JFA: letter PMT to JF, 2 September 1921.

71. BFA: AR.ABC.1921.118, letter PMT to ACB, 15 August 1921.

72. BFA: AR.ABC.1921.118, letters ACB to PMT, 13 and 23 September 1921.

73. Box 4, JQMC, NYPL: letter to JQ, 5 September 1921.

74. Box 4, JQMC, NYPL: letter JQ to PMT, 29 November 1921.

75. JFA: letter PMT to JF, 2 September 1921.

76. Box 4, JQMC, NYPL: letter PMT to JQ, 5 September 1921; BFA: AR.ABC.1921.118, letters PMT to ACB, 28 September 1921.

77. JFA: letter PMT to JF, 7 November 1921.

78. *BM*, vol. 39, no. 225, December 1921, p. 312.

79. TLA: Charleston Trust, letter Vanessa Bell to Roger Fry, 14 December 1921, TGA 8010.8.323.

80. Ibid., letter Roger Fry to Vanessa Bell, 20 December 1921, TGA 8010.5.849.

81. Ibid., letter Roger Fry to Vanessa Bell, 30 December 1921, TGA 8010.5.850.

82. Ibid., letter Roger Fry to Vanessa Bell, 20 December 1921, TGA 8010.5.849.

83. JFA: letter PMT to JF, 23 December 1921.

84. *American Art News*, 10 December 1921 p. 9; *BM*, vol. 40, no. 226, January 1922 p. 43.

85. JFA: letter PMT to JF 14 January 1922.

86. JFA: letters PMT to JF 4 February 1922 and 13 February 1922.

87. TLA: Charleston Trust, letter Vanessa Bell to Roger Fry, 24 February 1922, TGA 8010.8.328.

88. Ibid.,, letter Roger Fry to Vanessa Bell 28 February 1922, TGA 8010.5.854.

89. CIL: *Drawings and a few Oil Paintings by French and British Artists*, exh. cat. (London Independent Gallery, London, 1922); JFA: letter PMT to JF, 29 April 1922.

90. *BM*, vol. 40, No.229, April 1922, pp. 194–7.

91. JFA: letter PMT to JF, 29 April 1922.

92. Stock book A1, TFPs.

93. Singer, Anne, *Paul Maze, The Lost Impressionist* (Autumn Press, London, 1983), pp. 45, 49.

94. TA: *A Tribute to Paul Maze, The Painter and his Time*, exh. cat. (Marlborough Fine Art Ltd, London, 1967), p. 11, TA.

95. TL: *Paintings and Drawings by Bernard Adeney and Keith Baynes*, exh. cat. (Independent Gallery, London, 1922); *BM*, vol. 40, no. 230, May 1922, pp. 253–4.

96. Northampton (MA), Smith College, Neilson Library: *Paintings and Drawings by Vanessa Bell*, exh. cat (Independent Gallery, London, 1922); *BM*, vol. 40, no. 230, May 1922, p. 254.

97. NAL: *Painting and Drawings by Jean Marchand*, exh. cat. (Independent Gallery, London, 1922); *BM*, vol. 41, no. 232, July 1922, pp. 46–7.

98. Bibliothèque Centrale des Musées Nationaux, Ms 308, letter PMT to Paul Jamot, 25 July 1922.

99. *BM*, vol. 40, no. 228, March 1922, p. 139, pl. IIIE.

100. Jamot, Paul, *Les Le Nain* (H. Laurens, Paris, 1929), p. 37.

101. Wine, Humphrey, *Catalogue of the Seventeenth Century French Paintings* (National Gallery, London 2001), p. 198 and p. 201, n. 3.

102. Acquisition dossier for NG3879, letter FHS to Sir Charles Holmes, 17 March 1924.

103. Box 4, JQMC, NYPL: letter PMT to JQ 15 August 1922.

104. TFPs: unpublished autobiography PMT, pp. 25–6.

105. *The Courtauld Collection: A catalogue and introduction by Douglas Cooper, with a Memoir of Samuel Courtauld by Anthony Blunt* (Athlone Press, London, 1954), pp. 74–5.

106. Ibid., p. 4.

107. TL: Jamot, Paul and Percy Moore Turner, *Collection de tableaux français faite à Londres, 20 Portman Square par Samuel & Elizabth Courtauld 1914–1931* (Privately printed, 1935).

108. TFPs: unpublished autobiography PMT, pp. 26–7.

109. *The Courtauld Collection: A catalogue and introduction by Douglas Cooper, with a Memoir of Samuel Courtauld by Anthony Blunt* (Athlone Press, London, 1954), p.75

110. Ibid., p. 1.

111. Ibid., p. 5.

112. House, John, *Impressionism for England. Samuel Courtauld as Patron and Collector* (Courtauld Institute Galleries, London, 1994), p. 22.

113. Ibid., pp. 221–4.

114. Ibid., p. 22.

115. TLA: Courtauld Fund Correspondence, letter Samuel Courtauld to Aitken, 27 March 1926, TG 17/3/4/3.

116. JFA: letter PMT to JF, 9 August 1922.

117. Box 4, JQMC, NYPL: letter PMT to JQ, 28 September 1922.

118. BFA: AR.ABC.1922.136 letter PMT to ACB, 28 September 1922.

119. *Canadian Forum*, vol. III, no. 25, October 1922, pp. 82–4.

120. *The Spectator*, vol. 129, 7 October 1922, p. 463.

121. Box 4, JQMC, NYPL: letter JQ to PMT, 20 September 1922; letter PMT to JQ, 16 October 1922.

122. Ibid.: letter PMT to JQ, 16 October 1922.

123. BFA: AR.ABC.1922.136, letter PMT to ACB, 3 November 1922.

124. JFA: letter PMT to JF, 9 August 1922.

125. BFA: AR.ABC.1922.136, letter PMT to ACB, 9 November 1922.

126. *American Arts News*, 18 November 1922.

127. BFA: AR.ABC.1922.136, letter PMT to ACB, 3 November 1922.

128. Box 4, JQMC, NYPL: letter PMT to JQ, 27 November 1922.

129. BFA: AR.ABC.1922.136 letter PMT to ACB, 17 November 1922.

130. JFA: letter PMT to JF, 11 January 1923.

131. Box 4, JQMC, NYPL: letter PMT to JQ, 15 December 1922.

132. Ibid., 27 December 1922.

133. BFA: AR.ABC.1922.136, letter PMT to ACB, 29 December 1922.

134. Box 4, JQMC, NYPL: letter W.S. Budworth & Son to JQ, 28 December 1922.

135. Box 4, JQMC, NYPL: letter JQ to PMT, 29 December 1922.

136. Ibid., 30 December 1922.

137. Box 4, JQMC, NYPL: letter PMT to JQ, 8 January 1923.

138. Box 4, JQMC, NYPL: letter JQ to PMT, 24 March 1923.

139. Box 4, JQMC, NYPL: cables PMT to JQ, 9 January 1923, JQ to PMT, 9 January1923.

140. Box 4, JQMC, NYPL: letter PMT to JQ, 16 January 1923.

141. Ibid., 23 January 1923.

142. Reid, B.L., *The Man from New York, John Quinn and his friends* (Oxford University Press, Oxford, 1968), p. 572.

143. Box 4, JQMC, NYPL: letters between PMT and JQ, 23 January–27 February 1923.

144. *Arts*, vol. 3, no. 1, January 1923, pp. 25–30.

145. BFA: letter PMT to ACB, 30 January 1923, AR.ABC.1923.324.

146. Box 4, JQMC, NYPL: letter PMT to JQ, 20 February 1923.

147. Box 4, JQMC, NYPL: letter JQ to PMT, 6 March 1923.
148. Box 4, JQMC, NYPL: letter PMT to JQ, 10 February 1923.
149. Box 4, JQMC, NYPL: letter JQ to PMT, 6 March 1923.
149. Ibid., 15 March 1923.
150. Ibid., 20 March 1923.
151. Box 4, JQMC, NYPL: letters JQ to PMT, 26 and 27 March 1923.
152. *BM*, vol. 42, no. 240, March 1923, p. ii.
153. NAL: *Recent Paintings by Roger Fry*, exh. cat. (Independent Gallery, London, 1923).
154. *Arts News*, 14 April 1923, p. 8.
155. Sutton, Denys (ed.), *Letters of Roger Fry* (Chatto and Windus, London, 1972), vol. 2, letter Roger Fry to Virginia Woolf, 20 June 1923, p. 540.
156. Box 5, JQMC, NYPL: cables PMT to JQ and JQ to PMT, 11 April 1923.
157. Box 5, JQMC, NYPL: letter PMT to JQ, 12 April 1923.
158. Ibid., 1, 8 and 17 May 1923.
159. *BM*, vol. 42, no. 243, June 1923, pp. 311–12.
160. Box 5, JQMC, NYPL: letter PMT to JQ, 25 May 1923.
161. Box 5, JQMC, NYPL: cable JQ to PMT, 2 June 1923.
162. Box 5, JQMC, NYPL: letter PMT to JQ, 25 May 1923.
163. NAL: *Recent Paintings and Drawings by Duncan Grant*, exh. cat. (Independent Gallery, London, 1923).
164. *BM*, vol. 43, no. 244, July 1923, pp. 40–45.
165. *New Statesman*, 9 July 1923, TGA 7243.65.
166. Box 5, JQMC, NYPL: letter PMT to JQ, 13 June 1923.
167. Box 5, JQMC, NYPL: cable JQ to PMT, 20 June 1923.
168. Box 5, JQMC, NYPL: letter JQ to PMT, 21 June 1923.
169. Box 5, JQMC, NYPL: letter PMT to JQ, 13 June 1923.
170. TL: *Exhibition of Mr John Quinn's Collection of Earlier Drawings of Augustus John*, exh. cat. (Independent Gallery, London, 1923)
171. Box 5, JQMC, NYPL: letter PMT to JQ, 3 July 1923.
172. Ibid., 12 July 1923.
173. *BM*, vol. 43, no. 245, August 1923 pp. 96–7.
174. Box 5, JQMC, NYPL: letter PMT to JQ, 26 July 1923; cable JQ to PMT, 15 August 1923.
175. Box 5, JQMC, NYPL: letter PMT to JQ, 16 August 1923.
176. TLA: Charleston Trust, letter Vanessa Bell to Roger Fry, 27 September 1923, TGA 8010.8.350.
177. TL: *Exhibition of Paintings, Drawings and Etchings by Andre Dunoyer de Segonzac*, exh. cat. (Independent Gallery, London, 1923).
178. BFA: AR.ABC.1923.324, letter PMT to ACB, 8 November 1923.
179. TL: *Exhibition of Etchings and Lithographs by Toulouse-Lautrec*, exh. cat. (Independent Gallery, London, 1923).
180. Birmingham City University Art and Design Archives, Marion Richardson Collection, IMR/792.
181. Box 5, JQMC, NYPL: letter JQ to PMT, 6 December 1923.
182. Box 5, JQMC, NYPL: letter PMT to JQ, 27 December 1923.
183. *BM*, vol. 43, no. 249, December 1923, p. iv.
184. Box 5, JQMC, NYPL: letter JQ to PMT, 30 January 1924.
185. Box 5, JQMC, NYPL: letter PMT to JQ, 12 February 1924.
186. *BM*, vol. 44, no. 251, February 1924, pp. ii and iv.

187. TFPs: building specifications for Oxnead.
188. Box 5, JQMC, NYPL: letters JQ to PMT, 20 February 1924, and PMT to JQ, 4 March 1924.
189. JFA: letter PMT to JF, 8 March 1924.
190. *BM*, vol. 44, no. 251, February 1924 p. ii and vol. 44, no. 252, March 1924, pp. ii and iv.
191. *Saturday Review*, 5 April 1924, p. 365.
192. Chenil Gallery, *Artist Biographies, British and Irish Artists of the 20th Century*. Accessed 14 September 2017, www.artbiogs.co.uk>galleries>chenil galleries193. Helmreich, Anne and Ysanne Holt, 'Marketing Bohemia, The Chenil Gallery in Chelsea, 1905–1926', *Oxford Art Journal*, vol. 33.1, 2010, p. 56; Holroyd, Michael, *Augustus John* (Pimlico, London 2011), p. 478.
194. Box 5, JQMC, NYPL: letter PMT to JQ, 30 May 1924.
195. Box 5, JQMC, NYPL: letter JQ to PMT, 24 June 1924.
196. *The Arts*, June 1924, p. 356 and *BM*, vol. 44, June 1924, pp. ii and xvi.
197. TLA: Chaleston Trust, letter Vanessa Bell to Roger Fry, 22 June 1924, TGA 8010.8.359.
198. *BM*, vol. 45, no. 256, July 1924, pp. ii and iv.
199. Reid, B.L., *The Man from New York, John Quinn and his Friends* (Oxford University Press, Oxford, 1968), p. 630 and Box 5, JQMC, NYPL: press cuttings.
200. Box 4, JQMC, NYPL: letter Executors of John Quinn's estate to PMT, 22 September 1924.
201. Box 5, JQMC, NYPL: in preparation, *Chenil Gallery Catalogue of Etchings by Augustus John*.
202. *BM*, vol. 45, no. 259, October 1924, pp. ii, iv and 200.
203. *BM*, vol. 45, no. 261, December 1924, pp. iv and 316.
204. NAL: *Exhibition of Paintings of the Tropics and France by Gerald Reitlinger*, exh. cat. (Independent Gallery, London, 1925).
205. *BM*, vol. 46, no. 264, March 1925, pp. ii and iv.
206. *BM*, vol. 46, no. 265, April 1925, pp. ii and iv.
207. NAL: *Water-colour Drawings by Betty Sadler* (Independent Gallery, London, 1925).
208. NAL: *Exhibition of Hand-printed silks and other Fabrics designed by Alec Walker*, exh. cat. (Independent Gallery, London, 1925). No month was given on the catalogue, however, the Independent Gallery was named as Alec Walker's agent.
209. NAL: *A Few Masterpieces of French Painting (Ingres to Cézanne)*, exh. cat. (Independent Gallery, London, 1925).
210. *BM*, vol. 46, no. 267, June 1925, pp. 287–8.
211. Netherlands Institute for Art History, The Hague, Bibliotheck F. Lugt: *Old Masters and a few pieces of Oriental Pottery and Bronzes*, exh. cat. (Independent Gallery, London, 1925).
212. TFPs: *The Centenary of the Norwich Museum, Loan Collection of Pictures Illustrative of the Evolution of Painting from XVIIth Century to the Present Day*, 24 October–1 November 1925, exh. cat. (Norwich Museum, Norwich, 1925), no. 15.
213. TFPs: *The Gainsborough Bicentenary Memorial Exhibition at Ipswich*, 7 October–5 November 1927, exh. cat. (Ipswich Gallery, Ipswich 1927), no. 20.
214. National Gallery, London, NG 5984.

215. Ashmolean Museum, Oxford, WA 1951.009, now listed as after Peter-Paul Rubens.
216. TFPs: letter Paul Jamot to PMT, 21 September 1925.
217. *BM*, vol. 47, no. 271, October 1925, pp. 209–10.
218. *Apollo*, vol. 2, no. 11, November 1925, p. 310.
219. TFPs: unpublished autobiography PMT, pp. 38–9; Sutton, Denys (ed.), *Letters of Roger Fry* (Chatto and Windus, London, 1972), p. 81; London Artist's Association, *Artist Biographies*; Spalding, Frances, *Roger Fry, Art and Life* (Granada Publishing, London, 1980), p. 252.
220. CIL: PMT archives 1/13, *Eastern Daily Press*, 11 January 1926, *Daily Telegraph*, 12 January 1926.
221. Ibid., *Eastern Daily Press*, 9 February 1926.
222. *Saturday Review*, 6 February 1926, p. 157.
223. NAL: 66.H.72-83121, Colman, Russell James and Sydney D. Kitson, *The Colman Collection. A catalogue of the oil paintings, watercolour paintings, pencil drawings and chalk drawings by artists of the Norwich school and others in the collection at Crown Point, Norwich.* (Privately printed, Norwich, 1942), entry nos 138–9, 142–8, 151, 153, 154, 187, 200, 201. Hereafter known as *The Colman Collection* catalogue 1942.
224. Mardle, Jonathan, *Russell James Colman 1861–1946* (Fletcher and Son, Norwich, 1954), pp. 29–30, 35.
225. Ibid., p. 20.
226. Ibid., pp. 89–90.
227. CIL: *Exhibition of Paintings by Simon-Levy*, exh. cat. (Independent Gallery, London, 1926).
228. NAL: *Exhibition of Paintings and Drawings by J.W. Power*, exh. cat. (Independent Gallery, London, 1926).
229. *Saturday Review*, 20 March 1926, p. 366.
230. *BM*, vol. 48, no. 278, May 1926, pp. ii and iv.
231. TL: *Exhibition of Paintings by Lucien Paul Maze*, exh. cat. (Independent Gallery, London, 1925).
232. *BM*, vol. 49, no. 285, December 1926, p. iv.
233. *Saturday Review*, 4 December 1926, p. 679.
234. Norfolk Records Office, letters to Russell Colman re. his Norwich School collection COL 11/15/1-49, letter PMT to JRC, 21 September 1926.
235. BFA: AR.ABC.1926.849, letter PMT to ACB, 1 November 1926.
236. JS&Co Records, Box 398, Folder 20: de Hauke to PMT, 22 January 1927.
237. JS&Co Records, Box 398, Folder 20: cable PMT to de Hauke, 3 February 1927; letter PMT to de Hauke, 3 February 1927; cable de Hauke to PMT, 9 February 1927; cable PMT to de Hauke, 2 February 1927; cable PMT to de Hauke, 11 February 1927; letter PMT to de Hauke, 18 February 1927.
238. TLA: J.B. Manson correspondence, letter Augustus John to Manson, 19 February 1927, TGA 806/1/448; Helmreich, Anne and Ysanne Holt, 'Marketing Bohemia: The Chenil Gallery in Chelsea 1905–1926', *Oxford Art Journal*, vol. 33.1, 2010, p. 60; Chenil Gallery, *Artist Biographies, British and Irish Artists of the 20th Century*. Accessed 14 September 2017, www.artbiogs. co.uk>galleries>chenil galleries239. Norfolk Records Office: letter to Russell Colman re. his Norwich School collections, COL 11/15/1-49; letters PMT to RJC, 17 and 29 February 1927.
240. TL and NAL: *Recent Oil Paintings by Jean Marchand*, exh. cat. (Independent

Gallery, London, 1927).

241. National Gallery Research Centre, London, NG14/89/1.
242. JS&Co Records, Seligmann 3, Box 398, Folder 20, letters C.W. Adams to C. de Hauke, 22 March 1927 and 11 April 1927.
243. CIL: PMT archives 1/13, *Eastern Daily Press*, 5 May 1927, Report of the Castle Museum Committee, 1927.
244. Norfolk Records Office: letters to Russell Colman re. his Norwich School collection from PMT and others, letter PMT to RJC, 9 May 1927, COL11/15/1-49.
245. TL: *Works by Andre Dunoyer de Segonzac*, exh. cat. (Independent Gallery, London, 1927).
246. TFPs: unpublished autobiography PMT, p. 37.
247. CIL: PMT archives 1/13, *Daily Telegraph*, 2 July 1927.
248. National Gallery Research Centre, London, NG14/89/1.
249. JS&Co Records, Seligmann 3, Box 398, Folder 20, letter de Hauke to PMT, 31 October 1927.
250. Ibid., letter PMT to de Hauke, 15 November 1927.
251. BM, vol. 51, no. 296, November 1927, pp. 238–9.
252. National Gallery Library, (P.)/NH 1055/ Sisley/3/1927.
253. JS&Co Records, Seligmann 3, Box 398, Folder 20.
254. Ibid., letters Paris to PMT, 14 January 1928; de Hauke to PMT, 14 January 1928; Paris to PMT, 14 January 1928.
255. Ibid., letter PMT to Germain Seligman, 16 January 1928.
256. Ibid., letter Paris to PMT, 18 January 1928.
257. Ibid., cable Independent Gallery to de Hauke, 24 January 1928.
258. Ibid., letter de Hauke in Paris to PMT, 21 January 1928.
259. Ibid., letter Paris Office Seligman to PMT, 25 January 1928.
260. Ibid., letter PMT to de Hauke, 31 January 1928.
261. Ibid., letter de Hauke to PMT, 8 February 1928.
262. Ibid., letter de Hauke to PMT, 2 February 1928.
263. Ibid., cable PMT to de Hauke, 17 February 1928.
264. Ibid., letter PMT to de Hauke, 27 February 1928.
265. Ibid., letter PMT to de Hauke, 2 March 1928.
266. England and Wales, Death Index 1916–2007, England and Wales Free BMD Death Index 1858–1966
267. TFPs: legal documents setting up trusts for Percy's sister, Maud.
268. Bibliothèque des musées du Louvre 16722, Collection de M. T. ... , de Londres, Tableau Modern, Paris, Hotel Drouot, 2 April 1928, sale 6, Me Alphonse Bellier.
269. JS&Co Records, Seligmann 3, Box 398, Folder 20: letter de Hauke to PMT, 30 March 1928.
270. Ibid., letters de Hauke to PMT, 13 April 1928, PMT to de Hauke, 13 April 1928.
271. Ibid., cable PMT to de Hauke in Paris, 7 May 1928, letter PMT to de Hauke 13 April 1928.
272. Ibid., letters James St O'Toole for de Hauke to PMT, 8 and 29 May 1928; Paris to PMT, 19 May 1928.
273. CIL: *Early English Watercolours and Drawings*, exh. cat. (Independent Gallery, London, 1928).
274. TL and NAL: *Paintings and Pastels by 19th and 20th Century French Masters*, exh. cat. (Independent Gallery, London, 1928).

275. CIL: PMT archives 1/13, *Daily Telegraph*, 20 May 1928.
276. JS&Co Records, Seligmann 2, Box 398, Folder 19, letter PMT to de Hauke, 18 June 1928.
277. Ibid., letter PMT to de Hauke, 14 November 1928.
278. Ibid., letter James St O'Toole for de Hauke to PMT, 3 December 1928.
279. Ibid., letter PMT to de Hauke, 21 June 1928.
280. Ibid., letters PMT to de Hauke, 4 and 11 July 1928.
281. TFPs: postcard, 23 July 1928.
282. TFPs.
283. TL: *Paintings by Renoir*, exh. cat. (Independent Gallery, London, 1928).
284. JS&Co Records, Seligmann 2, Box 398, Folder 19: cables PMT to de Hauke, 20 December 1928, de Hauke to PMT 22 December 1928.
285. TFPs: Stockbook A2.
286. Castle Museum, Norwich, Colman Collection Box File, letter Kennedy North's Secretary to Miss Turner at Crown Point 13 October 1936.
287. JS&Co Records, Seligmann 2, Box 398, Folder 19: letter Adams for PMT to de Hauke, 2 January 1929.
288. Ibid., letter de Hauke to PMT, 15 February 1929.
289. Ibid., letter Lewis for PMT to Miss Lambert, 18 February 1929.
290. Ibid., letter Adams for PMT to de Hauke, 8 January 1929.
291. Norfolk Records Office, letters to Russell Colman re. his Norwich School Collection from PMT and others COL 11/15/1-49, letter PMT to RSJ, 10 January 1929.
292. Norfolk Record Office, letters to Russell Colman re. his Norwich School Collection from PMT and others COL 11/15/1-49, letter, 12 April 1929.
293. TL: *Exhibition of Water-colours and Drawings by Frelaut, Friesz, Marchand, Maze, Segonzac, Signac, etc.*, exh. cat. (Independent Gallery, London, 1929).
294. JS&Co Records, Seligmann 2, Box 398, Folder 2: letter Lewis for PMT to de Hauke 25 January 1929.
295. *Saturday Review*, 16 and 23 March 1929, pp. 376 and 420.
296. JS&Co Records, letter James St O'Toole to PMT, 4 April 1929.
297. JS&Co Records, Seligmann 2, Box 398, Folder 19: cable de Hauke to PMT, 23 April 1929.
298. Ibid., letter de Hauke to C.W. Adams for PMT, 3 May 1929.
299. Ibid., letter Adams for PMT to de Hauke, 6 May 1929.
300. Ibid., letter PMT to de Hauke, 28 June 1928.
301. Ibid., cable PMT to de Hauke, 25 June 1929.
302. Castle Museum, Norwich, Colman Collection Documents File, letters between PMT and Mrs Colman 29 April 1929, 5 May 1932, 9, 11 and 28 February and 8 May 1935, 8 and 11 February, 27 July and 5 October 1936. NAL: 66.H.72-83121, *The Colman Collection* catalogue 1942.
303. TL: *Paintings and Pastels by Modern French Masters*, exh. cat. (Independent Gallery, London, 1929).
304. *Collection d'un amateur anglais, Tableau modernes, Paris, Hotel Drouot, 29 May 1929, sale 6. Me. Alphonse Bellier*, exh. cat. Bilblithèque des Musées du Louvre, 17248.
305. NAL: *Maurice de Vlaminck*, exh. cat. (Independent Gallery, London, 1929).
306. JS&Co Records, Selimann 2, Box 398, Folder 19, cable de Hauke to PMT 29 June 1929, letter and cable to de Hauke 1 July 1929, cable de Hauke to PMT 1 July 1929.

307. TFPs: postcards PMT to MGT, 18 October 1928; PMT to GMT from Washington, DC, October 1929.

308. JS&Co Records, Seligmann 2, Box 398, Folder 19, Letters de Hauke to Independent Gallery, G 26 October 1929, Lewis to Messr. de Hauke, 7 November 1929.

309. BFA: AR.ABC. 1929.802, letter PMT to ACB, 26 November 1929.

310. CIL: *Lithographs of Honoré Daumier*, exh. cat. (Independent Gallery, London, 1929).

311. BFA: AR.ABC.1929.802 Letter PMT to ACB, 26 November 1929.

312. JS&Co Records, Seligmann 2, Box 398, Folder 19: cable and letter PMT to de Hauke, 29 November 1929; cables Germain Seligman to PMT, 29 and 30 November 1929; cable PMT to de Hauke, 3 December 1929; cable Germain Seligman to PMT, 3 December 1929; letter PMT to de Hauke, 9 December 1929; cable PMT to de Hauke, 10 December 1929.

313. Ibid., letter de Hauke to PMT, 10 January 1930.

314. JS&Co Records, Seligmann 2, Box 398, Folder 19, letter PMT to de Hauke, 23 January 1930.

315. Ibid., letter PMT tode Hauke, 24 January 1930.

316. Ibid., letter PMT to de Hauke, 28 January 1930.

317. Ibid., letter PMT to de Hauke, 10 February 1930.

318. Ibid., letter de Hauke to PMT, 31 March 1930.

319. TL: *Esther M. Nelson*, exh. cat. (Independent Gallery, London, 1930).

320. BFA: AR.ABC. 1930.642, letter PMT to ACB, 21 February 1930.

321. CIL: *19th Century French Masterpieces*, exh. cat. (Independent Gallery, London, 1930).

322. NAL: *Drawings by Richard* [otherwise known as Walter] *Sickert ARA and André Dunoyer de Segonzac*, exh. cat. (Independent Gallery, London, 1930).

323. *Saturday Review*, 24 May 1930, p. 672.

324. CIL: *A Loan Exhibition of 19th and 20th Century French Painting*, exh. cat. (Independent Gallery, London, 1930).

325. NAL: *Paintings by Paul Maze*, exh. cat. (Independent Gallery, London, 1930).

326. JS&Co Records, Seligmann 2, Box 398, Folder 19: letter PMT to de Hauke, 20 June 1930.

327. TFPs: postcards.

328. Norfolk Records Office, letters to Russell Colman re. his Norwich School collections from PMT and others COL 11/15/1-49, letter PMT to RJC, 6 October 1930.

329. Accessed 28 August 2017, http://www.ourgreatyarmouth.org.uk330. TFPs: *Crome Centenary Exhibition*, exh. cat. (Castle Museum, Norwich, 1921).

331. TFPs: Stockbook A2.

332. Mardle, Jonathan, *Russell James Colman 1861–1946* (Fletcher and Son, Norwich, 1954), p. 88.

333. TFPs: Stockbook A2.

334. BM, vol. 58, no. 355, February 1931, pp. ii and xxxi.

335. BM, vol. 58, no. 336, March 1931, pp. ii and xxxi.

336. NAL: *Oil paintings by H. de Buys Roessingh*, exh. cat. (Independent Gallery, London, 1930).

337. CIL: *Contemporary French Painting*, exh. cat. (Independent Gallery, London, 1930).

338. Ibid.

339. BFA. AR. ABC.1931.625, letter PMT to ACB, 16 February 1931.

340. Ibid., letters PMT to ACB, 2 November 1931 and PMT to PMT, 14 November 1931.

341. Ashmolean Museum, Sands End Affair file, letters PMT to Clark 1 February 1932, Clark to PMT, 27 February 1932.

342. Ibid., letter PMT to Clark, 4 March 1932; Samuel Palmer *Landscape with Repose of the Holy Family*, WA 1932.2.

343. CIL: *Modern British Painting*, exh. cat. (Independent Gallery, London, 1932).

344. CIL: PMT archives 1/13, *The Sphere*, 10 July 1932, pp. 163–4.

345. JS&Co Records, Seligmann 1, Box 96, letter Germain Seligman to PMT, 31 December 1932.

346. JFA: letter PMT to JF, 29 December 1932.

347. JS&Co Records, Seligmann 1, Box 96, letter PMT to Germain Seligman, 17 January 1933.

348. Ibid., letter PMT to Jacques Seligmann et Fils, 18 April 1933.

349. Ibid., letter de Hauke to PMT, 5 May 1934.

350. Ibid., Paris to PMT, 7 December 1935.

351. JFA: letters PMT to JF, 9 March 1933 and 31 December 1939.

352. JFA: letter PMT to JF, 17 March 1933.

353. TFPs: *Eastern Daily Press*, 14 March 1933.

354. JFA: letter PMT to JF, 12 April 1933.

355. CIL: PMT archives 1/11, letter Marion Scarles to PMT, 16 April 1933.

356. SLAD minutes of meeting, 30 May 1933, held at Messrs P. and D. Colnaghi's Galeries, 144 New Bond Street, London W1.

357. SLAD minutes of meeting, 14 April 1932.

358. SLAD minutes of meeting, 21 June 1932.

359. JFA: letter PMT to JF, 12 July 1933.

360. Roux-Frélaut, Cecile, *Jean Frélaut, l'oeuvre peint* (Editions Apogee, 1997), p. 146.

361. CIL: *Jean Frélaut*, exh. cat. (Leicester Galleries, London, 1933). *La Noce en Bretagne*: Tate, NO4797. Now known as *Repas de Noce en Bretagne* (*Wedding feast in Brittany*).

362. National Gallery Research Centre, London, NG14/145/1.

363. NAL: 66.H.72-83121, *The Colman Collection* catalogue 1942, no. 119.

364. National Gallery Research Centre, London, NG14/145/1.

365. TL: Jamot, Paul and Percy Moore Turner, *Collection de tableaux français faite à Londres, 20 Portman Square par Samuel & Elizabth Courtauld 1914–1931* (Privately printed, 1935).

366. JFA: letter PMT to JF, 28 October 1934.

367. Letter PMT to Paul Vitry, 15 April 1935.

368. TFPs: stockbooks.

369. Accessed 15 September 2017, www.thepeerage.com (Winifred Beatrice Campbell-Orde).

370. TFPs: stockbooks.

371. CIL: PMT archives 1/13, *Eastern Daily Press*, 19 June 1935; TFPs: Stockbook A3, PMT 2149-2183; Castle Museum, Norwich, Report of Museum Committees 1929–1939.

372. National Gallery Research Centre, London, NG14/73/1.

373. TFPs: unpublished autobiography PMT, p. 37.

374. National Gallery, London, NG 4815.

375. National Gallery Research Centre, London, NG14/73/1.
376. TFPs.
377. SLAD minutes of meeting, 3 January 1936.
378. National Gallery Research Centre, *Hadleigh Castle*, NG3/4810/2.
379. CIL: PMT archives 1/13, *The Morning Post*, 8 February 1936.
380. Ibid., *Illustrated London News*, 8 February 1936.
381. Ibid., *Sunday Times*, 9 February 1936.
382. Tate, NO4797. Now known as *Repas de Noce en Bretagne* (*Wedding feast in Brittany*).
383. JFA: letter PMT to JF, 2 April 1936.
384. Castle Museum, Norwich, Report of the Castle Museum's Committees 1950–1951, p. 7.
385. TFPs: Stockbook A3, PMT 2331, 2329, 2330.
386. Letter Ho. Andrew Shirley to *The Daily Telegraph*, 12 March 1958.
387. TFPs: Stockbook A3, PMT 2400.
388. Accessed 29 August 2017, http://www.museumswales.ac.uk/en/art/collections/daviessisters/article on their collection.
389. AMN: Thérèse Bertin-Mourot to George Salles, 14 May 1948, 10v116 no. 12.
390. Bertin-Mourot, Thérèse, 'Cinq nouveaux Georges de la Tour expose au Louvre', *Arts*, 6 August 1948, p. 1.
391. TFPs: correspondence relating to postponed Bonington exhibition, letter PMT to M. Charles Stirling, 31 January 1938.
392. Jamot, Paul, 'A propos de quelques tableaux nouvelle decouvert II', *Gazette des Beaux-Arts*, no. 140, May–June 1939, pp. 271–86.
393. Ibid., p. 406. Letters René Huyghe to PMT 21 April 1938 and René Huyghe to PMT, undated, in reply to PMT letter, 1 April 1938.
394. National Gallery Research Centre, statement from Philip Hendry concerning P.M. Turner's de la Tour and the National Gallery, London, NG14/104/1.
395. Norfolk Records Office, letters to Russell Colman re. his Norwich School Collection from PMT and others COL 11/15/1-49 PMT to RJC 19 September 1937; NAL: 66.H.72-83121, *The Colman Collection* catalogue 1942, picture no. 232.
396. CIL: PMT archives 1/13, *Eastern Daily Press*, 8 December 1938.
397. Castle Museum, Norwich, Report of Castle Museum Committees 1924, Museum Lectures.
398. Ibid., Report of Castle Museum Committees 1925, p. 8.
399. Paris, Documentation du department des Sculpture du Musée du Louvre, dossier d'oeuvre RF 1636, letter PMT to P. Vitry, 23 January 1939.
400. TFPs: letter Segonzac to PMT, 3 May 1939; 9 December 1939, 14 June 1946.
401. SLAD minutes of meeting, 21 June 1939.
402. TFPs: unpublished autobiography PMT, p. 42.
403. Ashmolean Museum, FHS bequest file, letter Miss Campbell-Orde to Parker, 24 January 1940.
404. JFA: letter PMT to JF, 31 December 1939.

5. OTHER EXHIBITIONS AND THE OXFORD ARTS CLUB

1. TFPs: unpublished autobiography PMT, pp. 30–31; TFPs: Catalogue Crome Centenary Exhibition; TFPs: two Invitations to Opening of Crome Centenary Exhibition; TFPs: photograph Dinner Crome Centenary Exhibition.
2. Ashmolean Museum, Oxford Arts Club file, Annual Report 1938, p. 2.

3. Sadler, Michael, *Michael Ernest Sadler (Sir Michael Sadler KCSI) 1861–1943* (Constable, London, 1949), p. 330.
4. Ashmolean Museum, Oxford Arts Club file, Annual Report 1938, p. 1.
5. Ibid., p. 13.
6. Ibid., Minutes of Arts Club, 23 November 1920–3 November 1929; minutes 28 April 1921.
7. Ashmolean Museum, Oxford Arts Club file, Minutes of Arts Club, 1 February 1923.
8. Ibid., Annual Report Oxford Arts Club 1938, p. 5.
9. CIL: PMT archives 1/13, *Catalogue of Exhibition of Oil Paintings and Drawings by the Late R. Bagge Scott.*
10. Ibid., *Eastern Daily Press*, 17 June 1925.
11. TFPs: unpublished autobiography PMT, pp. 31–2.
12. TFPs: catalogue, *The Centenary of the Norwich Museum Loan Collection of Pictures illustrative of the Evolution of Painting from XVIIth Century to the Present Day.*
13. *BM*, Index Blog, 14 November 2013.
14. CIL: PMT archives 1/13, *Eastern Daily Press*, 24 October 1925.
15. Ibid., Official Programme for Norwich Museum Centenary opened by the Duke and Duchess of York.
16. TFPs: unpublished autobiography PMT, pp. 34–5.
17. Ashmolean Museum, Minutes of the Oxford Arts Club, 31 September 1925.
18. CIL: *Catalogue of Pictures by Artists of the Norwich School and also by Constable and Gainsborough*, exh. cat. (Norwich Castle Museum, Norwich, 1927); CIL: PMT archives 1/13, *Eastern Daily Press*, 12 February 1927.
19. TFPs: unpublished autobiography PMT, pp. 32–5.
20. Ibid., p. 35.
21. TFPs: *T. Gainsborough R.A. 1727–88, Bicentary Memorial Exhibition 1927*, exh. cat. (Ipwich Museum, Ipswich 1927).
22. TFPs: unpublished autobiography PMT, pp. 35–7.
23. TFPs: *Loan Collection of Oil Paintings, Water-Colour Drawings, etc., illustrative of the work of the artists of the Norwich School of Painting deceased prior to 1900*, exh. cat. (Norwich Castle Museum, Norwich, 1927).
24. Ashmolean Museum, Oxford Arts Club file: letter PMT to Miss Price, 8 December 1927.
25. Ibid., letter C.W. Adams to Miss Price, 25 January 1928.
26. Ibid., *Oil Paintings and Drawings by Dunoyer de Segonzac lent by Sir Michael Sadler, Mr P.M. Turner and the Independent Gallery*, exh. cat. (Oxford Arts Club, Oxford, 1928).
27. Ibid., letter PMT to Miss Price, 14 February 1928.
28. Ibid., Minutes of Oxford Arts Club, 4 July 1928.
29. Ibid., Minutes of Oxford Arts Club, 17 July 1928.
30. Obituaries, The Hon. Andrew Shirley, *The Times*, 21 June 1958.
31. Huyghe, René, *Une Vie pour L'Art* (Éditions de Fallois, Paris, 1994), pp. 63–5.
32. Royal Academy of Arts, Collections: Online Catalogues, 'Exhibition of French Art 1200–1900', 1932. Accessed 15 September 2017: http://www.racollection.org.uk/ixbin/indexplus?record=VOL6204
33. TFPs: *Loan Collection of Works by Early Devon Painters Born Before the Year 1800*, exh. cat. (City and County of Exeter, Exeter 1932).
34. *Plarr's Lives of the Fellows* online, Royal College of Surgeons, England. Accessed 29 August 2017, http://livesonline.rcseng.ac.uk

35. Whiteley, Jon, *Catalogue of the Collection of Drawings, French School*, vol. VII (Oxford University Press, Oxford, 2000), p. 14; Ashmolean Museum, Oxford Arts Club file, Report of Oxford Arts Club 1938, p. 11.

36. Ashmolean Museum, Oxford Arts Club file, Report of Oxford Arts Club 1938, p. 16.

37. Ibid., p. 12.

38. TFPs: unpublished autobiography PMT, p. 37.

39. TFPs: *Centenary Memorial Exhibition of John Constable R.A., his origins and influence*, exh. cat. (Wildenstein's Galleries, London, 1937).

40. TFPs: unpublished autobiography PMT, p. 37; TFPs: seating plan, Constable Centenary Dinner at the Café Royal.

41. Ashmolean Museum, Oxford Arts Club file, Report of Oxford Arts Club 1938, p.13; *Richard Wilson and John Constable*, exh. cat. (Oxford Arts Club, Oxford, 1938).

42. TFPs: unpublished autobiography PMT, p. 40.

43. TFPs: projected Bonington exhibition file, letter PMT to comtesse Aymar de Dampierre, 23 December 1937; letter comtesse de Dampierre to PMT, 31 December 1937.

44. TFPs: unpublished autobiography PMT, p. 40.

45. Ibid., letter PMT to comtesse de Dampierre, 1 February 1938.

46. Ibid., letter PMT to Charles Stirling, 31 January 1938.

47. TFPs: projected Bonington exhibition file, letter comtesse de Dampierre to PMT, 13 February 1938.

48. Ibid., letter PMT to René Huyghe, 15 February 1938.

49. NAL: *Pictures and Drawings by Richard Bonington and his Circle*, exh. cat. (Burlington Fine Arts Club. London, 1937).

50. TFPs: prospective Bonington exhibition file, letter PMT to Charles Stirling, 21 February 1938.

51. Ibid., letter Charles Stirling to PMT, 27 March 1938.

52. Ibid., letter Henri Verne to Monsieur Le Conservateur, 29 March 1938.

53. Ibid., letter PMT to René Huyghe, 1 April 1938.

54. Ibid., letter PMT to René Huyghe, 21 April 1938.

55. Ibid., letter PMT to Charles Stirling, 21 April 1938.

56. Ibid., letter PMT to Mme Delaroche-Vernet 18 May 1938; Norwich Museum Services, Shire Hall, City of Norwich, Report of the Museum Committee to the City Council for the years 1929–38, pp. 13–14; TFPs: Shirley, Andrew, *Bonington* (Kegan Paul, Trench Trubuer and Co., London, 1940).

57. TFPs: prospective Bonington exhibition file, letter PMT to McIlhenny, 18 May 1938; letter PMT to Mrs Ella S. Siple, 18 May 1938; letter PMT to Abbott, 19 May 1938.

58. Ibid., letter McIlhenny to PMT, 1 June 1938.

59. Ibid., letter Siple to PMT, 13 June 1938.

60. Ibid., letter PMT to R.W. Reford, 26 May 1938.

61. Ibid., letter PMT to Mme Delaroche-Vernet, 10 June 1938; ibid., René Huyghe to PMT, 10 June 1938.

62. Ibid., letter PMT to Mme Delaroche-Vernet, 8 July 1938.

63. Ibid., list of PMT's expenses; ibid., letter PMT to Henri Verne 8 July 1938; ibid., letter PMT to M. Maurice Allemand, Besançon, 22 September 1938.

64. TFPs: prospective Bonington exhibition file, letter Reford to PMT, 18 August 1938.

65. Ibid., letter PMT to Henri Verne, 21 September 1938.

66. Ibid., letter PMT to Henri Verne, 3 October 1938.

67. Ibid., letter PMT to Mrs Siple 13 October 1938; ibid., letter PMT to Reford, 13 October 1938.

68. TFPs: *Loan Exhibition of Pictures illustrative of Contemporary British and French Art* , exh. cat. (Norwich Museum and Art Galleries, Norwich, 1938), p. 5.

69. Norfolk Museum Service, Shirehall. Report of the Museums Committees to the City Council for the Years 1929–1938, pp. 13–14.

70. TFPs: *Loan Exhibition of Pictures illustrative of Contemporary British and French Art*, exh. cat. (Norwich Museum and Art Galleries, Norwich, 1938), pp. 11–23.

6. THE WAR YEARS 1939–45

1. England and Wales, National Probate Calendar 1858–1966.

2. Manchester Art Gallery, FHS bequest file, letter Haward to PMT, 30 October 1939.

3. Manchester Art Gallery, FHS bequest file, Councillor Tylecote's report on visit to Mr F. Hindley Smith on 16 and 17 July 1937, p. 1.

4. TFPs: Turner, Sarah A.M., 'The Frank Hindley Smith Art Collection' (unpublished paper), p. 1.

5. Manchester Art Gallery, FHS bequest file, Councillor Tylecote's report on visit to Mr F. Hindley Smith on 16 and 17 July 1937, p. 4.

6. TFPs: unpublished autobiography PMT, p. 44; *BM*, vol. 76, no. 445, April 1940, pp. 130–32.

7. TFPs: unpublished autobiography PMT, pp. 44–6.

8. Manchester Art Gallery, FHS bequest file: letter Haward to PMT, 30 October 1939.

9. Ibid., letter FHS to Haward, 7 June 1922.

10. Ibid., letter PMT to Haward, 29 June 1922.

11. Ibid., letter Haward to FHS, 19 July 1922; letter Haward to PMT, 30 October 1939.

12. Ibid., Haward to PMT, 6 November 1939.

13. Peterborough Museum and Art Gallery, FHS bequest file, letter Dobbs to Proby, 15 November 1939.

14. Bolton Museum and Art Gallery, FHS bequest file, letter PMT to Hendy, 2 December 1939.

15. Ibid., letter PMT to Hendy 19 December 1939; Peterborough Museum and Art Gallery, FHS bequest file: letter PMT to Dobbs, 20 December 1939; Manchester Art Gallery, FHS bequest file: letter PMT to Haward, 19 December 1939; Norfolk Museums Services, Shirehall, FHS bequest file, letter PMT to Miss Barnard, 19 December 1939; Ashmolean Museum, FHS bequest file, letter PMT to Parker, 21 December 1939.

16. Bolton Museum and Art Gallery, *Museums Journal*, June 1940, p. 82.

17. TFPs: unpublished autobiography PMT, pp. 44, 46–9; Waddesdon Archive at Windmill Hill, Waddesdon, Mrs de Rothschild's Diaries 1939 and 1940: ref. no. DMR1/1/26 and ref no. DMR1/1/27 respectively; Rothschild, Mrs James de, *The Rothschilds at Waddesdon Manor* (Collins, London, 1979), p. 126.

18. Norfolk Museums Service, Shirehall: Report of the Museums Committee Years 1939–46, p. 6.

19. Ibid., FHS bequest file, letter Miss Barnard to PMT, 7 November 1939.

20. SLAD minutes of meeting, 21 November 1939.

21. Proby, Granville, *NAL Supplement to the Catalogue of the pictures at Elton Hall* (William Clawes and Sons, London, 1939), pp. vii–viii, General Collection 41.A.110.

22. Norfolk Museums Services, Shirehall, FHS bequest file, letter PMT to Miss Barnard 26 December 1939.

23. Ibid., letter PMT to Miss Barnard, 9 January 1940; Bolton Museum and Art Gallery, FHS bequest file, letter PMT to Hendy, 9 January 1940; Peterborough Museum and Art Gallery, FHS bequest file, letter PMT to Dobbs, 9 January 1940; Manchester Art Gallery, FHS bequest file, letter PMT to Haward, 9 January 1940.

24. Ibid., letter PMT to Haward, 13 January 1940.

25. JFA: letter PMT to JF, 26 January 1940.

26. Ibid., letter PMT to JF, 4 November 1944.

27. Norfolk Museums Service, Shirehall, FHS bequest file letter Miss Barnard to PMT, 2 February 1940; ibid., letter PMT to Miss Barnard, 10 February 1940.

28. Norfolk Museums Service, Shirehall, FHS bequest file, letter PMT to Miss Barnard, 10 February 1940.

29. Ibid., letter PMT to Miss Barnard, 14 February 1940.

30. Ibid., letters PMT to Miss Barnard, 22 and 23 February 1940.

31. Ibid., letter Miss Barnard to PMT, 23 February 1940.

32. Norfolk Museums Service, Shirehall, FHS bequest file, Frank Leney, 'Pictures for Public Galleries, Generous Bequest to Norwich', *Eastern Daily Press*, 14 March 1940; Ashmolean Museum, FHS bequest file, Frank Davis, 'The Hindley Smith Collection: A remarkable bequest to the Nation', *London Illustrated News*, 16 March 1940.

33. Norfolk Museums Service, Shirehall, FHS bequest file, letter PMT to Miss Barnard, 9 March 1940; Manchester Art Gallery, FHS bequest file letter PMT to Haward, 9 March 1940.

34. Ibid., letter Haward to PMT, 21 March 1940.

35. Ibid., letter Haward to PMT, 1 March 1940.

36. Manchester Art Gallery, FHS bequest file, telegram PMT to Haward, 23 April 1940.

37. Ibid., letter PMT to Haward, 11 April 1940.

38. Ibid., letter Haward to Major W.H. Lowe, executor, 22 April 1940. Ibid., letter PMT to Haward, 30 April 1940.

39. Peterborough Museum and Art Gallery, FHS bequest file, letter PMT to Dobbs, 25 March 1940; Bolton Museum and Art Gallery, FHS bequest file, letter PMT to Hendy, 11 April 1940.

40. Manchester Art Gallery, FHS bequest file, letter Haward to PMT, 11 April 1940; ibid., letter PMT to Haward, 20 April 1940.

41. Ibid., letter Haward to PMT, 22 April 1940.

42. Norfolk Museums Service, Shirehall, FHS bequest file, letter PMT to Miss Barnard, 1 April 1940.

43. Ibid., *Eastern Daily Press*, 4 April 1940.

44. Norfolk Museums Service, Shirehall, FHS bequest file, letter PMT to Miss Barnard, 1 April 1940.

45. TFPs: unpublished autobiography PMT, p. 46; Gow, A.S.F., *Letters from Cambridge* (Jonathan Cape, London, 1945) pp. 38–9.

46. Norfolk Museums Service, Shirehall, FHS bequest file, letter PMT to Miss Barnard, 16 April 1940.

47. Ibid., letter PMT to Miss Barnard, 19 April 1940.
48. Martin Brown (personal communication), Account of Partial Division of the Estate, 5 October 1947.
49. TFPs: unpublished autobiography PMT, p. 44.
50. SLAD minutes, 15 May 1940.
51. Ibid., minutes committee meeting and AGM, 10 June 1940.
52. Manchester Art Gallery, FHS bequest file, letter PMT to Haward, 12 September 1940.
53. SLAD minutes, 24 December 1940.
54. Ibid., 28 March 1941.
55. SLAD minutes, 8 April 1941.
56. SLAD minutes, 11 June 1941.
57. TFPs: Stockbook A3 PMT 2632.
58. CIL: *Loan Exhibition of Pictures Representative of Modern Art*, exh. cat. (Borough of Bury St Edmunds, October 1941).
59. Norfolk Museums Service, Shirehall, City of Norwich Report of the Museums Committee to the City Council for Years 1939–46, p. 10.
60. NAL: 66.H.72-83121, *The Colman Collection* catalogue, 1942.
61. TL: Kenneth Clark correspondence, File Mic T., letter PMT to Kenneth Clark, 9 February 1942, TGA 8812/1/1/11/138.
62. Robert Alfred Worthington in *Plarr's Lives of the Fellows* online, Royal College of Surgeons, England. Accessed 29 August 2017, http://livesonline.rcseng.ac.uk; TFPs: unpublished autobiography PMT, pp. 42–4.
63. SLAD minutes AGM, 9 June 1942.
64. SLAD report of meeting, 10 August 1942.
65. TFPs: Stockbook A3 PMT 2736.
66. National Gallery Research Centre, London, NG14/104, letters PMT to Kenneth Clark, 2 January 1943, Trustees to PMT, 17 February 1943.
67. TLA: Kenneth Clark correspondence, letter PMT to Clark, 28 September 1942, TGA 8812/1/1/36/92.
68. TFPs: Stockbook A3 PMT 2730.
69. Robert Sainsbury Library, Norwich: Sir Robert Sainsbury account book, 1937–45.
70. Hooper, Steven (ed.), *Robert and Lisa Sainsbury Collection* (Yale University Press in association with the University of East Anglia, Norwich, 1997), 3 vols, vol. I, p. xlix.
71. TFPs: unpublished autobiography PMT, p. 44.
72. TLA: Kenneth Clark correspondence, letter Kenneth Clark's secretary to PMT, 2 December 1942, TGA 8812/1/1/36.
73. Ibid., letter PMT to Kenneth Clark, 4 December 1942.
74. Ibid., letter PMT to Kenneth Clark, 8 December 1942.
75. NAL: Catalogue Collection, National Gallery Catalogues 1940–43, 77.L 38041800716303.
76. National Gallery Research Centre NG14/104, letter PMT to Kenneth Clark, 21 February 1943.
77. Ibid., letter PMT to Clark, 16 January 1943.
78. Ibid., letter PMT to Clark, 21 January 1943.
79. Ibid., letter Trustees to PMT, 17 February 1943.
80. TFPs: Stockbook A3 PMT 2518; TLA: Kenneth Clark correspondence, TGA 8812/1/1/36, letter PMT to Kenneth Clark, 11 February 1943.
81. TLA: Kenneth Clark correspondence, TGA 8812/1/1/36, letter Kenneth Clark

to PMT, 13 February 1943.

82. Ibid., letter PMT to Kenneth Clark, 15 February 1943.

83. Ibid., letter PMT to Kenneth Clark, 29 February 1943.

84. TLA: Kenneth Clark correspondence, TGA 8812/1/1/36, letter PMT to Kenneth Clark, 14 March 1943.

85. Ibid., letter PMT to Kenneth Clark, 9 April 1943.

86. SLAD minutes AGM, 24 May 1943.

87. TLA: Kenneth Clark correspondence, TGA 8812/1/1/36, letter PMT to Kenneth Clark, 8 June 1943.

88. Ibid., letter PMT to Kenneth Clark, 2 October 1943.

89. Letter Kenneth Clark to PMT, 2 October 1943.

90. City of Norwich, illustrated guide, *The Colman Collection of Norwich School Pictures* (Norwich Castle Museum, June 1951), p. 3.

91. Norfolk Museums Service, Shirehall, Report of Museums Committee Years 1939–1946, p. 5.

92. SLAD minutes, 25 November 1943.

93. SLAD minutes, 1 December 1943.

94. Norfolk Museums Service, Shirehall, Colman Collection file, letter Curator to Mrs Colman, 10 January 1944.

95. SLAD minutes, 9 May 1944.

96. SLAD minutes, 20 July 1944.

97. SLAD minutes, 26 September 1944.

98. JFA: letter PMT to JF, 4 November 1944.

99. Dijon, Documentation du Musée des Beaux-Arts, letter Paul Quarre to PMT, 17 November 1944.

100. Ibid., PMT to Paul Quarre, 14 December 1944.

101. TFPs: letter Paul Quarre to PMT, 11 January 1945.

102. Dijon, Documentation du Musée des Beaux-Arts, letter Paul Quarre to PMT, 30 January 1945.

103. Ibid., letter PMT to Paul Quarre, 5 February 1945.

104. JFA: letter PMT to JF, 12 February 1945.

105. TLA: Kenneth Clark correspondence, TGA 8812/1/2/6592 letter PMT to Kenneth Clark, 16 February 1945.

106. TFPs: unpublished autobiography PMT, p. 51.

107. Dijon, Documentation du Musée des Beaux-Arts, letter PMT to Paul Quarre, 28 February 1945.

108. Ibid., letter Paul Quarre to PMT, 22 March 1945.

109. JFA: letter PMT to JF, 30 March 1945.

110. TFPs: unpublished autobiography PMT, p. 50.

111. Dijon, Documentation du Musée des Beaux-Arts, letter A Henraux to Paul Quarre, 17 April 1945.

112. Ibid., letter PMT to Paul Quarre, 26 April 1945.

7. THE FINAL YEARS

1. TFPs: unpublished autobiography PMT, pp. 50–51.

2. Dijon, Documentation du Musée des Beaux-Arts, letter Paul Quarre to PMT, 8 June 1945.

3. SLAD minutes, 14 June 1945.

4. Dijon, Documentation du Musée des Beaux-Arts, letter PMT to Paul Quarre, 5 July 1945.

5. JFA: letter PMT to JF, 4 August 1945.
6. Dijon, Documentation du Musée des Beaux-Arts, letter PMT to Paul Quarre, 20 September 1945.
7. Ibid., letter PMT to Paul Quarre, 5 October 1945.
8. Ibid., letter Paul Quarre to PMT, 10 October 1945.
9. England and Wales National Probate Calendar 1858–1966.
10. TLA: Kenneth Clark correspondence, TGA 8812/1/2/6593, letter PMT to Kenneth Clark, 28 September 1945.
11. Ibid., TGA 8812/1/2/6594, letter Kenneth Clark to PMT, 10 October 1945.
12. TLA: Kenneth Clark correspondence, TGA. 8812.1.2.6593, letter PMT to Kenneth Clark, 28 September 1945.
13. TL: *Masterpieces by British Landscape Painters of the 18th and 19th Centuries*, exh. cat. (Fine Arts Society, London, 1945).
14. AMN: Z66 Dijon, Musée des Beaux-Arts, letter Paul Quarre to Georges Salles, 29 October 1945.
15. Royal Academy of Arts, Collections: Online Catalogues, 'Exhibition of French Art 1200–1900', 1932.
Accessed 15 September 2017: http://www.racollection.org.uk/ixbin/indexplus?record=VOL6204
16. SLAD letter PMT to members, 30 October 1945.
17. Dijon, Documentation du Musée des Beaux-Arts, letter Paul Quarre to PMT, 21 December 1945.
18. AMN: letter Georges Salles to PMT, 27 December 1945.
19. Dijon, Documentation du Musée des Beaux-Arts, letter PMT to Paul Quarre, 31 December 1945.
20. JFA: letter PMT to JF, 22 December 1945.
21. 'The National Gallery, A newly acquired Portrait', *The Times*, Wednesday, 9 January 1946, p. 6.
22. Norfolk Museums Service, Shirehall, Frank Hindley Smith bequest file, letter PMT to Miss Barnard, 9 January 1946.
23. TLA: Kenneth Clark correspondence, TGA 8812/1/2/6595, letter Kenneth Clark to PMT, 9 January 1946.
24. TLA: Kenneth Clark correspondence, TGA 8812/1/2/6596, letter PMT to Kenneth Clark, 10 January 1946.
25. SLAD, letter PMT to members, 31 January 1946, and notes on Conference with Board of Trade, 6 November 1945.
26. AMN: Z66 Dijon, Musée des Beaux-Arts, letter F. Kir to PMT, 9 February 1946.
27. Ibid., letter PMT to F. Kir, 4 March 1946.
28. *Plarr's Lives of the Fellows* online, Royal College of Surgeons, England. Accessed 29 August 2017, http://livesonline.rcseng.ac.uk.
29. CIL: PMT archives 1/13, Worthington, Robert A., *Memorial Exhibition of Watercolours of Dartmoor and elsewhere*, 20 March–12 April 1946, exh. cat. (Fine Art Society, London, 1946).
30. Dijon, Documentation du Musée des Beaux-Arts, letter Paul Quarre to PMT, 17 April 1946.
31. TFPs: Stockbook B1, PMT 429.
32. JFA: letter PMT to JF, 21 April 1946.
33. Ibid., letter PMT to JF, 22 May 1946.
34. SLAD minutes, 10 May 1946.
35. TLA: Kenneth Clark correspondence, TGA 8812/1/2/6597, letter PMT to

Kenneth Clark, 10 May 1946.

36. Ibid., TGA 8812/1/2/6598, letter Kenneth Clark to PMT, 13 May 1946.
37. TFPs: letter Paul Quarre to PMT, 3 June 1946.
38. TFPs: Bulletin de la Societé des Amis du Musée de Dijon 1944–5.
39. AMN: Z66 Dijon, Musée des Beaux-Arts, letter PMT to F. Kir, 7 June 1946.
40. TFPs: letter André Segonzac to PMT, 14 June 1946.
41. SLAD minutes, 14 June 1946, and letter PMT to Lord Hinchingbrooke, 17 June 1946.
42. TLA Kenneth Clark correspondence, TGA 8812/1/2/6599, letter PMT to Kenneth Clark, 15 June 1946.
43. TFPs: letter Paul Quarre to PMT, 17 June 1946.
44. TLA: Kenneth Clark correspondence, TGA 8812/1/2/6600, letter Kenneth Clark to PMT, 22 June 1946.
45. Ibid., TGA 8812/1/2/6601, letter PMT to Kenneth Clark, 29 June 1946.
46. Paris, Quarre family, Paul Quarre's journal, 21 October 1946.
47. SLAD minutes, 6 January 1947.
48. TFPs: letter Paul Quarre to PMT, 28 January 1947.
49. Paris, Quarre family, Paul Quarre's journal, 18 November 1946.
50. CIL: PMT archives 1/12, correspondence re. gift of pictures to the Louvre, letter PMT to René Varin, 20 June 1947.
51. Ibid., and TFPs.
52. JFA: letter PMT to JF, 12 August 1947.
53. JFA: letter PMT to JF, 15 December 1947.
54. CIL: PMT archives 1/12, correspondence re. gift of pictures to the Louvre, letter René Huyghe to PMT, 15 December 1947.
55. Ibid., letter René Huyghe to PMT, 5 February 1948.
56. Ibid., letter PMT to René Huyghe, 10 February 1948.
57. Ibid., letter René Huyghe to PMT, 16 February 1948.
58. SLAD minutes, 11 February 1948.
59. TLA: Kenneth Clark correspondence, TGA 8812/1/2/6602, letter PMT to Kenneth Clark, 22 February 1948.
60. TLA: Kenneth Clark correspondence, TGA 8812/1/2/6603, letter Kenneth Clark to PMT, 26 February 1948.
61. Ibid., TGA 8812/1/2/6604, letter PMT to Kenneth Clark, 1 March 1948.
62. CIL: PMT archives 1/12, correspondence re. gift of pictures to the Louvre, letter PMT to René Huyghe, 31 March 1948.
63. Ibid., letter René Huyghe to PMT, 3 April 1948.
64. TFPs: letter Thérèse Bertin-Mourot to PMT, 18 September 1948.
65. JFA: letter PMT to JF, 8 May 1948.
66. TFPs: letter Miss Barnard to PMT, 15 May 1948.
67. Ibid., letter Geoffrey Eastwood to PMT, 24 May 1948.
68. TLA: Kenneth Clark correspondence, TGA 8812/1/2/6605, letter Kenneth Clark to PMT, 14 June 1948.
69. TFPs: Bulletin de la Société Poussin, May 1950, pp. 4–8.
70. TFPs: letter Thérèse Bertin-Mourot to PMT, 9 June 1948.
71. TFPs: preface to the unpublished autobiography PMT, written by his wife, MGT.
72. TFPs: card André Segonzac to PMT 18 June 1948, letter Alphonse Bellier to PMT, 29 June 1948, letter Claude Roger Marx to PMT, 14 July 1948.
73. TFPs: letter André Segonzac to PMT, 20 June 1948.

74. TLA Kenneth Clark correspondence, TGA 8812/1/2/6606, letter PMT to Kenneth Clark, 28 June 1948.

75. Ibid., TGA 8812/1/2/6608, letter PMT to Kenneth Clark, 3 July 1948.

76. TFPs: letter Paul Quarre to PMT, 19 July 1948.

77. TFPs: letter Georges Salles to PMT, 2 August 1948.

78. TFPs: letter Georges Salles, 29 September 1948.

79. TFPs: letter Georges Salles to PMT, 2 November 1948.

80. CIL: PMT archives, Newspaper cuttings 3/4, *Eastern Daily Press*, 30 May 1949; TLA: Kenneth Clark correspondence, TGA 8812/1/2/6609, letter PMT to Kenneth Clark, 26 May 1949.

81. TFPs: letter Thérèse Bertin-Mourot to PMT, 30 November 1948.

82. SLAD minutes AGM, 8 December 1948.

83. JFA: letter PMT to JF, 11 December 1948.

84. Ibid., letter PMT to JF, 27 December 1948.

85. CIL: PMT archives 3/4 Press cuttings 1948–9.

86. JFA: letter PMT to JF, 9 May 1949.

87. TFPs: Stockbook B2 PMT 1539.

88. AMN: Z 62 927 Turner, letter PMT to René Huyghe, 26 May 1949.

89. AMN: Z 62 927 Turner, letter René Huyghe to PMT, 3 June 1949.

90. AMN: 30 O 358, letter René Varin to René Huyghe, 26 July 1949.

91. Ibid., letter René Huyghe to René Varin, 3 August 1949.

92. 'Présentation Provisoire de la Peinture Française', *Gazette de Beaux-Arts*, 10 November 1950, p. 1.

93. TFPs: letter Hon. Andrew Shirley to MGT, 14 December 1952.

94. JFA: letter PMT to JF, 1 September 1949.

95. JFA: letter PMT to JF, 15 December 1949.

96. TFPs: 'Particulars of Decorations contained in this case'.

97. Ibid., *The Daily Mail*, Friday, 16 December 1949, p. 5.

98. JFA: letter PMT to JF, 4 February 1950.

99. TFPs: letter Mrs L. Somerville to PMT, 6 February 1950.

100. Ibid., letter Harold Wright to PMT, 6 February 1950.

101. Ibid., letter Harold Wright to PMT, 15 September 1950.

102. JS&Co Records, Seligmann I Box 96, letter Germain Seligman to PMT, 11 May 1950.

103. Ibid., letter PMT to Germain Seligman, 16 May 1950.

104. Ibid., letter Germain Seligman to PMT, 22 May 1950.

105. JS&Co Records, Seligmann I Box 96, letter Miss Campbell-Orde to Germain Seligman, 26 May 1950.

106. TFPs: catalogue.

107. Ibid., letter René Varin to PMT, 14 June 1950.

108. TFPs: letter PMT to Dudley Tooth, 17 June 1950.

109. TFPs: letter PMT to Harold Wright, 19 June 1950.

110. TFPs: letter PMT to Miss Barnard, 14 July 1950.

111. TFPs: letter André Segonzac to PMT, 2 September 1950.

112. TFPs: letter Walter Hetherington to Town Clerk, Norwich, 20 June 1957.

113. England and Wales, Death Index 1916–2007, England and Wales; National Probate Calendar 1858–1966.

114. TFPs: letter MGT to Alfred Daber, 29 October 1950.

115. Woking Crematorium Archives.

116. *Daily Telegraph*, Death Notices, 21 September 1950.

117. TFPs: telegram Georges Salles to MGT, 27 September 1950.

118. TFPs: telegram André Segonzac to MGT, 26 September 1950.

119. TFPs: letter René Huyghe to MGT, 29 September 1950.

120. SLAD minutes, 7 November 1950.

POSTSCRIPT

1. England and Wales, National Probate Calendar, 1858–1966.

2. TFPs: Executors' Financial Accounts, 19 September 1950–19 March 1956.

3. TFPs: letter MGT to Andrew Shirley, 8 March 1951.

4. TFPs: letter MGT to Andrew Shirley, 8 March 1952.

5. TFPs: letter MGT to Andrew Shirley, 15 November 1951.

6. TFPs: letter MGT to Gerald Brown, 1 May 1956.

7. TFPs: Gerald Brown to MGT, 27 April 1956.

8. TFPs: undated list of points in MGT's handwriting to be put to her solicitor.

9. TFPs: letter W.C. Hetherington to Town Clerk, Norwich, 20 June 1957.

10. TFPs: letters Fitzwilliam to MGT, 22 July 1957; Ashmolean to MGT, 29 July 1957.

11. TFPs: letter Andrew Shirley to MGT, 5 October 1951.

12. TFPs: letter Andrew Shirley, 27 February 1952.

13. TFPs: letter MGT to Gerald Brown, 5 October 1952.

14. National Probate Calendar, England and Wales, 1858–1966.

15. *Daily Telegraph*, 12 March 1958, letter from Andrew Shirley.

16. National Probate Calendar, England and Wales, 1858–1966.

17. TFPs: Executors correspondence with MGT.

18. *The Times*, Death Notices, 21 June 1958.

19. TFPs: André Segonzac's correspondence with MGT.

20. National Probate Calendar, England and Wales, 1973–95.

LIST OF ILLUSTRATIONS AND WORKS OF ART

ILLUSTRATIONS

1. Percy's Father, Thomas Turner (1845–1906)
2. Thomas Turner's shop at 12 and 13 Old Market
3. Sarah Jane Robotham (1844–1928), Percy's mother
4. Percy and Maud Ethel Moore Turner, taken in Halifax, 11 June 1881 (Thomas Turner's birthday)
5. Percy and Maud Ethel Moore Turner, taken in Halifax, 11 June 1883
6. Percy and Maud Ethel Moore Turner, taken in Halifax, 11 June 1885
7. The Turner family at 42 Mill Road, Norwich
8. Percy and Maud Ethel Moore Turner at 42 Mill Road, Norwich
9. Percy and Maud Ethel Moore Turner, taken in Norwich, 11 June 1897
10. Percy as a leather salesman, *c.* 1900
11. Émile Molinier
12. Percy's wife, Mabel Grace, and their son, Geoffrey
13. Multiple portrait of Percy, *c.* 1917
14. Percy as a Private in 2/1st Northern Cyclist Battalion, February 1917
15. Percy in uniform as a Second Lieutenant, June 1917
16. Percy with the 67th (2nd Home Counties) Division
17. Percy in the 1920s
18. Courtauld catalogue
19. The title page from the Courtauld catalogue
20. Oxnead, Marsham Way, Gerrards Cross
21. The garden at Oxnead, Marsham Way, Gerrards Cross
22. & 23. Old Hall Farm, East Tuddenham, Norfolk
24. André Dunoyer de Segonzac
25. Segonzac's sketch of Percy's son
26. Letters to Percy from André Dunoyer de Segonzac
27. A Centenary Memorial Exhibition for Constable held at Wildenstein Gallery, London, 21 April to 29 May 1937

28. Percy, his wife, his sister-in-law and her husband at the wedding of Percy's son, 12 April 1944
29. Percy photographed next to his small choirboy at the Salles des Gardes in 1946
30. Percy pictured by the Abbot's Kitchen, Glastonbury Abbey, showing his increased frailty
31. Percy in 1948
32. Attributed to François Quesnel, *La Petite Princesse* (photograph of the original painting)

WORKS OF ART

1. John Crome, *The Glade,* pen and ink with wash on paper, 129.5 x 104.1 cm, undated, Norwich Castle Museum & Art Gallery

2. Pierre Puvis de Chavannes, *The River (La Rivière),* oil on canvas, 129.5 x 252.1 cm, *c.* 1864, Metropolitan Museum of Art, New York

3. Pierre Puvis de Chavannes, *Cider (Le Vendange),* oil on canvas, 129.5 x 252.1 cm, *c.* 1864, Metropolitan Museum of Art, New York

4. Paul Gauguin, *Where do we come from? What are we? Where are we going?,* oil on canvas, 139.1 x 374.6 cm, 1897–98 (left side detail), Museum of Fine Arts, Boston, Massachusetts

5. André Lhote, *Study for 'Homage to Watteau',* oil on canvas, 33.3 x 36.0 cm, 1918, Tate, London

6. Pierre Bonnard, *Landscape,* oil on mill board, 56.2 x 78.1 cm, 1902, Fitzwilliam Museum, University of Cambridge

7. Jean Frélaut, *Pommier en Fleur,* oil on canvas, 60 x 74 cm, 1920, Ashmolean Museum, University of Oxford

8. The Le Nain Brothers, *Four Figures at a Table,* oil on canvas, 44.8 x 55 cm, *c.* 1643, National Portrait Gallery, London

9. Pierre-Auguste Renoir, *Le Printemps* (now *Spring at Chatou*), oil on canvas, 59 x 74 cm, *c.* 1872–5, Private Collection

10. Thomas Gainsborough, *Portrait of Master Plampin,* oil on canvas, 50.2 x 60.3 cm, *c.* 1752, National Gallery, London

11. Peter Paul Rubens, *Portrait of the Archduke Albert,* oil on canvas, 78 x 57 cm, *c.* 1615, Ashmolean Museum, University of Oxford

12. John Sell Cotman, *Silver Birches*, oil on canvas, 76.2 x 62.7 cm, *c.* 1824–8, Norwich Castle Museum & Art Gallery

13. Edgar Degas, *Two Dancers Entering the Stage*, pastel over monotype in black ink, 38.1 x 35 cm, *c.* 1877–8, Fogg Art Museum, Harvard Art Museums, USA

14. Henri de Toulouse-Lautrec, *Jane Avril in the entrance to the Moulin Rouge, putting on her gloves*, oil and pastel on millboard, 102 x 55 cm, *c.* 1892, The Courtauld Gallery, London

15. Samuel Palmer, *Landscape with Repose of the Holy Family*, oil on panel, 31 x 39 cm, *c.* 1824–5, Ashmolean Museum, University of Oxford

16. Jean Frélaut, *Repas de noce en Bretagne*, oil on canvas, 89.5 x 130.8 cm, 1908, Tate, London

17. Peter Paul Rubens, *The Watering Place*, oil on oak, 99.4 x 135 cm, *c.* 1615–22, National Gallery, London

18. John Constable, *Hadleigh Castle*, oil on canvas, 122.6 x 167.3 cm *c.* 1828–9, National Gallery, London

19. Georges de La Tour, *St Joseph, the Carpenter*, oil on canvas, 130 × 100 cm, *c.* 1642, Musée des Beaux-Arts et d'Archeologie, Besançon, France

20. François Clouet, *Portrait of a Man with a Blind Eye Holding a Flute*, oil on canvas, 27.6 x 20.7 cm, 1566, Paris, Musée du Louvre, Paris

21. John Constable, *Helmingham Dell*, oil on canvas, 103 x 129 cm, 1830, Paris, Musée du Louvre, Paris

22. Jean de La Huerta and/or Antonie Le Moiturier, *Pleurant no. 42, choirboy carrying a candlestick from the tomb of Jean sans Peur, duc de Bourgogne*, alabaster, *c.* 1443–69

23. John Scarlett Davis (previously attributed to Richard Parkes Bonington), *Man with a Top Hat*, oil on canvas, 63.5 x 52.7 cm, *c.* 1838, Tate, London

INDEX

Page numbers in italics refer to images.

PICTURE CREDITS

p. 23 John Crome, undated, *The Glade*, pen and ink with wash on paper, 129.5 x 104.1 cm, Accession number NWHCM : 1935.59.3, Norfolk Museums Service (Norwich Castle Museum & Art Gallery); p. 28 Pierre Puvis de Chavannes, *c.* 1864, *The River*, oil on canvas, 129.5 x 252.1 cm, drawing, Catharine Lorillard Wolfe Collection, Wolfe Fund, 1926, 26.46.2; p. 28 Pierre Puvis de Chavannes, *c.* 1864, *Cider*, oil on canvas, 129.5 x 252.1 cm, drawing, Catharine Lorillard Wolfe Collection, Wolfe Fund, 1926, 26.46.1; pp. 30-31 Paul Gauguin, 1897, *Where do we come from? What are we? Where are we going?* (left side detail), oil on canvas (see 207297, 207299), Museum of Fine Arts, Boston, Massachusetts, USA / Tompkins Collection / Bridgeman Images; p. 43 André Lhote, 1918, *Study for 'Homage to Watteau'*, oil on canvas, © Tate, London 2018; p. 41 Pierre Bonnard, 1902, *Landscape*, oil on mill board, Fitzwilliam Museum, University of Cambridge, UK / Bridgeman Images; p. 48 Jean Frélaut, 1920, *Apple Blossom*, oil on canvas, 60 x 74 cm, WA1940.1.30, © Artist's Estate. Image © Ashmolean Museum, University of Oxford; p. 54 The Le

Nain Brothers, *c.* 1643, *Four Figures at a Table*, oil on canvas, 44.8 x 55 cm, Wikimedia Commons – in public domain (published in the US before 1923 and public domain in the US); p. 57 Pierre-Auguste Renoir, *c.* 1872–5, *Le Printemps* (now *Spring at Chatou*), oil on canvas, 59 x 74 cm, Private Collection / Bridgeman Images; p. 68 Thomas Gainsborough, *c.* 1752, *Portrait of Master Plampin*, oil on canvas, 50.2 x 60.3 cm, bequeathed by Percy Moore Turner in 1951 to the National Gallery, Room 35; p. 69 Peter Paul Rubens, *c.* 1615, *Portrait of the Archduke Albert*, oil on canvas, 78 x 57 cm, Ashmolean Museum, University of Oxford, UK / Bridgeman Images; p. 73 John Sell Cotman, *c.* 1824–8, *Silver Birches*, oil on canvas, 76.2 x 62.7 cm, Accession number NWHCM : 1951.235.119 Norfolk Museums Service (Norwich Castle Museum & Art Gallery); p. 76 Edgar Degas, *c.* 1877–8, *Two Dancers Entering the Stage*, pastel over monotype on paper, 38.1 x 35 cm, Fogg Art Museum, Harvard Art Museums, USA / Bequest of Grenville L. Winthrop / Bridgeman Images; p. 81 P.1932.SC.465 Toulouse-Lautrec, Henri de (1864-1901): *Jane Avril in the entrance to the Moulin Rouge, putting on her gloves*, *c.* 1892, oil and pastel on millboard laid on panel, 102 x 55.1 cm, The Samuel Courtauld Trust, The Courtauld Gallery, London; p. 84 Samuel Palmer, *c.* 1824–5, *Landscape with Repose of the Holy Family*, oil on panel, 31 x 39 cm, Ashmolean Museum, University of Oxford, UK / Bridgeman Images; pp. 88–9: Jean Frélaut, 1908, *Repas de noce en Bretagne*, oil on canvas, 89.5 x 130.8 cm, © Tate, London 2017; p. 91 Peter Paul Rubens, *c.* 1615–22, *The Watering Place*, oil on oak, 99.4 x 135 cm, National Gallery, London, UK / Photo © Stefano Baldini / Bridgeman Images; p. 93 John Constable, *c.* 1828–9, *Hadleigh Castle*, oil on canvas, 122.6 x 167.3 cm, National Gallery, London, UK, NG4810; p. 95 Georges de La Tour, *c.* 1642, *St Joseph, the Carpenter*, oil on canvas, 130 x 100 cm, Web Gallery of Art: info about artwork http://www.magnificat.com/lifeteen/image This work is in the public domain in its country of origin and other countries and areas where the copyright term is the author's life plus 100 years or less (published in the US before 1923 and public domain in the US); p. 122 François Clouet, 1566, *Portrait of a Man with a Blind Eye Holding a Flute*, oil on canvas, 27.6 x 20.7 cm, RF1948-26 Paris, musée du Louvre, photo © RMN-Grand Palais (musée du Louvre) / Droits réservés; p. 125 John Constable, 1830, *Helmingham Dell*, oil on canvas, 103 x 129 cm, RF1948-5 Paris, musée du Louvre, Photo © RMN-Grand palais (musée du Louvre) / Mathieu Rabeau; p. 133 John Scarlett Davis (previously attributed to Richard Parks Bonington), *c.* 1838, *Man in a Top Hat*, oil on canvas, 63.5 x 52.7 cm, © Tate, London 2017.